THE ELEMENTS OF DRAWING.

THE

ELEMENTS OF DRAWING;

IN

THREE LETTERS TO BEGINNERS.

BY JOHN RUSKIN, M. A.,

AUTHOR OF "MODERN PAINTERS," "SEVEN LAMPS OF ARCHITECTURE," "STONES OF
VENICE," "LECTURES ON ARCHITECTURE AND PAINTING," ETC. ETC.

With Illustrations Drawn by the Author.

CONTENTS.

LETTER I.

LETTER II.

LETTER III.

PREFACE

Iт may perhaps be thought, that in prefacing a Manual of Drawing, I ought to expatiate on the reasons why drawing should be learned ; but those reasons appear to me so many and so weighty, that I cannot quickly state or enforce them. With the reader's permission, as this volume is too large already, I will waive all discussion respecting the importance of the subject, and touch only on those points which may appear questionable in the method of its treatment.

In the first place, the book is not calculated for the use of children under the age of twelve or fourteen. I do not think it advisable to engage a child in any but the most voluntary practice of art. If it has talent for drawing, it will be continually scrawling on what paper it can get ; and should be allowed to scrawl at its own free will, due praise being given for every appearance of care, or truth, in its efforts. It should be allowed to amuse itself with cheap colours almost as soon as it has sense enough to wish for them. If it merely daubs the paper with shapeless stains, the colour-box may be taken away till it knows better : but as soon as it begins painting red

coats on soldiers, striped flags to ships, etc., it should have
colours at command ; and, without restraining its choice of
subject in that imaginative and historical art, of a military
tendency, which children delight in, (generally quite as valu-
able, by the way, as any historical art delighted in by their
elders,) it should be gently led by the parents to try to draw,
in such childish fashion as may be, the things it can see and
likes,—birds, or butterflies, or flowers, or fruit. In later years,
the indulgence of using the colour should only be granted as a
reward, after it has shown care and progress in its drawings
with pencil. A limited number of good and amusing prints
should always be within a boy's reach : in these days of cheap
illustration he can hardly possess a volume of nursery tales
without good woodcuts in it, and should be encouraged to copy
what he likes best of this kind ; but should be firmly restricted
to a *few* prints and to a few books. If a child has many toys,
it will get tired of them and break them ; if a boy has many
prints he will merely dawdle and scrawl over them ; it is by
the limitation of the number of his possessions that his pleasure
in them is perfected, and his attention concentrated. The
parents need give themselves no trouble in instructing him, as
far as drawing is concerned, beyond insisting upon economical
and neat habits with his colours and paper, showing him the
best way of holding pencil and rule, and, so far as they take
notice of his work, pointing out where a line is too short or too
long, or too crooked, when compared with the copy ; *accuracy*
being the first and last thing they look for. If the child shows
talent for inventing or grouping figures, the parents should

neither check, nor praise it. They may laugh with it frankly, or show pleasure in what it has done, just as they show pleasure in seeing it well, or cheerful ; but they must not praise it for being clever, any more than they would praise it for being stout. They should praise it only for what costs it self-denial, namely attention and hard work ; otherwise they will make it work for vanity's sake, and always badly. The best books to put into its hands are those illustrated by George Cruikshank or by Richter. (See Appendix.) At about the age of twelve or fourteen, it is quite time enough to set youth or girl to serious work ; and then this book will, I think, be useful to them ; and I have good hope it may be so, likewise, to persons of more advanced age wishing to know something of the first principles of art.

Yet observe, that the method of study recommended is not brought forward as absolutely the best, but only as the best which I can at present devise for an isolated student. It is very likely that farther experience in teaching may enable me to modify it with advantage in several important respects; but I am sure the main principles of it are sound, and most of the exercises as useful as they can be rendered without a master's superintendence. The method differs, however, so materially from that generally adopted by drawing-masters, that a word or two of explanation may be needed to justify what might otherwise be thought wilful eccentricity.

The manuals at present published on the subject of drawing are all directed, as far as I know, to one or other of two objects. Either they propose to give the student a power of

dexterous sketching with pencil or water-colour, so as to emu
late (at considerable distance) the slighter work of our second-
rate artists ; or they propose to give him such accurate com-
mand of mathematical forms as may afterwards enable him to
design rapidly and cheaply for manufactures. When drawing
is taught as an accomplishment, the first is the aim usually
proposed ; while the second is the object kept chiefly in view
at Marlborough House, and in the branch Government Schools
of Design.

Of the fitness of the modes of study adopted in those
schools, to the end specially intended, judgment is hardly yet
possible ; only, it seems to me, that we are all too much in the
habit of confusing art as *applied* to manufacture, with manufac-
ture itself. For instance, the skill by which an inventive work-
man designs and moulds a beautiful cup, is skill of true art; but
the skill by which that cup is copied and afterwards multiplied
a thousandfold, is skill of manufacture : and the faculties
which enable one workman to design and elaborate his original
piece, are not to be developed by the same system of instruc-
tion as those which enable another to produce a maximum
number of approximate copies of it in a given time. Farther :
it is surely inexpedient that any reference to purposes of manu-
facture should interfere with the education of the artist him-
self. Try first to manufacture a Raphael ; then let Raphael
direct your manufacture. He will design you a plate, or cup,
or a house, or a palace, whenever you want it, and design them
in the most convenient and rational way ; but do not let your
anxiety to reach the platter and the cup interfere with your

education of the Raphael. Obtain first the best work you can, and the ablest hands, irrespective of any consideration of economy or facility of production. Then leave your trained artist to determine how far art can be popularised, or manufacture ennobled.

Now, I believe that (irrespective of differences in individual temper and character) the excellence of an artist, as such, depends wholly on refinement of perception, and that it is this, mainly, which a master or a school can teach ; so that while powers of invention distinguish man from man, powers of perception distinguish school from school. All great schools enforce delicacy of drawing and subtlety of sight : and the only rule which I have, as yet, found to be without exception respecting art, is that all great art is delicate.

Therefore, the chief aim and bent of the following system is to obtain, first, a perfectly patient, and, to the utmost of the pupil's power, a delicate method of work, such as may ensure his seeing truly. For I am nearly convinced, that when once we see keenly enough, there is very little difficulty in drawing what we see ; but, even supposing that this difficulty be stil great, I believe that the sight is a more important thing than the drawing ; and I would rather teach drawing that my pupils may learn to love Nature, than teach the looking at Nature that they may learn to draw. It is surely also a more important thing for young people and unprofessional students, to know how to appreciate the art of others, than to gain much power in art themselves. Now the modes of sketching ordi-narily taught are inconsistent with this power of judgment

No person trained to the superficial execution of modern water-colour painting, can understand the work of Titian or Leonardo ; they must for ever remain blind to the refinement of such men's pencilling, and the precision of their thinking. But, however slight a degree of manipulative power the student may reach by pursuing the mode recommended to him in these letters, I will answer for it that he cannot go once through the advised exercises without beginning to understand what masterly work means ; and, by the time he has gained some proficiency in them, he will have a pleasure in looking at the painting of the great schools, and a new perception of the exquisiteness of natural scenery, such as would repay him for much more labour than I have asked him to undergo.

That labour is, nevertheless, sufficiently irksome, nor is it possible that it should be otherwise, so long as the pupil works unassisted by a master. For the smooth and straight road which admits unembarrassed progress must, I fear, be dull as well as smooth ; and the hedges need to be close and trim when there is no guide to warn or bring back the erring traveller. The system followed in this work will, therefore, at first, surprise somewhat sorrowfully those who are familiar with the practice of our class at the Working Men's College ; for here, the pupil, having the master at his side to extricate him from such embarrassments as his first efforts may lead into, is *at once* set to draw from a solid object, and soon finds enter-tainment in his efforts and interest in his difficulties. Of course the simplest object which it is possible to set before the eye is a sphere ; and practically, I find a child's toy, a white

leather ball, better than anything else ; as the gradations on balls of plaster of Paris, which I use sometimes to try the strength of pupils who have had previous practice, are a little too delicate for a beginner to perceive. It has been objected that a circle, or the outline of a sphere, is one of the most difficult of all lines to draw. It is so ; but I do not want it to be drawn. All that his study of the ball is to teach the pupil, is the way in which shade gives the appearance of projection. This he learns most satisfactorily from a sphere ; because any solid form, terminated by straight lines or flat surfaces, owes some of its appearance of projection to its perspective ; but in the sphere, what, without shade, was a flat circle, becomes, merely by the added shade, the image of a solid ball ; and this fact is just as striking to the learner, whether his circular outline be true or false. He is, therefore, never allowed to trouble himself about it ; if he makes the ball look as oval as an egg, the degree of error is simply pointed out to him, and he does better next time, and better still the next. But his mind is always fixed on the gradation of shade, and the outline left to take, in due time, care of itself. I call it outline, for the sake of immediate intelligibility,—strictly speaking, it is merely the edge of the shade ; no pupil in my class being ever allowed to draw an outline, in the ordinary sense. It is pointed out to him, from the first, that Nature relieves one mass, or one tint, against another ; but outlines none. The outline exercise, the second suggested in this letter, is recommended, not to enable the pupil to draw outlines, but as the only means by which, unassisted, he can test his accuracy of eye, and discipline his

hand When the master is by, errors in the form and exteut
of shadows can be pointed out as easily as in outline, and the
handling can be gradually corrected in details of the work.
But the solitary student can only find out his own mistakes by
help of the traced limit, and can only test the firmness of his
oand by an exercise in which nothing but firmness is required ;
and during which all other considerations (as of softness, com-
plexity, &c.) are entirely excluded.

Both the system adopted at the Working Men's College, and
that recommended here, agree, however, in one principle, which
I consider the most important and special of all that are in-
volved in my teaching : namely, the attaching its full import-
ance, from the first, to local colour. I believe that the endeavour
to separate, in the course of instruction, the observation of light
and shade from that of local colour, has always been, and must
always be, destructive of the student's power of accurate sight,
and that it corrupts his taste as much as it retards his progress.
I will not occupy the reader's time by any discussion of the
principle here, but I wish him to note it as the only distinctive
one in my system, so far as it *is* a system. For the recommen-
dation to the pupil to copy faithfully, and without alteration.
whatever natural object he chooses to study, is serviceable,
among other reasons, just because it gets rid of systematic rules
altogether, and teaches people to draw, as country lads learn
to ride, without saddle or stirrups ; my main object being, at
first, not to get my pupils to hold their reins prettily, but to
" sit like a jackanapes, never off."

In these written instructions, therefore, it has always been

with regret that I have seen myself forced to advise anything like monotonous or formal discipline. But, to the unassisted tudent, such formalities are indispensable, and I am not without hope that the sense of secure advancement, and the pleasure of independent effort, may render the following out of even the more tedious exercises here proposed, possible to the solitary learner, without weariness. But if it should be otherwise, and he finds the first steps painfully irksome, I can only desire him to consider whether the acquirement of so great a power as that of pictorial expression of thought be not worth some toil ; or whether it is likely, in the natural order of matters in this working world, that so great a gift should be attainable by those who will give no price for it.

One task, however, of some difficulty, the student will find I have not imposed upon him : namely, learning the laws of perspective. It would be worth while to learn them, if he could do so easily ; but without a master's help, and in the way perspective is at present explained in treatises, the difficulty is greater than the gain. For perspective is not of the slightest use, except in rudimentary work. You can draw the rounding line of a table in perspective, but you cannot draw the sweep of a sea bay ; you can foreshorten a log of wood by it, but you cannot foreshorten an arm. Its laws are too gross and few to be applied to any subtle form ; therefore, as you must learn to draw the subtle forms by the eye, certainly you may draw the simple ones. No great painters ever trouble themselves about perspective, and very few of them know its laws ; they draw everything by the eye, and, naturally enough, disdain in the

easy parts of their work rules which cannot help them in diffi
cult ones. It would take about a month's labour to draw im-
perfectly, by laws of perspective, what any great Venetian will
draw perfectly in five minutes, when he is throwing a wreath
of leaves round a head, or bending the curves of a pattern in
and out among the folds of drapery. It is true that when per-
spective was first discovered, everybody amused themselves
with it ; and all the great painters put fine saloons and arcades
behind their madonnas, merely to show that they could draw in
perspective : but even this was generally done by them only to
catch the public eye, and they disdained the perspective so much,
that though they took the greatest pains with the circlet of a
crown, or the rim of a crystal cup, in the heart of their
picture, they would twist their capitals of columns and towers
of churches about in the background in the most wanton way,
wherever they liked the lines to go, provided only they left just
perspective enough to please the public. In modern days, I
doubt if any artist among us, except David Roberts, knows so
much perspective as would enable him to draw a Gothic arch
to scale, at a given angle and distance. Turner, though he was
professor of perspective to the Royal Academy, did not know
what he professed, and never, as far as I remember, drew a
single building in true perspective in his life ; he drew them
only with as much perspective as suited him. Prout also knew
nothing of perspective, and twisted his buildings, as Turner did,
into whatever shapes he liked. I do not justify this ; and
would recommend the student at least to treat perspective with
common civility, but to pay no court to it. The best way he

can learn it, by himself, is by taking a pane of glass, fixed in a
frame, so that it can be set upright before the eye, at the dis·
tance at which the proposed sketch is intended to be seen
Let the eye be placed at some fixed point, opposite the middle
of the pane of glass, but as high or as low as the student likes ;
then with a brush at the end of a stick, and a little body-colour
that will adhere to the glass, the lines of the landscape may be
traced on the glass, as you see them through it. When so
traced they are all in true perspective. If the glass be
sloped in any direction, the lines are still in true perspective,
only it is perspective calculated for a sloping plane, while com·
mon perspective always supposes the plane of the picture to be
vertical. It is good, in early practice, to accustom yourself to
enclose your subject, before sketching it, with a light frame of
wood held upright before you ; it will show you what you may
legitimately take into your picture, and what choice there is
between a narrow foreground near you, and a wide one farther
off ; also, what height of tree or building you can properly
take in, &c.[1]

Of figure drawing, nothing is said in the following pages,
because I do not think figures, as chief subjects, can be drawn
to any good purpose by an amateur. As accessaries in land·
scape, they are just to be drawn on the same principles as any·
thing else.

[1] If the student is fond of architecture, and wishes to know more of
perspective than he can learn in this rough way, Mr. Runciman (of 49
Accacia Road, St. John's Wood), who was my first drawing-master, and
to whom 1 owe many happy hours, can teach it him quickly, easily, and
rightly.

Lastly : If any of the directions given subsequently to the student should be found obscure by him, or if at any stage of the recommended practice he find himself in difficulties which I have not provided enough against, he may apply by letter to Mr. Ward, who is my under drawing-master at the Working Men's College (45 Great Ormond Street), and who will give any required assistance, on the lowest terms that can remunerate him for the occupation of his time. I have not leisure myself in general to answer letters of inquiry, however much I may desire to do so ; but Mr. Ward has always the power of referring any question to me when he thinks it necessary. I have good hope, however, that enough guidance is given in this work to prevent the occurrence of any serious embarrassment ; and I believe that the student who obeys its directions will find, on the whole, that the best answer of questions is perseverance ; and the best drawing-masters are the woods and hills.

THE

ELEMENTS OF DRAWING.

LETTER I.

ON FIRST PRACTICE.

My dear Reader:

Whether this book is to be of use to you or not, depends wholly on your reason for wishing to learn to draw. If you desire only to possess a graceful accomplishment, to be able to converse in a fluent manner about drawing, or to amuse yourself listlessly in listless hours, I cannot help you: but if you wish to learn drawing that you may be able to set down clearly, and usefully, records of such things as cannot be described in words, either to assist your own memory of them, or to convey distinct ideas of them to other people; if you wish to obtain quicker perceptions of the beauty of the natural world, and to preserve something like a true image of beautiful things that pass away, or which you must yourself leave; if, also, you wish to understand the minds of great painters, and to be able to appreciate their work sincerely, seeing it for yourself, and loving it, not merely taking up the

thoughts of other people about it ; then I *can* help **you, or,** which is better, show you how to help yourself.

Only you must understand, first of all, that these **powers** which indeed are noble and desirable, cannot be got without **work.** It is much easier to learn to draw well, than it **is** to learn to play well on any musical instrument ; but you know that it takes three or four years of practice, giving three or four hours a day, to acquire even ordinary command over the keys of a piano ; and you must not think that a masterly command of your pencil, and the knowledge of what may be done with it, can be acquired without painstaking, **or in a** *very* short time. The kind of drawing which is taught, or supposed to be taught, in our schools, in a term or two, perhaps at the rate of an hour's practice a week, is not drawing at all. It is only the performance of a few dexterous (not always even that) evolutions on paper with a black-lead pencil ; profitless alike to performer and beholder, unless as a matter of vanity, and that the smallest possible vanity. If any young person, after being taught what is, in polite circles, called "drawing," will try to copy the commonest piece of real *work*—suppose a lithograph on the titlepage of a new opera air, or a woodcut in the cheapest illustrated newspaper of the day—they will find themselves entirely beaten. And yet that common lithograph was drawn with coarse chalk, much more difficult to manage than the pencil of which an accomplished young lady is supposed to have command ; and that woodcut was drawn in urgent haste, and half spoiled in the cutting afterwards ; and both were done by people whom nobody thinks of as artists, or praises for their power ; both were done for daily bread, with no more artist's pride than any simple handicraftsmen feel in the work they live by.

Do not, therefore, think that you can learn drawing, any more than a new language, without some hard and disagreeable labour. But do not, on the other hand, if you are ready and willing to pay this price, fear that you may be unable to get on for want of special talent. It is indeed true that the persons who have peculiar talent for art, draw instinctively and get on almost without teaching; though never without toil. It is true, also, that of inferior talent for drawing there are many degrees ; it will take one person a much longer time than another to attain the same results, and the results thus painfully attained are never quite so satisfactory as those got with greater ease when the faculties are naturally adapted to the study. But I have never yet, in the experiments I have made, met with a person who could not learn to draw at all ; and, in general, there is a satisfactory and available power in every one to learn drawing if he wishes, just as nearly all persons have the power of learning French, Latin, or arithmetic, in a decent and useful degree, if their lot in life requires them to possess such knowledge.

Supposing then that you are ready to take a certain amount of pains, and to bear a little irksomeness and a few disappointments bravely, I can promise you that an hour's practice a day for six months, or an hour's practice every other day for twelve months, or, disposed in whatever way you find convenient, some hundred and fifty hours' practice, will give you sufficient power of drawing faithfully whatever you want to draw, and a good judgment, up to a certain point, of other people's work : of which hours, if you have one to spare at present, we may as well begin at once.

EXERCISE I.

EVERYTHING that you can see, in the world around you, pre‑ sents itself to your eyes only as an arrangement of patches of different colours variously shaded.[1] Some of these patches of

[1] (N. B. This note is only for the satisfaction of incredulous or curious readers. You may miss it if you are in a hurry, or are willing to take the statement in the text on trust.)

The perception of solid Form is entirely a matter of experience. We *see* nothing but flat colours; and it is only by a series of experiments that we find out that a stain of black or grey indicates the dark side of a solid substance, or that a faint hue indicates that the object in which it appears is far away. The whole technical power of painting depends on our recovery of what may be called the *innocence of the eye;* that is to say, a sort of childish perception of these flat stains of colour, merely as such, without consciousness of what they signify, as a blind man would see them if suddenly gifted with sight.

For instance; when grass is lighted strongly by the sun in certain directions, it is turned from green into a peculiar and somewhat dusty‑ looking yellow. If we had been born blind, and were suddenly endowed with sight on a piece of grass thus lighted in some parts by the sun, it would appear to us that part of the grass was green, and part a dusty yellow (very nearly of the colour of primroses); and, if there were prim‑ roses near, we should think that the sunlighted grass was another mass of plants of the same sulphur‑yellow colour. We should try to gather some of them, and then find that the colour went away from the grass when we stood between it and the sun, but not from the primroses; and by a series of experiments we should find out that the sun was really the cause of the colour in the one,—not in the other. We go through such processes of experiment unconsciously in childhood; and having once come to conclusions touching the signification of certain colours, we always suppose that we *see* what we only know, and have hardly any consciousness of the real aspect of the signs we have learned to inter‑ pret. Very few people have any idea that sunlighted grass is yellow.

colour have an appearance of lines or texture within them, as a
piece of cloth or silk has of threads, or an animal's skin shows
texture of hairs ; but whether this be the case or not, the first
broad aspect of the thing is that of a patch of some definite
colour ; and the first thing to be learned is, how to produce
extents of smooth colour, without texture.

This can only be done properly with a brush ; but a brush,
being soft at the point, causes so much uncertainty in the
touch of an unpractised hand, that it is hardly possible to
learn to draw first with it, and it is better to take, in early
practice, some instrument with a hard and fine point, both that
we may give some support to the hand, and that by working
over the subject with so delicate a point, the attention may be
properly directed to all the most minute parts of it. Even the
best artists need occasionally to study subjects with a pointed
instrument, in order thus to discipline their attention : and

Now, a highly accomplished artist has always reduced himself as nearly
as possible to this condition of infantine sight. He sees the colours of
nature exactly as they are, and therefore perceives at once in the sun-
lighted grass the precise relation between the two colours that form its
shade and light. To him it does not seem shade and light, but bluish
green barred with gold.

Strive, therefore, first of all, to convince yourself of this great fact
about sight. This, in your hand, which you know by experience and
touch to be a book, is to your eye nothing but a patch of white, variously
gradated and spotted; this other thing near you, which by experience
you know to be a table, is to your eye only a patch of brown, variously
darkened and veined; and so on: and the whole art of Painting consists
merely in perceiving the shape and depth of these patches of colour, and
putting patches of the same size, depth, and shape on canvass. The only
obstacle to the success of painting is, that many of the real colours are
brighter and paler than it is possible to put on canvass: we must put
darker ones to represent them.

a beginner must be content to do so for a considerable period.

Also, observe that before we trouble ourselves about diffe-rences of colour, we must be able to lay on *one* colour properly, in whatever gradations of depth and whatever shapes we want. We will try, therefore, first to lay on tints or patches of *grey*, of whatever depth we want, with a pointed instrument. Take any finely-pointed steel pen (one of Gillott's lithographic crow-quills is best), and a piece of quite smooth, but not shining, note-paper, cream-laid, and get some ink that has stood already some time in the inkstand, so as to be quite black, and as thick as it can be without clogging the pen. Take a rule, and draw four straight lines, so as to enclose a square or nearly a square, about as large as *a*, Fig. 1. I say nearly a square, because it does not in the least matter whether it is quite square or not, the object being merely to get a space enclosed by straight lines.

a *b*

Fig. 1.

Now, try to fill in that square space with crossed lines, so completely and evenly that it shall look like a square patch of grey silk or cloth, cut out and laid on the white paper, as at *b*. Cover it quickly, first with straightish lines, in any direction you like, not troubling yourself to draw them much closer or neater than those in the square *a*. Let them quite dry before retouching them. (If you draw three or four squares side by side, you may always be going on with one while the others

are drying.) Then cover these lines with others in a different direction, and let those dry ; then in another direction still, and let those dry. Always wait long enough to run no risk of blotting, and then draw the lines as quickly as you can. Each ought to be laid on as swiftly as the dash of the pen of a good writer ; but if you try to reach this great speed at first you will go over the edge of the square, which is a fault in this exercise. Yet it is better to do so now and then than to draw the lines very slowly ; for if you do, the pen leaves a little dot of ink at the end of each line, and these dots spoil your work. So draw each line quickly, stopping always as nearly as you can at the edge of the square. The ends of lines which go over the edge are afterwards to be removed with the penknife, but not till you have done the whole work, otherwise you roughen the paper, and the next line that goes over the edge makes a blot.

When you have gone over the whole three or four times, you will find some parts of the square look darker than other parts. Now try to make the lighter parts as dark as the rest, so that the whole may be of equal depth or darkness. You will find, on examining the work, that where it looks darkest the lines are closest, or there are some much darker lines, than else-where ; therefore you must put in other lines, or little scratches and dots, *between* the lines in the paler parts ; and where there are very conspicuous dark lines, scratch them out lightly with the penknife, for the eye must not be attracted by any line in particular. The more carefully and delicately you fill in the little gaps and holes the better ; you will get on faster by doing two or three squares perfectly than a great many badly. As the tint gets closer and begins to look even, work with very little ink in your pen, so as hardly to make any mark on the paper ; and at last, where it is too dark, use the

edge of your penknife very lightly, and for some t.ir.e, to wear it softly into an even tone. You will find that the greatest difficulty consists in getting evenness : one bit will always look darker than another bit of your square ; or there will be a granulated and sandy look over the whole. When you find your paper quite rough and in a mess, give it up and begin another square, but do not rest satisfied till you have done your best with every square. The tint at last ought *at least* to be as close and even as that in *b*, Fig. 1. You will find, however, that it is very difficult to get a *pale* tint ; because, naturally, the ink lines necessary to produce a close tint at all, blacken the paper more than you want. You must get over this difficulty not so much by leaving the lines wide apart as by trying to draw them excessively fine, lightly and swiftly; being very cautious in filling in; and, at last, passing the penknife over the whole. By keeping several squares in progress at one time, and reserving your pen for the light one just when the ink is nearly exhausted, you may get on better. The paper ought, at last, to look lightly and evenly toned all over, with no lines distinctly visible.

EXERCISE II.

As this exercise in shading is very tiresome, it will be well to vary it by proceeding with another at the same time. The power of shading rightly depends mainly on *lightness* of hand and *keenness* of sight ; but there are other qualities required in drawing, dependent not merely on lightness, but steadiness of hand ; and the eye, to be perfect in its power, must be made *accurate* as well as keen, and not only see shrewdly, but measure justly.

Possess yourself, therefore, of any cheap work on botany

containing *outline* plates of leaves and flowers, it does not
matter whether bad or good : "Baxter's British Flowering
Plants" is quite good enough. Copy any of the simplest out-
lines, first with a soft pencil, following it, by the eye, as nearly
as you can ; if it does not look right in proportions, rub out
and correct it, always by the eye, till you think it is right :
when you have got it to your mind, lay tracing-paper on the
book, on this paper trace the outline you have been copying,
and apply it to your own ; and having thus ascertained the
faults, correct them all patiently, till you have got it as nearly
accurate as may be. Work with a very soft pencil, and do not
rub out so hard[1] as to spoil the surface of your paper ; never
mind how *dirty* the paper gets, but do not roughen it ; and let
the false outlines alone where they do not really interfere with
the true one. It is a good thing to accustom yourself to hew
and shape your drawing out of a dirty piece of paper. When
you have got it as right as you can, take a quill pen, not very
fine at the point ; rest your hand on a book about an inch and
a half thick, so as to hold the pen long ; and go over your
pencil outline with ink, raising your pen point as seldom as pos-
sible, and never leaning more heavily on one part of the line
than on another. In most outline drawings of the present day,
parts of the curves are thickened to give an effect of shade ;

[1] Stale crumb of bread is better, if you are making a delicate drawing,
than India-rubber, for it disturbs the surface of the paper less: but it
crumbles about the room and makes a mess; and, besides, you waste the
good bread, which is wrong; and your drawing will not for a long while
be worth the crumbs. So use India-rubber very lightly , or, if heavily
pressing it only, not passing it over the paper, and leave what pencil
marks that will not come away so, without minding them. In a finished
drawing the uneffaced penciling is often serviceable, helping the general
tone, and enabling you to take out little bright lights.

all such outlines are bad, but they will serve wel enough for
your exercises, provided you do not imitate this character : it
is better, however, if you can, to choose a book of pure out-
lines. It does not in the least matter whether your pen outline
be thin or thick ; but it matters greatly that it should be *equal*,
not heavier in one place than in another. The power to be
obtained is that of drawing an even line slowly and in any
direction ; all *dashing* lines, or approximations to penmanship,
are bad. The pen should, as it were, walk slowly over the
ground, and you should be able at any moment to stop it, or to
turn it in any other direction, like a well-managed horse.

As soon as you can copy every curve *slowly* and accurately,
you have made satisfactory progress ; but you will find the dif-
ficulty is in the *slowness*. It is easy to draw what appears to be
a good line with a sweep of the hand, or with what is called
freedom ;[1] the real difficulty and masterliness is in never letting
the hand *be* free, but keeping it under entire control at every
part of the line

[1] What is usually so much sought after under the term "freedom" is
the character of the drawing of a great master in a hurry, whose hand is
so thoroughly disciplined, that when pressed for time he can let it fly as
it will, and it will not go far wrong. But the hand of a great master at
real *work* is *never* free : its swiftest dash is under perfect government.
Paul Veronese or Tintoret could pause within a hair's breadth of any
appointed mark, in their fastest touches; and follow, within a hair's
breadth, the previously intended curve. You must never, therefore, aim
at freedom. It is not required of your drawing that it should be free,
but that it should be *right* : in time you will be able to do right easily,
and then your work will be free in the best sense ; but there is no merit
in doing *wrong* easily.

These remarks, however, do not apply to the lines used in shading,
which, it will be remembered, are to be made as *quickly* as possible. The
reason of this is, that the quicker a line is drawn, the lighter it is at the

EXERCISE III.

M EANTIME, you are always to be going on with your shaded
squares, and chiefly with these, the outline exercises being
taken up only for rest.

As soon as you find you have some command of the pen as a
shading instrument, and can lay a pale or dark tint as you
choose, try to produce gradated spaces like Fig. 2., the dark

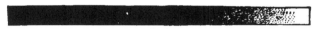

Fig. 2.

tint passing gradually into the lighter ones. Nearly *all* expres-
sion of form, in drawing, depends on your power of gradating
delicately ; and the gradation is always most skilful which
passes from one tint into another *very little* paler. Draw, there-
fore, two parallel lines for limits to your work, as in Fig. 2.,
and try to gradate the shade evenly from white to black, pass-
ing over the greatest possible distance, yet so that every part
of the band may have visible change in it. The perception of
gradation is very deficient in all beginners (not to say, in many
artists), and you will probably, for some time, think your gra-

ends, and therefore the more easily joined with other lines, and concealed
by them ; the object in perfect shading being to conceal the lines as
much as possible.

And observe, in this exercise, the object is more to get firmness of
hand than accuracy of eye for outline ; for there are no outlines in
Nature, and the ordinary student is sure to draw them falsely if he draws
them at all. Do not, therefore, be discouraged if you find mistakes con-
tinue to occur in your outlines ; be content at present if you find your
hand gaining command over the curves.

dation skilful enough when it is quite patchy and imperfect.
By getting a piece of grey shaded riband, and comparing it
with your drawing, you may arrive, in early stages of your
work, at a wholesome dissatisfaction with it. Widen your band
ttle by little as you get more skilful, so as to give the grada-
tion more lateral space, and accustom yourself at the same time
to look for gradated spaces in Nature. The sky is the largest
and the most beautiful ; watch it at twilight, after the sun is
down, and try to consider each pane of glass in the window you
look through as a piece of paper coloured blue, or grey, or
purple, as it happens to be, and observe how quietly and con-
tinuously the gradation extends over the space in the window,
of one or two feet square. Observe the shades on the outside
and inside of a common white cup or bowl, which make it look
round and hollow ;[1] and then on folds of white drapery; and
thus gradually you will be led to observe the more subtle
transitions of the light as it increases or declines on flat sur-
faces. At last, when your eye gets keen and true, you will see
gradation on everything in Nature.

But it will not be in your power yet awhile to draw from any
objects in which the gradations are varied and complicated ;
nor will it be a bad omen for your future progress, and for the
use that art is to be made of by you, if the first thing at which
you aim should be a little bit of sky. So take any narrow
space of evening sky, that you can usually see, between the
boughs of a tree, or between two chimneys, or through the
corner of a pane in the window you like best to sit at, and try
to gradate a little space of white paper as evenly as that is
gradated—as *tenderly* you cannot gradate it without colour, no,

[1] If you can get any pieces of *dead* white porcelain, not glazed, they
will be useful models.

nor with colour either ; but you may do it as evenly ; or, if you
get impatient with your spots and lines of ink, when you look
at the beauty of the sky, the sense you will have gained of that
beauty is something to be thankful for.　But you ought not to
be impatient with your pen and ink ; for all great painters,
however delicate their perception of colour, are fond of the
peculiar effect of light which may be got in a pen-and-ink
sketch, and in a woodcut, by the gleaming of the white paper
between the black lines ; and if you cannot gradate well with
pure black lines, you will never gradate well with pale ones.
By looking at any common woodcuts, in the cheap publications
of the day, you may see how gradation is given to the sky by
leaving the lines farther and farther apart ; but you must make
your lines as *fine* as you can, as well as far apart, towards the
light ; and do not try to make them long or straight, but let
them cross irregularly in any direction easy to your hand,
depending on nothing but their gradation for your effect.　On
this point of direction of lines, however, I shall have to tell
you more presently ; in the meantime, do not trouble yourself
about it.

EXERCISE IV.

As soon as you find you can gradate tolerably with the pen,
take an H. or HH. pencil, using its point to produce shade,
from the darkest possible to the palest, in exactly the same
manner as the pen, lightening, however, now with India-rubber
instead of the penknife.　You will find that all *pale* tints of
shade are thus easily producible with great precision and ten-
derness, but that you cannot get the same dark power as with
the pen and ink, and that the surface of the shade is apt to

become glossy and metallic, or dirty-looking, or sandy. Perse-
vere, however, in trying to bring it to evenness with the fine
point, removing any single speck or line that may be too black,
with the *point* of the knife : you must not scratch the whole
with the knife as you do the ink. If you find the texture very
speckled-looking, lighten it all over with India-rubber, and
recover it again with sharp, and excessively fine touches of the
pencil point, bringing the parts that are too pale to perfect
evenness with the darker spots.

You cannot use the point too delicately or cunningly in
doing this; work with it as if you were drawing the down on a
butterfly's wing.

At this stage of your progress, if not before, you may be
assured that some clever friend will come in, and hold up his
hands in mocking amazement, and ask you who could set you
to that " niggling ;" and if you persevere in it, you will have to
sustain considerable persecution from your artistical acquaint-
ances generally, who will tell you that all good drawing de-
pends on " boldness." But never mind them. You do not
hear them tell a child, beginning music, to lay its little hand
with a crash among the keys, in imitation of the great masters :
yet they might, as reasonably as they may tell you to be bold
in the present state of your knowledge. Bold, in the sense of
being undaunted, yes ; but bold in the sense of being careless,
confident, or exhibitory,—no,—no, and a thousand times no ;
for, even if you were not a beginner, it would be bad advice
that made you bold. Mischief may easily be done quickly, but
good and beautiful work is generally done slowly; you will find
no boldness in the way a flower or a bird's wing is painted; and
if Nature is not bold at *her* work, do you think you ought to
be at *yours*? So never mind what people say, but work with
your pencil point very patiently; and if you can trust me in

an}thing, trust me when I tell you, that though there are all
kinds and ways of art,—large work for large places, small work
for narrow places, slow work for people who can wait, and
quick work for people who cannot,—there is one quality, and,
think, only one, in which all great and good art agrees;—it
is all *delicate* art. Coarse art is always bad art. You cannot
nderstand this at present, because you do not know yet how
much tender thought, and subtle care, the great painters put
into touches that at first look coarse; but, believe me, it is true,
and you will find it is so in due time.

You will be perhaps also troubled, in these first essays at
pencil drawing, by noticing that mere delicate gradations are
got in an instant by a chance touch of the India-rubber, than
by an hour's labour with the point ; and you may wonder why
I tell you to produce tints so painfully, which might, it appears,
be obtained with ease. But there are two reasons : the first,
that when you come to draw forms, you must be able to gra-
date with absolute precision, in whatever place and direction
you wish; not in any wise vaguely, as the India-rubber does it :
and, secondly, that all natural shadows are more or less
mingled with gleams of light. In the darkness of ground there
is the light of the little pebbles or dust ; in the darkness of
foliage, the glitter of the leaves; in the darkness of flesh,
transparency; in that of a stone, granulation : in every case
there is some mingling of light, which cannot be represented by
the leaden tone which you get by rubbing, or by an instrument
known to artists as the "stump." When you can manage the
point properly, you will indeed be able to do much also with
this instrument, or with your fingers ; but then you will have to
retouch the flat tints afterwards, so as to put life and light into
them, and that can only be done with the point. Labour on
therefore, courageously, with that only.

EXERCISE V.

WHEN you can manage to tint and gradate tenderly with
the pencil point, get a good large alphabet, and try to *tint* the
letters into shape with the pencil point. Do not outline them
first, but measure their height and extreme breadth with the

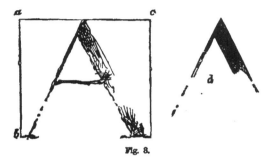

Fig. 3.

compasses, as *a b*, *a c*, Fig. 3., and then scratch in their shapes
gradually; the letter A, enclosed within the lines, being in what
Turner would have called a "state of forwardness." Then,
when you are satisfied with the shape of the letter, draw pen
and ink lines firmly round the tint, as at *d*, and remove any
touches outside the limit, first with the India-rubber, and then
with the penknife, so that all may look clear and right. If you
rub out any of the pencil inside the outline of the letter, re-
touch it, closing it up to the inked line. The straight lines of
the outline are all to be *ruled*,[1] but the curved lines are to be

[1] Artists who glance at this book may be surprised at this per-
mission. My chief reason is, that I think it more necessary that the
pupil's eye should be trained to accurate perception of the relations of
curve and right lines, by having the latter absolutely true, than that he
should practice drawing straight lines. But also, I believe, though I am

drawn by the eye and hand ; and you will soon find what good practice there is in getting the curved letters, such as Bs, Cs, &c., to stand quite straight, and come into accurate form.

All these exercises are very irksome, and they are not to be persisted in alone ; neither is it necessary to acquire perfec power in any of them. An entire master of the pencil or brush ought, indeed, to be able to draw any form at once, as Giotto his circle; but such skill as this is only to be expected of the consummate master, having pencil in hand all his life, and all day long, hence the force of Giotto's proof of his skill; and it is quite possible to draw very beautifully, without attaining even an approximation to such a power; the main point being, not that every line should be precisely what we intend or wish, but that the line which we intended or wished to draw should be right. If we always see rightly and mean rightly, we shall get on, though the hand may stagger a little; but if we mean wrongly, or mean nothing, it does not matter how firm the hand is. Do not, therefore, torment yourself because you cannot do as well as you would like; but work patiently, sure that every square and letter will give you a certain increase of power; and as soon as you can draw your letters pretty well, here is a more amusing exercise for you.

not quite sure of this, that he never *ought* to be able to draw a straight line. I do not believe a perfectly trained hand ever can draw a line without some curvature in it, or some variety of direction. Prout could draw a straight line, but I do not believe Raphael could, nor Tintoret. A great draughtsman can, as far as I have observed, draw every line *but* a straight one.

EXERCISE VI.

CHOOSE any tree that you think pretty, which is nearly bare
f leaves, and which you can see against the sky, or against a
pale wall, or other light ground : it must not be against strong
light, or you will find the looking at it hurt your eyes ; nor
must it be in sunshine, or you will be puzzled by the lights on
the boughs. But the tree must be in shade ; and the sky blue,
or grey, or dull white. A wholly grey or rainy day is the
best for this practice.

You will see that *all* the boughs of the tree are *dark* against
the sky. Consider them as so many dark rivers, to be laid
down in a map with absolute accuracy ; and, without the least
thought about the *roundness* of the stems, map them all out in
flat shade, scrawling them in with pencil, just as you did the
limbs of your letters ; then correct and alter them, rubbing
out and out again, never minding how much your paper is
dirtied (only not destroying its surface), until every bough is
exactly, or as near as your utmost power can bring it, right in
curvature and in thickness. Look at the white interstices
between them with as much scrupulousness as if they were
little estates which you had to survey, and draw maps of, for
some important lawsuit, involving heavy penalties if you cut
the least bit of a corner off any of them, or gave the hedge
anywhere too deep a curve ; and try continually to fancy the
whole tree nothing but a flat ramification on a white ground.
Do not take any trouble about the little twigs, which look like
a confused network or mist ; leave them all out,[1] drawing only

[1] Or, if you feel able to do so, scratch them in with confused quick
touches, indicating the general shape of the cloud or mist of twigs roune
the main branches ; but do not take much trouble about them.

the main branches as far as you can see them distinctly, your
object at present being not to draw a tree, but to *learn how* tc
do so. When you have got the thing as nearly right as you
can—and it is better to make one good study than twenty left
unnecessarily inaccurate—take your pen, and put a fine outline
to all the boughs, as you did to your letter, taking care, as far
as possible, to put the outline within the edge of the shade, so
as not to make the boughs thicker : the main use of the out-
line is to *affirm* the whole more clearly ; to do away with little
accidental roughnesses and excrescences, and especially to mark
where boughs cross, or come in front of each other, as at such
points their arrangement in this kind of sketch is unintelligible
without the outline. It may perfectly well happen that in
Nature it should be less distinct than your outline will make it;
but it is better in this kind of sketch to mark the facts clearly.
The temptation is always to be slovenly and careless, and the
outline is like a bridle, and forces our indolence into attention
and precision. The outline should be about the thickness of
that in Fig. 4, which represents the ramification of a small
stone pine, only I have not endeavoured to represent the pencil
shading within the outline, as I could not easily express it in a
woodcut ; and you have nothing to do at present with the
indication of the foliage above, of which in another place.
You may also draw your trees as much larger than this figure
as you like ; only, however large they may be, keep the out-
line as delicate, and draw the branches far enough into their
outer sprays to give quite as slender ramification as you have
in this figure, otherwise you do not get good enough practice
out of them.

You cannot do too many studies of this kind : every one
will give you some new notion about trees : but when you are
tired of tree boughs, take any forms whatever which are drawn

in flat colour, one upon another ; as patterns on any kind of

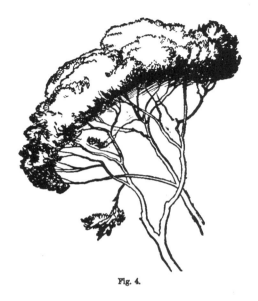

Fig. 4.

cloth, or flat china (tiles, for instance), executed in two colours
only ; and practise drawing them of the right shape and size
by the eye, and filling them in with shade of the depth
required.

In doing this, you will first have to meet the difficulty of
representing depth of colour by depth of shade. Thus a pat-
tern of ultramarine blue will have to be represented by a
darker tint of grey than a pattern of yellow.

And now it is both time for you to begin to learn the
mechanical use of the brush, and necessary for you to do so
in order to provide yourself with the gradated scale of colour
which you will want. If you can, by any means, get acquaint-
ed with any ordinarily skilful water-colour painter, and prevail

on him to show you how to lay on tints with a brush, by all
means do so ; not that you are yet, nor for a long while yet,
to begin to colour, but because the brush is often more con-
venient than the pencil for laying on masses or tints of shade,
and the sooner you know how to manage it as an instrumen
the better. If, however, you have no opportunity of seeing
how water-colour is laid on by a workman of any kind, the
following directions will help you :—

<center>**EXERCISE VII.**</center>

GET a shilling cake of Prussian blue. Dip the end of it in
water so as to take up a drop, and rub it in a white saucer till
you cannot rub much more, and the colour gets dark, thick,
and oily-looking. Put two teaspoonfuls of water to the colour
you have rubbed down, and mix it well up with a camel's-hair
brush about three quarters of an inch long.

Then take a piece of smooth, but not glossy, Bristol board
or pasteboard ; divide it, with your pencil and rule, into
squares as large as those of the very largest chess-board : they
need not be perfect squares, only as nearly so as you can
quickly guess. Rest the pasteboard on something sloping as
much as an ordinary desk ; then, dipping your brush into the
colour you have mixed, and taking up as much of the liquid as
it will carry, begin at the top of one of the squares, and lay a
pond or runlet of colour along the top edge. Lead this pond
of colour gradually downwards, not faster at one place than
another, but as if you were adding a row of bricks to a build-
ing, all along (only building down instead of up), dipping the
brush frequently so as to keep the colour as full in that, and
in as great quantity on the paper, as you can, so only that it

does not run down anywhere in a little stream. But if it
should, never mind ; go on quietly with your square till you
have covered it all in. When you get to the bottom, the
colour will lodge there in a great wave. Have ready a piece
of blotting-paper ; dry your brush on it, and with the dry
brush take up the superfluous colour as you would with a
sponge, till it all looks even.

In leading the colour down, you will find your brush con-
tinually go over the edge of the square, or leave little gaps
within it. Do not endeavour to retouch these, nor take much
care about them ; the great thing is to get the colour to lie
smoothly where it reaches, not in alternate blots and pale
patches ; try, therefore, to lead it over the square as fast as
possible, with such attention to your limit as you are able to
give. The use of the exercise is, indeed, to enable you finally
to strike the colour up to the limit with perfect accuracy ; but
the first thing is to get it even, the power of rightly striking
the edge comes only by time and practice ; even the greatest
artists rarely can do this quite perfectly.

When you have done one square, proceed to do another
which does not communicate with it. When you have thus
done all the alternate squares, as on a chess-board, turn the
pasteboard upside down, begin again with the first, and put
another coat over it, and so on over all the others. The use
of turning the paper upside down is to neutralise the increase
of darkness towards the bottom of the squares, which would
otherwise take place from the ponding of the colour.

Be resolved to use blotting-paper, or a piece of rag, instead
of your lips, to dry the brush. The habit of doing so, once
acquired, will save you from much partial poisoning. Take
care, however, always to draw the brush from root to point,
otherwise you will spoil it. You may even wipe it as you

would a pen when you want it very dry, without doing harm, provided you do not crush it upwards. Get a good brush at first, and cherish it ; it will serve you longer and better than many bad ones.

When you have done the squares all over again, do them a third time, always trying to keep your edges as neat as possible. When your colour is exhausted, mix more in the same proportions, two teaspoonfuls to as much as you can grind with a drop ; and when you have done the alternate squares three times over, as the paper will be getting very damp, and dry more slowly, begin on the white squares, and bring them up to the same tint in the same way. The amount of jagged dark line which then will mark the limits of the squares will be the exact measure of your unskilfulness.

As soon as you tire of squares draw circles (with compasses) ; and then draw straight lines irregularly across circles, and fill up the spaces so produced between the straight line and the circumference ; and then draw any simple shapes of leaves, according to the exercise No. 2., and fill up those, until you can lay on colour quite evenly in any shape you want.

You will find in the course of this practice, as you cannot always put exactly the same quantity of water to the colour, that the darker the colour is, the more difficult it becomes to lay it on evenly. Therefore, when you have gained some definite degree of power, try to fill in the forms required with a full brush, and a dark tint, at once, instead of laying several coats one over another ; always taking care that the tint, however dark, be quite liquid ; and that, after being laid on, so much of it is absorbed as to prevent its forming a black line at the edge as it dries. A little experience will teach you how apt the colour is to do this, and how to prevent it ; not

that it needs always to be prevented, for a great master in water-colours will sometimes draw a firm outline, when he *wants* one, simply by letting the colour dry in this way at the edge.

When, however, you begin to cover complicated forms with the darker colour, no rapidity will prevent the tint from drying irregularly as it is led on from part to part. You will then find the following method useful. Lay in the colour very pale and liquid ; so pale, indeed, that you can only just see where it is on the paper. Lead it up to all the outlines, and make it precise in form, keeping it thoroughly wet everywhere. Then, when it is all in shape, take the darker colour, and lay some of it *into* the middle of the liquid colour. It will spread gradually in a branchy kind of way, and you may now lead it up to the outlines already determined, and play it with the brush till it fills its place well ; then let it dry, and it will be as flat and pure as a single dash, yet defining all the complicated forms accurately.

Having thus obtained the power of laying on a tolerably flat tint, you must try to lay on a gradated one. Prepare the colour with three or four teaspoonfuls of water ; then, when it is mixed, pour away about two-thirds of it, keeping a teaspoonful of pale colour. Sloping your paper as before, draw two pencil lines all the way down, leaving a space between them of the width of a square on your chess-board. Begin at the top of your paper, between the lines ; and having struck on the first brushful of colour, and led it down a little, dip your brush deep in water, and mix up the colour on the plate quickly with as much more water as the brush takes up at that one dip : then, with this paler colour, lead the tint farther down. Dip in water again, mix the colour again, and thus lead down the tint, always dipping in water once between each replenishing of the brush, and stirring the color on the plate

well, but as quickly as you can. Go on until the colour has become so pale that you cannot see it ; then wash your brush thoroughly in water, and carry the wave down a little farther with that, and then absorb it with the dry brush, and leave it to dry.

If you get to the bottom of your paper before your colour gets pale, you may either take longer paper, or begin, with the tint as it was when you left off, on another sheet ; but be sure to exhaust it to pure whiteness at last. When all is quite dry, recommence at the top with another similar mixture of colour, and go down in the same way. Then again, and then again, and so continually until the colour at the top of the paper is as dark as your cake of Prussian blue, and passes down into pure white paper at the end of your column, with a perfectly smooth gradation from one into the other.

You will find at first that the paper gets mottled or wavy, instead of evenly gradated ; this is because at some places you have taken up more water in your brush than at others, or not mixed it thoroughly on the plate, or led one tint too far before replenishing with the next. Practice only will enable you to do it well ; the best artists cannot always get gradations of this kind quite to their minds ; nor do they ever leave them on their pictures without after touching.

As you get more power, and can strike the colour more quickly down, you will be able to gradate in less compass ; [1] beginning with a small quantity of colour, and adding a drop of water, instead of a brushful ; with finer brushes, also, you may gradate to a less scale. But slight skill will enable you

[1] It is more difficult, at first, to get, in colour, a narrow gradation than an extended one · but the ultimate difficulty is, as with the pen, to make the gradation go *far*.

to test the relations of colour to shade as far as is necessary for your immediate progress, which is to be done thus :—

Take cakes of lake, of gamboge, of sepia, of blue-black, of cobalt, and vermilion ; and prepare gradated columns (exactly as you have done with the Prussian blue) of the lake and blue-black.[1] Cut a narrow slip, all the way down, of each gradated colour, and set the three slips side by side ; fasten them down, and rule lines at equal distances across all the three, so as to divide them into fifty degrees, and number the degrees of each, from light to dark, 1, 2, 3, &c. If you have gradated them rightly, the darkest part either of the red or blue will be nearly equal in power to the darkest part of the blue-black, and any degree of the black slip will also, accurately enough for our purpose, balance in weight the degree similarly numbered in the red or the blue slip. Then, when you are drawing from objects of a crimson or blue colour, if you can match their colour by any compartment of the crimson or blue in your scales, the grey in the compartment of the grey scale marked with the same number is the grey which must represent that crimson or blue in your light and shade drawing.

Next, prepare scales with gamboge, cobalt, and vermilion You will find that you cannot darken these beyond a certain point ;[2] for yellow and scarlet, so long as they remain yellow and scarlet, cannot approach to black ; we cannot have, properly speaking, a dark yellow or dark scarlet. Make your scales of full yellow, blue, and scarlet, half-way down ; passing *then* gradually to white. Afterwards use lake to darken the upper half of the vermilion and gamboge ; and Prussian blue

Of course, all the columns of colour are to be of equal length.

[2] The degree of darkness you can reach with the given colour it always indicated by the colour of the solid cake in the box.

to darken the cobalt. You will thus have three more scales passing from white nearly to black, through yellow and orange, through sky-blue, and through scarlet. By mixing the gamboge and Prussian blue you may make another with green; mixing the cobalt and lake, another with violet; the sepia alone will make a forcible brown one; and so on, until you have as many scales as you like, passing from black to white through different colours. Then, supposing your scales properly gradated and equally divided, the compartment or degree No. 1. of the grey will represent in chiaroscuro the No. 1. of all the other colours; No. 2. of grey the No. 2. of the other colours, and so on.

It is only necessary, however, in this matter that you should understand the principle; for it would never be possible for you to gradate your scales so truly as to make them practically accurate and serviceable; and even if you could, unless you had about ten thousand scales, and were able to change them faster than ever juggler changed cards, you could not in a day measure the tints on so much as one side of a frost-bitten apple: but when once you fully understand the principle, and see how all colours contain as it were a certain quantity of darkness, or power of dark relief from white—some more, some less; and how this pitch or power of each may be represented by equivalent values of grey, you will soon be able to arrive shrewdly at an approximation by a glance of the eye, without any measuring scale at all.

You must now go on, again with the pen, drawing patterns, and any shapes of shade that you think pretty, as veinings in marble, or tortoiseshell, spots in surfaces of shells, &c., as tenderly as you can, in the darknesses that correspond to their colours; and when you find you can do this successfully, it is time to begin rounding.

EXERCISE VIII.

Go out into your garden, or into the road, and pick up the first round or oval stone you can find, not very white, nor very dark ; and the smoother it is the better, only it must not *shine.* Draw your table near the window, and put the stone, which I will suppose is about the size of *a* in Fig. 5. (it had better not be much larger), on a piece of not very white paper, on the table in front of you. Sit so that the light may come from your left, else the shadow of the pencil point interferes with your sight of your work. You must not let the *sun* fall on the stone, but only ordinary light : therefore choose a window which the sun does not come in at. If you can shut the shutters of the other windows in the room it will be all the better ; but this is not of much consequence.

Now, if you can draw that stone, you can draw anything : I mean, anything that is drawable. Many things (sea foam, for instance) cannot be drawn at all, only the idea of them more or less suggested ; but if you can draw the stone *rightly,* every thing within reach of art is also within yours.

For all drawing depends, primarily, on your power of repre senting *Roundness.* If you can once do that, all the rest is easy and straightforward ; if you cannot do that, nothing else that you may be able to do will be of any use. For Nature is all made up of roundnesses ; not the roundness of perfect globes, but of variously curved surfaces. Boughs are rounded, leaves are rounded, stones are rounded, clouds are rounded, cheeks are rounded, and curls are rounded : there is no more flatness in the natural world than there is vacancy. The world itself is round, and so is all that is in it, more or less, except human work, which is often very flat indeed.

Therefore, set yourself steadily to conquer that round stone, and you have won the battle.

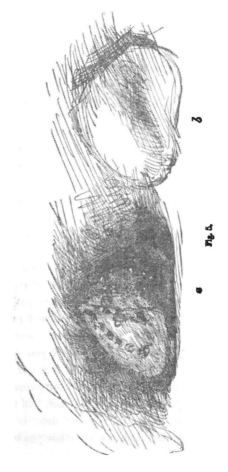

Fig. 5.

Look your stone antagonist boldly in the face. You will see that the side of it next the window is lighter than most of the

paper ; that the side of it farthest from the window is darker
than the paper ; and that the light passes into the dark gra-
dually, while a shadow is thrown to the right *on* the paper
itself by the stone : the general appearance of things being
more or less as in *a*, Fig. 5., the spots on the stone excepted
of which more presently.

Now remember always what was stated in the outset, that
every thing you can see in Nature is seen only so far as it is
lighter or darker than the things about it, or of a different
colour from them. It is either seen as a patch of one colour
on a ground of another ; or as a pale thing relieved from a
dark thing, or a dark thing from a pale thing. And if you can
put on patches of colour or shade of exactly the same size,
shape, and gradations as those on the object and its ground,
you will produce the appearance of the object and its ground.
The best draughtsmen—Titian and Paul Veronese themselves—
could do no more than this ; and you will soon be able to get
some power of doing it in an inferior way, if you once under-
stand the exceeding simplicity of what is to be done. Suppose
you have a brown book on a white sheet of paper, on a red
tablecloth. You have nothing to do but to put on spaces of
red, white, and brown, in the same shape, and gradated from
dark to light in the same degrees, and your drawing is done.
If you will not look at what you see, if you try to put on
brighter or duller colours than are there, if you try to put them
on with a dash or a blot, or to cover your paper with " vigo-
rous " lines, or to produce anything, in fact, but the plain, un-
affected, and finished tranquillity of the thing before you, you
need not hope to get on. Nature will show you nothing if you
set yourself up for her master. But forget yourself, and try
to obey *her*, and you will find obedience easier and happier
than you think.

The real difficulties are to get the *refinement* of the forms and the *evenness* of the gradations. You may depend upon it, when you are dissatisfied with your work, it is always too coarse or too uneven. It may not be wrong—in all probability is not wrong, in any (so-called) *great* point. But its edges are not true enough in outline; and its shades are in blotches, or scratches, or full of white holes. Get it more tender and more true, and you will find it is more powerful.

Do not, therefore, think your drawing must be weak because you have a finely pointed pen in your hand. Till you can draw with that, you can draw with nothing; when you can draw with that, you can draw with a log of wood charred at the end. True boldness and power are only to be gained by care. Even in fencing and dancing, all ultimate ease depends on early precision in the commencement; much more in singing or drawing.

Now, I do not want you to copy Fig. 5., but to copy the stone before you in the way that Fig. 5. is done. To which end, first measure the extreme length of the stone with compasses, and mark that length on your paper; then, between the points marked, leave something like the form of the stone in light, scrawling the paper all over, round it, as at *b*, Fig. 5. You cannot rightly see what the form of the stone really is till you begin finishing, so sketch it in quite rudely; only rather leave too *much* room for the high light, than too little : and then more cautiously fill in the shade, shutting the light gradually up, and putting in the dark cautiously on the dark side. You need not plague yourself about accuracy of shape, because, till you have practised a great deal, it is impossible for you to draw that shape quite truly, and you must gradually gain correctness by means of these various exercises : what you have mainly to do at present is, to get the stone to look solid and

3

round, not much minding what its exact contour is—only draw
it as nearly right as you can without vexation; and you will
get it *more* right by thus feeling your way to it in shade, than
if you tried to draw the outline at first. For you can *see* no
outline; what you see is only a certain space of gradated shade,
with other such spaces about it; and those pieces of shade you
are to imitate as nearly as you can, by scrawling the paper over
till you get them to the right shape, with the same gradations
which they have in Nature. And this is really more likely to
be done well, if you have to fight your way through a little
confusion in the sketch, than if you have an accurately traced
outline. For instance, I was going to draw, beside *a*, another
effect on the stone; reflected light bringing its dark side out
from the background : but when I had laid on the first few
touches, I thought it would be better to stop, and let you see
how I had begun it, at *b*. In which beginning it will be ob-
served that nothing is so determined but that I can more or
less modify, and add to or diminish the contour as I work on,
the lines which suggest the outline being blended with the
others if I do not want them; and the having to fill up the
vacancies and conquer the irregularities of such a sketch, will
probably secure a higher completion at last, than if half an
hour had been spent in getting a true outline before beginning

In doing this, however, take care not to get the drawing too
dark. In order to ascertain what the shades of it really are,
cut a round hole, about half the size of a pea, in a piece of
white paper, the colour of that you use to draw on. Hold this
bit of paper, with the hole in it, between you and your stone,
and pass the paper backwards and forwards, so as to see the
different portions of the stone (or other subject) through the
hole. You will find that, thus, the circular hole looks like one
of the patches of colour you have been accustomed to match,

only changing in depth as it lets different pieces of the stone be
seen through it. You will be able thus actually to *match* the
colour of the stone, at any part of it, by tinting the paper
beside the circular opening. And you will find that this open-
ing never looks quite *black*, but that all the roundings of the
stone are given by subdued greys.[1]

You will probably find, also, that some parts of the stone, or
of the paper it lies on, look luminous through the opening, so
that the little circle then tells as a light spot instead of a dark
spot. When this is so, you cannot imitate it, for you have no
means of getting light brighter than white paper : but by hold-
ing the paper more sloped towards the light, you will find that
many parts of the stone, which before looked light through the
hole, then look dark through it; and if you can place the paper
in such a position that every part of the stone looks slightly
dark, the little hole will tell always as a spot of shade, and if
your drawing is put in the same light, you can imitate or match
every gradation. You will be amazed to find, under these cir-
cumstances, how slight the differences of tint are, by which,
through infinite delicacy of gradation, Nature can express form.

If any part of your subject will obstinately show itself as a
light through the hole, that part you need not hope to imitate
Leave it white, you can do no more.

When you have done the best you can to get the general
form, proceed to finish, by imitating the texture and all the
cracks and stains of the stone as closely as you can; and note,
in doing this, that cracks or fissures of any kind, whether be-
tween stones in walls, or in the grain of timber or rocks, or in
any of the thousand other conditions they present, are never

[1] The figure *a*, Fig. 5., is very dark, but this is to give an example of
all kinds of depths of tint, without repeated figures.

expressible by single black lines, or lines of simple shadow. A
crack must always have its complete system of light and shade,
however small its scale. It is in reality a little *ravine*, with a
dark or shady side, and light or sunny side, and, usually, shadow
in the bottom. This is one of the instances in which it may be
as well to understand the reason of the appearance; it is not
often so in drawing, for the aspects of things are so subtle and
confused that they cannot in general be explained; and in the
endeavour to explain some, we are sure to lose sight of others,
while the natural overestimate of the importance of those on
which the attention is fixed, causes us to exaggerate them, so
that merely *scientific* draughtsmen caricature a third part of
Nature, and miss two thirds. The best scholar is he whose eye
is so keen as to see at once how the thing looks, and who need
not, therefore, trouble himself with any reasons why it looks
so : but few people have this acuteness of perception; and to
those who are destitute of it, a little pointing out of rule and
reason will be a help, especially when a master is not near
them. I never allow my own pupils to ask the reason of any-
thing, because, as I watch their work, I can always show them
how the thing is, and what appearance they are missing in it;
but when a master is not by to direct the sight, science may,
here and there, be allowed to do so in his stead.

Generally, then, every solid illumined object—for instance,
the stone you are drawing—has a light side turned towards
the light, a dark side turned away from the light, and a sha-
dow, which is cast on something else (as by the stone on the
paper it is set upon). You may sometimes be placed so as to
see only the light side and shadow, sometimes only the dark
side and shadow, and sometimes both, or either, without the
shadow ; but in most positions solid objects will show all the
three, as the stone does here.

Hold up your hand with the edge of it towards you, as you sit now with your side to the window, so that the flat of your hand is turned to the window. You will see one side of your hand distinctly lighted, the other distinctly in shade. Here are light side and dark side, with no seen shadow ; the shadow being detached, perhaps on the table, perhaps on the other side of the room ; you need not look for it at present.

Take a sheet of note-paper, and holding it edgeways, as you hold your hand, wave it up and down past the side of your hand which is turned from the light, the paper being, of course, farther from the window. You will see, as it passes a strong gleam of light strike on your hand, and light it considerably on its dark side. This light is *reflected* light. It is thrown back from the paper (on which it strikes first in coming from the window) to the surface of your hand, just as a ball would be if somebody threw it through the window at the wall and you caught it at the rebound.

Next, instead of the note-paper, take a red book, or a piece of scarlet cloth. You will see that the gleam of light falling on your hand, as you wave the book is now reddened. Take a blue book, and you will find the gleam is blue. Thus every object will cast some of its own colour back in the light that it reflects.

Now it is not only these books or papers that reflect light to your hand : every object in the room, on that side of it, reflects some, but more feebly, and the colours mixing all together form a neutral [1] light, which lets the colour of your hand itself be more distinctly seen than that of any object which reflects light

[1] Nearly neutral in ordinary circumstances, but yet with quite different tones in its neutrality, according to the colours of the various reflected rays that compose it.

to it ; but if there were no reflected light, that side of your hand would look as black as a coal.

Objects are seen, therefore in general, partly by direct light, and partly by light reflected from the objects around them, or from the atmosphere and clouds. The colour of their light sides depends much on that of the direct light, and that of the dark sides on the colours of the objects near them. It is therefore impossible to say beforehand what colour an object will have at any point of its surface, that colour depending partly on its own tint, and partly on infinite combinations of rays reflected from other things. The only certain fact about dark sides is, that their colour will be changeful, and that a picture which gives them merely darker shades of the colour of the light sides must assuredly be bad.

Now, lay your hand flat on the white paper you are drawing on. You will see one side of each finger lighted, one side dark, and the shadow of your hand on the paper. Here, therefore, are the three divisions of shade seen at once. And although the paper is white, and your hand of a rosy colour somewhat darker than white, yet you will see that the shadow all along, just under the finger which casts it, is darker than the flesh, and is of a very deep grey. The reason of this is, that much light is reflected from the paper to the dark side of your finger, but very little is reflected from other things to the paper itself in that chink under your finger.

In general, for this reason, a shadow, or, at any rate, the part of the shadow nearest the object, is darker than the dark side of the object. I say in general, because a thousand accidents may interfere to prevent its being so. Take a little bit of glass, as a wine-glass, or the ink-bottle, and play it about a little on the side of your hand farthest from the window ; you will presently find you are throwing gleams of light all over the

dark side of your hand, and in some positions of the glass the
reflection from it will annihilate the shadow altogether, and you
will see your hand dark on the white paper. Now a stupid
painter would represent, for instance, a drinking-glass beside
the hand of one of his figures, and because he had been
taught by rule that "shadow was darker than the dark side,"
he would never think of the reflection from the glass, but
paint a dark grey under the hand, just as if no glass were
there. But a great painter would be sure to think of the true
effect, and paint it ; and then comes the stupid critic, and
wonders why the hand is so light on its dark side.

Thus it is always dangerous to assert anything as a *rule*
in matters of art ; yet it is useful for you to remember that, in
a general way, a shadow is darker than the dark side of the
thing that casts it, supposing the colours otherwise the same ;
that is to say, when a white object casts a shadow on a white
surface, or a dark object on a dark surface : the rule will not
hold if the colours are different, the shadow of a black object
on a white surface being, of course, not so dark, usually, as
the black thing casting it. The only way to ascertain the ulti-
mate truth in such matters is to *look* for it ; but, in the mean-
time, you will be helped by noticing that the cracks in the
stone are little ravines, on one side of which the light strikes
sharply, while the other is in shade. This dark side usually
casts a little darker shadow at the bottom of the crack ; and
the general tone of the stone surface is not so bright as the
light bank of the ravine. And, therefore, if you get the surface
of the object of a uniform tint, more or less indicative of shade
and then scratch out a white spot or streak in it of any shape ;
by putting a dark touch beside this white one, you may turn it,
as you choose, into either a ridge or an incision, into either a
boss or a cavity. If you put the dark touch on the side of it

nearest the sun, or rather, nearest the place that the light comes from, you will make it a cut or cavity ; if you put it on the opposite side, you will make it a ridge or mound : and the complete success of the effect depends less on depth of shade than on the rightness of the drawing ; that is to say, on the evident correspondence of the form of the shadow with the form that casts it. In drawing rocks, or wood, or anything irregularly shaped, you will gain far more by a little patience in following the forms carefully, though with slight touches, than by laboured finishing of textures of surface and transparencies of shadow.

When you have got the whole well into shape, proceed to lay on the stains and spots with great care, quite as much as you gave to the forms. Very often, spots or bars of local colour do more to express form than even the light and shade, and they are always interesting as the means by which Nature carries light into her shadows, and shade into her lights, an art of which we shall have more to say hereafter, in speaking of composition. Fig. 5 is a rough sketch of a fossil sea-urchin, in which the projections of the shell are of black flint, coming through a chalky surface. These projections form dark spots in the light ; and their sides, rising out of the shadow, form smaller whitish spots in the dark. You may take such scattered lights as these out with the penknife, provided you are just as careful to place them rightly, as if you got them by a more laborious process.

When you have once got the feeling of the way in which gradation expresses roundness and projection, you may try your strength on anything natural or artificial that happens to take your fancy, provided it be not too complicated in form. I have asked you to draw a stone first, because any irregularities and failures in your shading will be less offensive to you, as being partly characteristic of the rough stone

surface, than they would be in a more delicate subject; and
you may as well go on drawing rounded stones of different
shapes for a little while, till you find you can really shade
delicately. You may then take up folds of thick white drapery,
a napkin or towel thrown carelessly on the table is as good
as anything, and try to express them in the same way; only
now you will find that your shades must be wrought with
perfect unity and tenderness, or you will lose the flow of the
folds. Always remember that a little bit perfected is worth
more than many scrawls; whenever you feel yourself inclined
to scrawl, give up work resolutely, and do not go back to
it till next day. Of course your towel or napkin must be
put on something that may be locked up, so that its folds
shall not be disturbed till you have finished. If you find
that the folds will not look right, get a photograph of a
piece of drapery (there are plenty now to be bought, taken
from the sculpture of the cathedrals of Rheims, Amiens, and
Chartres, which will at once educate your hand and your
taste), and copy some piece of that; you will then ascertain
what it is that is wanting in your studies from nature, whether
more gradation, or greater watchfulness of the disposition of
the folds. Probably for some time you will find yourself failing
painfully in both, for drapery is very difficult to follow in its
sweeps; but do not lose courage, for the greater the difficulty,
the greater the gain in the effort. If your eye is more just
in measurement of form than delicate in perception of tint,

pattern on the folded surface will help you. Try whether
it does or not; and if the patterned drapery confuses you,
keep for a time to the simple white one; but if it helps you,
continue to choose patterned stuffs (tartans, and simple che-
quered designs are better at first than flowered ones), and
even though it should confuse you, begin pretty soon to use

a pattern occasionally, copying all the distortions and per-
spective modifications of it among the folds with scrupulous
care.

Neither must you suppose yourself condescending in doing
this. The greatest masters are always fond of drawing pat-
terns; and the greater they are, the more pains they take
to do it truly.¹ Nor can there be better practice at any
time, as introductory to the nobler complication of natural
detail. For when you can draw the spots which follow the
folds of a printed stuff, you will have some chance of following
the spots which fall into the folds of the skin of a leopard
as he leaps; but if you cannot draw the manufacture, assu-
redly you will never be able to draw the creature. So the
cloudings on a piece of wood, carefully drawn, will be the
best introduction to the drawing of the clouds of the sky,
or the waves of the sea; and the dead leaf-patterns on a
damask drapery, well rendered, will enable you to disentagle
masterfully the living leaf-patterns of a thorn thicket, or a
violet bank.

Observe, however, in drawing any stuffs, or bindings of books,
or other finely textured substances, do not trouble yourself,
as yet, much about the woolliness or gauziness of the thing;
but get it right in shade and fold, and true in pattern
We shall see, in the course of after-practice, how the penned

If we had any business with the reasons of this, I might, perhaps,
be able to show you some metaphysical ones for the enjoyment, by
truly artistical minds, of the changes wrought by light, and shade, and
perspective in patterned surfaces; but this is at present not to the
point; and all that you need to know is that the drawing of such things
is good exercise, and moreover a kind of exercise which Titian, Vero-
nese, Tintoret, Giorgione, and Turner, all enjoyed, and strove to excel
in.

lines may be made indicative of texture ; but at present attend only to the light, and shade, and pattern. You will be puzzled . at first by *lustrous* surfaces, but a little attention will show you that the expression of these depends merely on the right drawing of their light, and shade, and reflections. Put a small black japanned tray on the table in front of some books ; and you will see it reflects the objects beyond it as in a little black rippled pond ; its own colour mingling always with that of the reflected objects. Draw these reflections of the books properly, making them dark and distorted, as you will see that they are, and you will find that this gives the lustre to your tray. It is not well, however, to draw polished objects in general practice ; only you should do one or two in order to understand the aspect of any lustrous portion of other things, such as you cannot avoid ; the gold, for instance, on the edges of books, or the shining of silk and damask, in which lies a great part of the expression of their folds. Observe, also, that there are very few things which are totally without lustre: you will frequently find a light which puzzles you, on some apparently dull surface, to be the dim image of another object.

And now, as soon as you can conscientiously assure me that with the point of the pen or pencil you can lay on any form and shade you like, I give you leave to use the brush with one colour,—sepia, or blue black, or mixed cobalt and blue black, or neutral tint ; and this will much facilitate your study, and refresh you. But, preliminarily, you must do one or two more exercises in tinting.

EXERCISE IX.

PREPARE your colour as before directed. Take a brush full
of it, and strike it on the paper in any irregular shape ; as the
brush gets dry sweep the surface of the paper with it as if you
were dusting the paper very lightly ; every such sweep of the
brush will leave a number of more or less minute interstices in
the colour. The lighter and faster every dash the better
Then leave the whole to dry, and as soon as it is dry, with
little colour in your brush, so that you can bring it to a fine
point, fill up all the little interstices one by one, so as to make
the whole as even as you can, and fill in the larger gaps with
more colour, always trying to let the edges of the first and of
the newly applied colour exactly meet, and not lap over each
other. When your new colour dries, you will find it in places
a little paler than the first. Retouch it, therefore, trying to
get the whole to look quite one piece. A very small bit of
colour thus filled up with your very best care, and brought to
look as if it had been quite even from the first, will give you
better practice and more skill than a great deal filled in care-
lessly ; so do it with your best patience, not leaving the most
minute spot of white; and do not fill in the large pieces first and
then go to the small, but quietly and steadily cover in the whole
up to a marked limit ; then advance a little farther, and so on;
thus always seeing distinctly what is done and what undone.

EXERCISE X.

LAY a coat of the blue, prepared as usual, over a whole
square of paper. Let it dry. Then another coat over four

fifths of the square, or thereabouts, leaving the edge rather
irregular than straight, and let it dry. Then another coat over
three fifths ; another over two fifths ; and the last over one
fifth ; so that the square may present the appearance of gra-
dual increase in darkness in five bands, each darker than the
one beyond it. Then, with the brush rather dry (as in the
former exercise, when filling up the interstices), try, with
small touches, like those used in the pen etching, only a little
broader, to add shade delicately beyond each edge, so as to
lead the darker tints into the paler ones imperceptibly. By
touching the paper very lightly, and putting a multitude of
little touches, crossing and recrossing in every direction, you
will gradually be able to work up to the darker tints, outside
of each, so as quite to efface their edges, and unite them ten-
derly with the next tint. The whole square, when done,
should look evenly shaded from dark to pale, with no bars ;
only a crossing texture of touches, something like chopped
straw, over the whole.[1]

Next, take your rounded pebble ; arrange it in any light
and shade you like ; outline it very loosely with the pencil.
Put on a wash of colour, prepared *very* pale, quite flat over
all of it, except the highest light, leaving the edge of your
colour quite sharp. Then another wash, extending only over
the darker parts, leaving the edge of that sharp also, as in
tinting the square. Then another wash over the still darker
parts, and another over the darkest, leaving each edge to dry
sharp Then, with the small touches, efface the edges, reinforce
the darks, and work the whole delicately together, as you

[1] The use of acquiring this habit of execution is that you may be able,
when you begin to colour, to let one hue be seen in minute portions,
gleaming between the touches of another.

would with the pen, till you have got it to the likeness of the
true light and shade. You will find that the tint underneath
is a great help, and that you can now get effects much more
subtle and complete than with the pen merely.

The use of leaving the edges always sharp is that you may not
trouble or vex the colour, but let it lie as it falls suddenly on
the paper; colour looks much more lovely when it has been laid
on with a dash of the brush, and left to dry in its own way,
than when it has been dragged about and disturbed ; so that it
is always better to let the edges and forms be a *little* wrong,
even if one cannot correct them afterwards, than to lose this
fresh quality of the tint. Very great masters in water-colour
can lay on the true forms at once with a dash, and *bad* masters
in water-colour lay on grossly false forms with a dash, and
leave them false ; for people in general, not knowing false from
true, are as much pleased with the appearance of power in the
irregular blot as with the presence of power in the determined
one ; but *we*, in our beginnings, must do- as much as we can
with the broad dash, and then correct with the point, till we
are quite right. We must take care to be right, at whatever
cost of pains ; and then gradually we shall find we can be
right with freedom.

I have hitherto limited you to colour mixed with two or
three teaspoonfuls of water ; but in finishing your light and
shade from the stone, you may, as you efface the edge of the
palest coat towards the light, use the colour for the small
touches with more and more water, till it is so pale as not to be
perceptible. Thus you may obtain a *perfect* gradation to the
light. And in reinforcing the darks, when they are very dark,
you may use less and less water. If you take the colour
tolerably dark on your brush, only always liquid (not pasty),
and dash away the superfluous colour on blotting-paper, you

will find that, touching the paper very lightly with the dry brush, you can, by repeated touches, produce a dusty kind of bloom, very valuable in giving depth to shadow; but it requires great patience and delicacy of hand to do this properly. You will find much of this kind of work in the grounds and shadows of William Hunt's drawings.[1]

As you get used to the brush and colour, you will gradually find out their ways for yourself, and get the management of them. Nothing but practice will do this perfectly; but you will often save yourself much discouragement by remembering what I have so often asserted,—that if anything goes wrong, it is nearly sure to be refinement that is wanting, not force; and connexion, not alteration. If you dislike the state your drawing is in, do not lose patience with it, nor dash at it, nor alter its plan, nor rub it desperately out, at the place you think wrong; but look if there are no shadows you can gradate more perfectly; no little gaps and rents you can fill; no forms you can more delicately define: and do not *rush* at any of the errors or incompletions thus discerned, but efface or supply slowly, and you will soon find your drawing take another look. A very useful expedient in producing some effects, is to wet the paper, and then lay the colour on it, more or less wet, according to the effect you want. You will soon see how prettily it gradates itself as it dries; when dry, you can reinforce it with delicate stippling when you want it darker. Also, while the colour is still damp on the paper, by drying your brush thoroughly, and touching the colour with the brush so dried, you may take out soft lights with great tenderness and precision. Try all sorts of experiments of this kind, noticing how the color behaves; but remembering always that your

[1] William Hunt, of the Old Water-colour Society.

final results must be obtained, and can only be obtained, by
pure work with the point, as much as in the pen drawing.

You will find also, as you deal with more and more com
plicated subjects, that Nature's resources in light and shade
are so much richer than yours, that you cannot possibly get all,
or anything *like* all, the gradations of shadow in any given
group. When this is the case, determine first to keep the
broad masses of things distinct : if, for instance, there is a
green book, and a white piece of paper, and a black inkstand
in the group, be sure to keep the white paper as a light mass,
the green book as a middle tint mass, the black inkstand as a
dark mass ; and do not shade the folds in the paper, or cor
ners of the book, so as to equal in depth the darkness of the
inkstand. The great difference between the masters of light
and shade, and imperfect artists, is the power of the former to
draw so delicately as to express form in a dark-coloured object
with little light, and in a light-coloured object with little
darkness ; and it is better even to leave the forms here and
there unsatisfactorily rendered than to lose the general rela-
tions of the great masses. And this observe, not because
masses are grand or desirable things in your composition (for
with composition at present you have nothing whatever to do),
but because it is a *fact* that things do so present themselves to
the eyes of men, and that we see paper, book, and inkstand as
three separate things, before we see the wrinkles, or chinks, or
corners of any of the three. Understand, therefore, at once,
that no detail can be as strongly expressed in drawing as it is
in the reality ; and strive to keep all your shadows and marks
and minor markings on the masses, lighter than they appear to
be in Nature ; you are sure otherwise to get them too dark
You will in doing this find that you cannot get the *projection*
of things sufficiently shown ; but never mind that ; there is no

need that they should appear to project, but great need that
their relations of shade to each other should be preserved. All
deceptive projection is obtained by partial exaggeration of
shadow ; and whenever you see it, you may be sure the draw-
ing is more or less bad ; a thoroughly fine drawing or painting
will always show a slight tendency towards *flatness*.

Observe, on the other hand, that however white an object
may be, there is always some small point of it whiter than the
rest. You must therefore have a slight tone of grey over
everything in your picture except on the extreme high lights ;
even the piece of white paper, in your subject, must be toned
slightly down, unless (and there are a thousand chances to one
against its being so) it should all be turned so as fully to front
the light. By examining the treatment of the white objects in
any pictures accessible to you by Paul Veronese or Titian, you
will soon understand this.[1]

As soon as you feel yourself capable of expressing with the
brush the undulations of surfaces and the relations of masses,
you may proceed to draw more complicated and beautiful
things.[2] And first, the boughs of trees, now not in mere dark

[1] At Marlborough House, among the four principal examples of Tur-
ner's later water-colour drawing, perhaps the most neglected is that of
fishing-boats and fish at sunset. It is one of his most wonderful works,
though unfinished. If you examine the larger white fishing-boat sail,
you will find it has a little spark of pure white in its right-hand upper
corner, about as large as a minute pin's head, and that all the surface of
the sail is gradated to that focus. Try to copy this sail once or twice,
and you will begin to understand Turner's work. Similarly the wing of
the Cupid in Correggio's large picture in the National Gallery is focussed
to two little grains of white at the top of it. The points of light on the
white flower in the wreath round the head of the dancing child-faun, in
Titian's Bacchus and Ariadne, exemplify the same thing.

[2] I shall not henceforward *number* the exercises recommended ; as

relief, but in full rounding. Take the first bit of branch or stump that comes to hand, with a fork in it ; cut off the ends of the forking branches, so as to leave the whole only about a foot in length ; get a piece of paper the same size, fix your bit of branch in some place where its position will not be altered, and draw it thoroughly, in all its light and shade, full size striving, above all things, to get an accurate expression of its structure at the fork of the branch. When once you have mastered the tree at its *armpits*, you will have little more trouble with it.

Always draw whatever the background happens to be, exactly as you see it. Wherever you have fastened the bough, you must draw whatever is behind it, ugly or not, else you will never know whether the light and shade are right ; they may appear quite wrong to you, only for want of the background. And this general law is to be observed in all your studies : whatever you draw, draw completely and unalteringly, else you never know if what you have done is right, or whether you *could* have done it rightly had you tried. There is nothing *visible* out of which you may not get useful practice.

Next, to put the leaves on your boughs. Gather a small twig with four or five leaves on it, put it into water, put a sheet of light-coloured or white paper behind it, so that all the leaves may be relieved in dark from the white field ; then sketch in their dark shape carefully with pencil as you did the complicated boughs, in order to be sure that all their masses and interstices are right in shape before you begin shading, and complete as far as you can with pen and ink, in the manner of Fig. 6., which is a young shoot of lilac.

they are distinguished only by increasing difficulty of subject, not by difference of method

You will probably, in spite of all your pattern drawings, be at first puzzled by leaf foreshortening ; especially because the look of retirement or projection depends not so much on the perspective of the leaves themselves as on the double sight of the two eyes. Now there are certain artifices by which good painters can partly conquer this difficulty; as slight exaggerations of force or colour in the nearer parts, and of obscurity in the more distant ones ; but you must not attempt anything of this kind. When you are first sketching the leaves, shut one of your eyes, fix a point in the background, to bring the point of one of the leaves against, and so sketch the whole bough

Fig. 6.

as you see it in a fixed position, looking with one eye only. Your drawing never can be made to look like the object itself, as you see that object with *both* eyes,[1] but it can be made perfectly like the object seen with one, and you must be content when you have got a resemblance on these terms.

In order to get clearly at the notion of the thing to be done, take a single long leaf, hold it with its point towards you, and

[1] If you understand the principle of the stereoscope you will know why ; if not, it does not matter ; trust me for the truth of the statement, as I cannot explain the principle without diagrams and much loss of time.

as flat as you can, so as to see nothing of it but its thinness, as if you wanted to know how thin it was ; outline it so. Then slope it down gradually towards you, and watch it as it length ens out to its full length, held perpendicularly down before you. Draw it in three or four different positions between these extremes, with its ribs as they appear in each position, and you will soon find out how it must be.

Draw first only two or three of the leaves ; then larger clusters ; and practise, in this way, more and more complicated pieces of bough and leafage, till you find you can master the most difficult arrangements, not consisting of more than ten or twelve leaves. You will find as you do this, if you have an opportunity of visiting any gallery of pictures, that you take a much more lively interest than before in the work of the great masters ; you will see that very often their best backgrounds are composed of little more than a few sprays of leafage, carefully studied, brought against the distant sky ; and that another wreath or two form the chief interest of their foregrounds. If you live in London you may test your progress *accurately* by the degree of admiration you feel for the leaves of vine round the head of the Bacchus, in Titian's Bacchus and Ariadne. All this, however, will not enable you to draw a mass of foliage. You will find, on looking at any rich piece of vegetation, that it is only one or two of the nearer clusters that you can by any possibility draw in this complete manner. The mass is too vast, and too intricate, to be thus dealt with.

You must now therefore have recourse to some confused mode of execution, capable of expressing the confusion of Nature. And, first, you must understand what the character of that confusion is. If you look carefully at the outer sprays of any tree at twenty or thirty yards' distance, you will see them defined against the sky in masses, which, at first, look

quite definite ; but if you examine them, you will see, mingled
with the real shapes of leaves, many indistinct lines, which are,
some of them, stalks of leaves, and some, leaves seen with the
edge turned towards you, and coming into sight in a broken
way ; for, supposing the real leaf shape to be as at *a*, Fig. 7.,
this, when removed some yards from the eye, will appear dark
against the sky, as at *b ;* then, when removed some yards

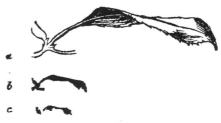

Fig. 7.

farther still, the stalk and point disappear altogether, the mid-
dle of the leaf becomes little more than a line ; and the result
is the condition at *c*, only with this farther subtlety in the look
of it, inexpressible in the woodcut, that the stalk and point of
the leaf, though they have disappeared to the eye, have yet
some influence in *checking the light* at the places where they
exist, and cause a slight dimness about the part of the leaf
which remains visible, so that its perfect effect could only be
rendered by two layers of colour, one subduing the sky tone a
little, the next drawing the broken portions of the leaf, as at *c*,
and carefully indicating the greater darkness of the spot in the
middle, where the under side of the leaf is.

This is the perfect theory of the matter. In practice we can-
not reach such accuracy ; but we shall be able to render the

general look of the foliage satisfactorily by the following mode
of practice.

Gather a spray of any tree, about a foot or eighteen inches
long. Fix it firmly by the stem in anything that will support
it steadily ; put it about eight feet away from you, or ten if
you are far-sighted. Put a sheet of not very white paper
behind it, as usual. Then draw very carefully, first placing
them with pencil, and then filling them up with ink, every leaf
mass and stalk of it in simple black profile, as you see them
against the paper : Fig. 8. is a bough of Phillyrea so drawn.
Do not be afraid of running the leaves into a black mass when
they come together ; this exercise is only to teach you what
the actual shapes of such masses are when seen against the sky.

Fig. 8.

Make two careful studies of this kind of one bough of every
common tree—oak, ash, elm, birch, beech &c. ; in fact, if you

are good, and industrious, you will make one such study care-
fully at least three times a week, until you have examples of
every sort of tree and shrub you can get branches of. You
are to make two studies of each bough, for this reason—all
masses of foliage have an upper and under surface, and the
side view of them, or profile, shows a wholly different organisa-
tion of branches from that seen in the view from above. They
are generally seen more or less in profile, as you look at the
whole tree, and Nature puts her best composition into the pro-
file arrangement. But the view from above or below occurs
not unfrequently, also, and it is quite necessary you should
draw it if you wish to understand the anatomy of the tree.
The difference between the two views is often far greater than

Fig. 9.

you could easily conceive. For instance, in Fig. 9., *a* is the
upper view, and *b* the profile, of a single spray of Phillyrea.
Fig. 8. is an intermediate view of a larger bough ; seen from
beneath, but at some lateral distance also.

When you have done a few branches in this manner, take
one of the *drawings*, and put it first a yard away from you,
then a yard and a half, then two yards ; observe how the thin-
ner stalks and leaves gradually disappear, leaving only a vague
and slight darkness where they were, and make another study
of the effect at each distance, taking care to draw nothing

more than you really see, for in this consists all the difference
between what would be merely a *miniature* drawing of the leaves
seen *near*, and a *full-size* drawing of the same leaves at a dis-
tance. By full size, I mean the size which they would really
appear of if their outline were traced through a pane of glass
held at the same distance from the eye at which you mean to
hold your drawing. You can always ascertain this full size of
any object by holding your paper upright before you, at the
distance from your eye at which you wish your drawing to be
seen. Bring its edge across the object you have to draw, and
mark upon this edge the points where the outline of the object
crosses, or goes behind, the edge of the paper. You will
always find it, thus measured, smaller than you supposed.

When you have made a few careful experiments of this kind on
your own drawings, (which are better for practice, at first, than
the real trees, because the black profile in the drawing is quite
stable, and does not shake, and is not confused by sparkles of
lustre on the leaves,) you may try the extremities of the real
trees, only not doing much at a time, for the brightness of the
sky will dazzle and perplex your sight. And this brightness
causes, I believe, some loss of the outline itself ; at least the
chemical action of the light in a photograph extends much
within the edges of the leaves, and, as it were, eats them away
so that no tree extremity, stand it ever so still, nor any other
form coming against bright sky, is truly drawn by a photo-
graph ; and if you once succeed in drawing a few sprays
rightly, you will find the result much more lovely and interest-
ing than any photograph can be.

All this difficulty, however, attaches to the rendering merely
the dark form of the sprays as they come against the sky.
Within those sprays, and in the heart of the tree, there is a
complexity of a much more embarrassing kind ; for nearly all

leaves have some lustre, and *all* are more or less translucent (letting light through them) ; therefore, in any given leaf, besides the intricacies of its own proper shadows and foreshortenings, there are three series of circumstances which alter or hide its forms. First, shadows cast on it by other leaves—often very forcibly. Secondly, light reflected from its lustrou surface, sometimes the blue of the sky, sometimes the white of clouds, or the sun itself flashing like a star. Thirdly, forms and shadows of other leaves, seen as darknesses *through* the translucent parts of the leaf ; a most important element of foliage effect, but wholly neglected by landscape artists in general.

The consequence of all this is, that except now and then by chance, the form of a complete leaf is never seen ; but a marvellous and quaint confusion, very definite, indeed, in its evidence of direction of growth, and unity of action, but wholly indefinable and inextricable, part by part, by any amount of patience. You cannot possibly work it out in fac simile, though you took a twelvemonth's time to a tree ; and you must therefore try to discover some mode of execution which will more or less imitate, by its own variety and mystery, the variety and mystery of Nature, without absolute delineation of detail.

Now I have led you to this conclusion by observation of tree form only, because in that the thing to be proved is clearest. But no natural object exists which does not involve in some part or parts of it this inimitableness, this mystery of quantity, which needs peculiarity of handling and trick of touch to express it completely. If leaves are intricate, so is moss, so is foam, so is rock cleavage, so are fur and hair, and texture of drapery, and of clouds. And although methods and dexterities of handling are wholly useless if you have not gained first the thorough knowledge of the form of the thing ; so that if you cannot draw a branch perfectly, then much less

4

a tree ; and if not a wreath of mist perfectly, much less a
flock of clouds ; and if not a single grass blade perfectly, much
less a grass bank ; yet having once got this power over deci-
sive form, you may safely—and must, in order to perfection of
work—carry out your knowledge by every aid of method and
dexterity of hand.

But, in order to find out what method can do, you must now
look at Art as well as at Nature, and see what means painters and
engravers have actually employed for the expression of these sub-
tleties. Whereupon arises the question, what opportunity have
you to obtain engravings ? You ought, if it is at all in your
power, to possess yourself of a certain number of good examples
of Turner's engraved works : if this be not in your power, you
must just make the best use you can of the shop windows, or
of any plates of which you can obtain a loan. Very possibly,
the difficulty of getting sight of them may stimulate you to put
them to better use. But, supposing your means admit of your
doing so, possess yourself, first, of the illustrated edition either
of Rogers's Italy or Rogers's Poems, and then of about a dozen
of the plates named in the annexed lists. The prefixed letters
indicate the particular points deserving your study in each
engraving.[1] Be sure, therefore, that your selection includes, a

[1] If you can, get first the plates marked with a star. The letters mean
as follows :—

 stands for architecture, including distant grouping of towns, cottages,
 &c.
c clouds, including mist and aerial effects.
f foliage.
g ground, including low hills, when not rocky.
l effects of light.
m mountains, or bold rocky ground.
p power of general arrangement and effect.

all events, one plate marked with each letter—of course the
.plates marked with two or three letters are, for the most part,
the best. Do not get more than twelve of these plates, nor

q quiet water.
r running or rough water; or rivers, even if calm, when their line of
flow is beautifully marked.

From the England Series.

a e f r. Arundel.
a f l. Ashby de la Zouche.
a l q r. Barnard Castle.*
f m r. Bolton Abbey.
f g r. Buckfastleigh.*
a l p. Caernarvon.
e l q. Castle Upnor.
a f l. Colchester.
l q. Cowes.
e f p. Dartmouth Cove.
e l q. Flint Castle.*
e f g l. Knaresborough.*
 m r. High Force of Tees.*

a f q. Trematon.
a f p. Lancaster.
e l m r. Lancaster Sands.*
a g f. Launceston.
e f l r. Leicester Abbey.
f r. Ludlow.
a f l. Margate.
a l q. Orford.
e p. Plymouth.
f. Powis Castle.
l m q. Prudhoe Castle.
f l m r. Chain Bridge over Tees.*
m q. Ulleswater.
 f m. Valle Crucis.

From the Keepsake.

m p q. Arona.
 , *m.* Drachenfells.
f l. Marley.*

p. St. Germain en Laye.
l p q. Florence.
l m. Ballyburgh Ness.*

From the Bible Series.

f m. Mount Lebanon.
 m. Rock of Moses at Sinai.
e l m. Jericho.

a e g. Joppa.
e l p q. Solomon's Pools.*
a l. Santa Saba.
 a l. Pool of Bethesda.

even all the twelve at first. For the more engravings you have, the less attention you will pay to them. It is a general truth, that the enjoyment derivable from art cannot be increased in quantity, beyond a certain point, by quantity of possession ; it is only spread, as it were, over a larger surface, and very often dulled by finding ideas repeated in different works. Now, for a beginner, it is always better that his attention should be concentrated on one or two good things, and all his enjoyment founded on them, than that he should look at many, with divided thoughts. He has much to discover ; and his best way of discovering it is to think long over few things, and watch them earnestly. It is one of the worst errors of this age to try to know and to see too much : the men who seem to know everything, never in reality know anything rightly. Beware of *hand-book* knowledge.

These engravings are, in general, more for you to look at than to copy ; and they will be of more use to you when we come to talk of composition, than they are at present ; still, it will do you a great deal of good, sometimes to try how far you can get their delicate texture, or gradations of tone ; as your

From Scott's Works.

p r. Melrose.	*e m.* Glencoe.
f r. Dryburgh.*	*e m.* Loch Coriskin.
	a l. Caerlaverock.

From the " Rivers of France."

a g. Château of Amboise, with large bridge on right.	*a p.* Rouen Cathedral.
	f p. Pont de l'Arche.
l p r. Rouen, looking down the river, poplars on right.*	*f l p.* View on the Seine, with avenue.
a l p. Rouen, with cathedral and rainbow, avenue on the left.	*a c p.* Bridge of Meulan.
	e g p r. Caudebec.*

pen-and-ink drawing will be apt to incline too much to a scratchy and broken kind of shade. For instance, the texture of the white convent wall, and the drawing of its tiled roof, in the vignette at p. 227. of Rogers's Poems, is as exquisite as work can possibly be ; and it will be a great and profitable achievement if you can at all approach it. In like manner, if you can at all imitate the dark distant country at p. 7., or the sky at p. 80., of the same volume, or the foliage at pp. 12. and 144., it will be good gain ; and if you can once draw the rolling clouds and running river at p. 9. of the "Italy," or the city in the vignette of Aosta at p. 25., or the moonlight at p. 223., you will find that even Nature herself cannot afterwards very terribly puzzle you with her torrents, or towers, or moonlight.

You need not copy touch for touch, but try to get the same effect. And if you feel discouraged by the delicacy required, and begin to think that engraving is not drawing, and that copying it cannot help you to draw, remember that it differs from common drawing only by the difficulties it has to encounter. You perhaps have got into a careless habit of thinking that engraving is a mere *business*, easy enough when one has got into the knack of it. On the contrary, it is a form of drawing more difficult than common drawing, by exactly so much as it is more difficult to cut steel than to move the pencil over paper. It is true that there are certain mechanical aids and methods which reduce it at certain stages either to pure machine work, or to more or less a habit of hand and arm; but this is not so in the foliage you are trying to copy, of which the best and prettiest parts are always etched—that is, drawn with a fine steel point and free hand : only the line made is white instead of black, which renders it much more difficult to judge of what you are about. And the trying to copy these plates

will be good for you, because it will awaken you to the rea
labour and skill of the engraver, and make you understand a
little how people must work, in this world, who have really to
do anything in it.

Do not, however, suppose that I give you the engraving as a
model—far from it ; but it is necessary you should be able to
do as well : before you think of doing better, and you will find
many little helps and hints in the various work of it. Only
remember that *all* engravers' foregrounds are bad ; whenever
you see the peculiar wriggling parallel lines of modern engrav-
ings become distinct, you must not copy ; nor admire : it is
only the softer masses, and distances; and portions of the foliage
in the plates marked *f*, which you may copy. The best for this
purpose, if you can get it, is the " Chain bridge over the Tees,"
of the England series ; the thicket on the right is very beauti-
ful and instructive, and very like Turner. The foliage in the
" Ludlow " and " Powis " is also remarkably good.

Besides these line engravings, and to protect you from what
harm there is in their influence, you are to provide yourself, if
possible, with a Rembrandt etching, or a photograph of one
(of figures, not landscape). It does not matter of what sub-
ject, or whether a sketchy or finished one, but the sketchy ones
are generally cheapest, and will teach you most. Copy it as
well as you can, noticing especially that Rembrandt's most
rapid lines have steady purpose ; and that they are laid with
almost inconceivable precision when the object becomes at all
interesting. The " Prodigal Son," " Death of the Virgin,"
" Abraham and Isaac," and such others, containing inciden

As *well ;*—not as minutely : the diamond cuts finer lines on the steel
than you can draw on paper with your pen ; but you must be able to get
tones as even, and touches as firm.

and character rather than chiaroscuro, will be the most instruc-
tive You can buy one ; copy it well; then exchange it, at
little loss, for another ; and so, gradually, obtain a good know-
ledge of his system. Whenever you have an opportunity of
examining his work at museums, &c., do so with the greatest
care, not looking at *many* things, but a long time at each. You
must also provide yourself, if possible, with an engraving of
Albert Durer's. This you will not be able to copy ; but you
must keep it beside you, and refer to it as a standard of precision
in line. If you can get one with a *wing* in it, it will be best.
The crest with the cock, that with the skull and satyr, and the
" Melancholy," are the best you could have, but any will do.
Perfection in chiaroscuro drawing lies between these two mas-
ters, Rembrandt and Durer. Rembrandt is often too lose and
vague ; and Durer has little or no effect of mist or uncertainty.
If you can see anywhere a drawing by Leonardo, you will find
it balanced between the two characters ; but there are no en-
gravings which present this perfection, and your style will be
best formed, therefore, by alternate study of Rembrandt and
Durer. Lean rather to Durer ; it is better for amateurs to err
on the side of precision than on that of vagueness : and though,
as I have just said, you cannot copy a Durer, yet try every
now and then a quarter of an inch square or so, and see how
much nearer you can come ; you cannot possibly try to draw
the leafy crown of the " Melancholia " too often.

It you cannot get either a Rembrandt or a Durer, you may
still learn much by carefully studying any of George Cruik
shank's etchings, or Leech's woodcuts in Punch, on the free
side ; with Alfred Rethel's and Richter's [1] on the severe side
But in so doing you will need to notice the following points :

[1] See, for account of these plates, the Appendix on " Works to be
studied."

When either the material (as the copper or wood) or the time of an artist, does not permit him to make a perfect draw·ing,—that is to say, one in which no lines shall be prominently visible,—and he is reduced to show the black lines, either drawn by the pen, or on the wood, it is better to make these lines help, as far as may be, the expression of texture and form You will thus find many textures, as of cloth or grass or flesh, and many subtle effects of light, expressed by Leech with zig·zag or crossed or curiously broken lines ; and you will see that Alfred Rethel and Richter constantly express the direction and rounding of surfaces by the direction of the lines which shade them. All these various means of expression will be useful to you, as far as you can learn them, provided you remember that they are merely a kind of shorthand ; telling certain facts, not in quite the *right* way, but in the only possible way under the conditions : and provided in any after use of such means, you never try to show your own dexterity; but only to get as much record of the object as you can in a given time ; and that you continually make efforts to go beyond such shorthand, and draw portions of the objects rightly.

And touching this question of *direction* of lines as indicating that of surface, observe these few points :

If lines are to be distinctly shown, it is better that, so far as they *can* indicate any thing by their direction, they should ex·plain rather than oppose the general character of the object. Thus, in the piece of wood-cut from Titian, Fig. 10., the lines are serviceable by expressing, not only the shade of the trunk, out partly also its roundness, and the flow of its grain. And Albert Durer, whose work was chiefly engraving, sets himself always thus to make his lines as *valuable* as possible ; telling much by them, both of shade and direction of surface : and if you were always to be limited to engraving on copper (and did

not want to express effects of mist or darkness, as well as deli-
cate forms), Albert Durer's way of work would be the best ex-

Fig. 10.

ample for you. But, inasmuch as the perfect way of drawing
is by shade without lines, and the great painters always con-
ceive their subject as complete, even when they are sketching
it most rapidly, you will find that, when they are not limited in
means, they do not much trust to direction of line, but will
often scratch in the shade of a rounded surface with nearly
straight lines, that is to say, with the easiest and quickest lines
possible to themselves. When the hand is free, the easiest line
for it to draw is one inclining from the left upwards to the
right, or *vice versâ*, from the right downwards to the left ; and
when done very quickly, the line is hooked a little at the end
by the effort at return to the next. Hence, you will always
find the pencil, chalk, or pen sketch of a *very* great master full
of these kind of lines ; and even if he draws carefully, you will
find him using simple straight lines from left to right, when an
inferior master would have used curved ones. Fig. 11. is a fair
facsimile of part of a sketch of Raphael's, which exhibits these
characters very distinctly. Even the careful drawings of Leo-

4*

nardo da Vinci are shaded most commonly with straight lines ;

and you may always assume it as a point increasing the probability of a drawing being by a great master if you find rounded surfaces, such as those of cheeks or lips, shaded with straight lines.

But you will also now understand how easy it must be for dishonest dealers to forge or imitate scrawled sketches like Figure 11., and pass them for the work of great masters ; and how the power of determining the genuineness of a drawing depends entirely on your knowing the *facts* of the object drawn, and perceiving whether the hasty handling is *all*

Fig. 11.

conducive to the expression of those truths. In a great man's work, at its fastest, no line is thrown away, and it is not by the rapidity, but the *economy* of the execution that you know him to be great. Now to judge of this economy, you must know exactly what he meant to do, otherwise you cannot of course

discern how far he has done it ; that is, you must know the beauty and nature of the thing he was drawing. All judgment of art thus finally founds itself on knowledge of Nature.

But farther observe, that this scrawled, or economic, or impetuous execution is never *affectedly* impetuous. If a great man is not in a hurry, he never pretends to be ; if he has no eagerness in his heart, he puts none into his hand ; if he thinks his effect would be better got with *two* lines, he never, to show his dexterity, tries to do it with one. Be assured, therefore (and this is a matter of great importance), that you will never produce a great drawing by imitating the *execution* of a great master. Acquire his knowledge and share is feelings, and the easy execution will fall from your hand as it did from his ; but if you merely scrawl because he scrawled, or blot because he blotted, you will not only never advance in power, but every able draughtsman, and every judge whose opinion is worth having, will know you for a cheat, and despise you accordingly.

Again, observe respecting the use of outline :

All merely outlined drawings are bad, for the simple reason, that an artist of any power can always do more, and tell more, by quitting his outlines occasionally, and scratching in a few lines for shade, than he can by restricting himself to outline only. Hence the fact of his so restricting himself, whatever may be the occasion, shows him to be a bad draughtsman, and not to know how to apply his power economically. This hard law, however, bears only on drawings meant to remain in the state in which you see them ; not on those which were meant to be proceeded with, or for some mechanical use. It is sometimes necessary to draw pure outlines, as an incipient arrangement of a composition, to be filled up afterwards with colour, or to be pricked through and used as patterns or

tracings; but if, with no such ultimate object, making the drawing wholly for its own sake, and meaning it to remain in the state he leaves it, an artist restricts himself to outline, he is a bad draughtsman, and his work is bad. There is no exception to this law. A good artist habitually sees masses, not edges, and can in every case make his drawing more expressive (with any given quantity of work) by rapid shade than by contours; so that all good work whatever is more or less touched with shade, and more or less interrupted as outline.

Hence, the published works of Retsch, and all the English imitations of them, and all outline engravings from pictures, are bad work, and only serve to corrupt the public taste, and of such outlines, the worst are those which are darkened in some part of their course by way of expressing the dark side, as Flaxman's from Dante, and such others; because an outline can only be true so long as it accurately represents the form of the given object with *one* of its edges. Thus, the outline *a* and the outline *b*, Fig. 12., are both *true* outlines of a

Fig. 12.

ball; because, however thick the line may be, whether we take the interior or exterior edge of it, that edge of it always draws a true circle. But *c* is a false outline of a ball, because either the inner or outer edge of the black line must be an untrue circle, else the line could not be thicker in one place than another. Hence all "force," as it is called, is gained by falsification of the contours; so that no artist whose eye is true and fine could endure to look at it. It does indeed often happen that a painter, sketching rapidly, and trying again and again for some line which he cannot quite strike, blackens or loads the first line by setting others beside and across

it ; and then a careless observer supposes it has been thick-
ened on purpose ; or, sometimes also, at a place where shade
is afterwards to enclose the form, the painter will strike a
broad dash of this shade beside his outline at once, looking
as if he meant to thicken the outline ; whereas this broad
line is only the first instalment of the future shadow, and the
outline is really drawn with its inner edge. And thus, far
from good draughtsmen darkening the lines which turn away
from the light, the *tendency* with them is rather to darken
them towards the light, for it is there in general that shade
will ultimately enclose them. The best example of this treat-
ment that I know is Raphael's sketch, in the Louvre, of the
head of the angel pursuing Heliodorus, the one that shows
part of the left eye ; where the dark strong lines which
terminate the nose and forehead towards the light are opposed
to tender and light ones behind the ear, and in other places
towards the shade. You will see in Fig. 11. the same principle
variously exemplified ; the principal dark lines, in the head
and drapery of the arms, being on the side turned to the
light.

All these refinements and ultimate principles, however,
do not affect your drawing for the present. You must try
to make your outlines as *equal* as possible ; and employ pure
outline only for the two following purposes : either (1.) to
steady your hand, as in Exercise II., for if you cannot draw
the line itself, you will never be able to terminate your shadow
in the precise shape required, when the line is absent ; or (2.)
to give you shorthand memoranda of forms, when you are
pressed for time. Thus the forms of distant trees in groups
are defined, for the most part, by the light edge of the rounded
mass of the nearer one being shown against the darker part
of the rounded mass of a more distant one ; and to draw

this properly, nearly as much work is required to round each
tree as to round the stone in Fig. 5. Of course you cannot
often get time to do this ; but if you mark the terminal line
of each tree as is done by Durer in Fig. 13., you will get
a most useful memorandum of their arrangement, and a very
interesting drawing. Only observe in doing this, you must
not, because the procedure is a quick one, hurry that pro-
cedure itself. You will find, on copying that bit of Durer,
that every one of his lines is firm, deliberate, and accurately
descriptive as far as it goes. It means a bush of such a size
and such a shape, definitely observed and set down ; it con-
tains a true "signalement" of every nut-tree, and apple-tree,
and higher bit of hedge, all round that village. If you have
not time to draw thus carefully, do not draw at all—you are

Fig. 18.

merely wasting your work and spoiling your taste. When
you have had four or five years' practice you may be able

to make useful memoranda at a rapid rate, but not yet ; except sometimes of light and shade, in a way of which I will tell you presently. And this use of outline, note farther, is wholly confined to objects which have *edges* or *limits*. You can outline a tree or a stone, when it rises against another tree or stone ; but you cannot outline folds in drapery, or waves in water ; if these are to be expressed at all it must be by some sort of shade, and therefore the rule that no good drawing can consist throughout of pure outline remains absolute. You see, in that woodcut of Durer's, his reason for even limiting himself so much to outline as he has, in those distant woods and plains, is that he may leave them in bright light, to be thrown out still more by the dark sky and the dark village spire ; and the scene becomes real and sunny only by the addition of these shades.

Fig. 14.

Understanding, then, thus much of the use of outline, we will

go back to our question about tree drawing left unanswered at page 73.

We were, you remember, in pursuit of mystery among the leaves. Now, it is quite easy to obtain mystery and disorder, to any extent ; but the difficulty is to keep organization in the midst of mystery. And you will never succeed in doing this unless you lean always to the definite side, and allow yourself rarely to become quite vague, at least through all your early practice. So, after your single groups of leaves, your first step must be to conditions like Figs. 14. and 15., which are careful facsimiles of two portions of a beautiful woodcut of Durer's, the Flight into Egypt. Copy these carefully,—never mind how

Fig. 15.

little at a time, but thoroughly ; then trace the Durer, and apply it to your drawing, and do not be content till the one fits the other, else your eye is not true enough to carry you safely through meshes of real leaves. And in the course of doing this, you will find that not a line nor dot of Durer's can be displaced without harm ; that all add to the effect, and either express something, or illumine something, or relieve something. If, afterwards, you copy any of the pieces of modern tree drawing, of which so many rich examples are given constantly in our cheap illustrated periodicals (any of the Christmas numbers of last year's *Illustrated News* or *Times* are full of them), you will see that, though good and forcible general effect is produced, the lines are thrown in by thousands without special intention, and might just as well go one way as another, so only that there

be enough of them to produce all together a well-shaped effect of intricacy : and you will find that a little careless scratching about with your pen will bring you very near the same result without an effort ; but that no scratching of pen, nor any fortunate chance, nor anything but downright skill and thought, will imitate so much as one leaf of Durer's. Yet there is considerable intricacy and glittering confusion in the interstices of those vine leaves of his, as well as of the grass.

Fig. 16.

When you have got familiarised to this firm manner, you may draw from Nature as much as you like in the same way ; and when you are tired of the intense care required for this, you may fall into a little more easy massing of the leaves, as in

Fig, 10. (p. 81.) This is facsimiled from an engraving after Titian, but an engraving not quite first-rate in manner, the leaves being a little too formal ; still, it is a good enough model for your times of rest ; and when you cannot carry the thing even so far as this, you may sketch the forms of the masses, as in Fig. 16.[1], taking care always to have thorough command over your hand ; that is, not to let the mass take a free shape because your hand ran glibly over the paper, but because in nature it has actually a free and noble shape, and you have faithfully followed the same.

And now that we have come to questions of *noble* shape as well as true shape, and that we are going to draw from nature at our pleasure, other considerations enter into the business, which are by no means confined to *first* practice, but extend to all practice ; these (as this letter is long enough, I should think, to satisfy even the most exacting of correspondents) I will arrange in a second letter ; praying you only to excuse the tiresomeness of this first one—tiresomeness inseparable from directions touching the beginning of any art,—and to believe me, even though I am trying to set you to dull and hard work.

<div style="text-align:center">Very faithfully yours,</div>

<div style="text-align:center">J. RUSKIN.</div>

[1] This sketch is not of a tree standing on its head, though it looks like t. You will find it explained presently.

MY DEAR READER :—

The work we have already gone throigh together has, I hope, enabled you to draw with fair success, either rounded and simple masses, like stones, or complicated arrangements of form, like those of leaves; provided only these masses or complexities will stay quiet for you to copy, and do not extend into quantity so great as to baffle your patience. But if we are now to go out to the fields, and to draw anything like a complete landscape, neither of these conditions will any more be observed for us. The clouds will not wait while we copy their heaps or clefts; the shadows will escape from us as we try to shape them, each, in its stealthy minute march, still leaving light where its tremulous edge had rested the moment before, and involving in eclipse objects that had seemed safe from its influence; and instead of the small clusters of leaves which we could reckon point by point, embarrassing enough even though numerable, we have now leaves as little to be counted as the sands of the sea, and restless, perhaps, as its foam.

In all that we have to do now, therefore, direct imitation becomes more or less impossible. It is always to be aimed at so far as it *is* possible ; and when you have time and opportunity, some portions of a landscape may, as you gain greater skill, be rendered with an approximation almost to mirrored

91

portraiture. Still, whatever skill you may reach, there will always be need of judgment to choose, and of speed to seize, certain things that are principal or fugitive ; and you must give more and more effort daily to the observance of characteristic points, and the attainment of concise methods.

I have directed your attention early to foliage for two reasons. First, that it is always accessible as a study ; and secondly, that its modes of growth present simple examples of the importance of leading or governing lines. It is by seizing these leading lines, when we cannot seize *all*, that likeness and expression are given to a portrait, and grace and a kind of *vital* truth to the rendering of every natural form. I call it *vital* truth, because these chief lines are always expressive of the past history and present action of the thing. They show in a mountain, first, how it was built or heaped up ; and secondly, how it is now being worn away, and from what quarter the wildest storms strike it. In a tree, they show what kind of fortune it has had to endure from its childhood ; how troublesome trees have come in its way, and pushed it aside, and tried to strangle or starve it ; where and when kind trees have sheltered it, and grown up lovingly together with it, bending as it bent ; what winds torment it most ; what boughs of it behave best, and bear most fruit ; and so on. In a wave or cloud, these leading lines show the run of the tide and of the wind, and the sort of change which the water or vapour is at any moment enduring in its form, as it meets shore, or counter-wave, or melting sunshine. Now remember, nothing distinguishes great men from inferior men more than their always, whether in life or in art, *knowing the way things are going.* Your dunce thinks they are standing still, and draws them all fixed ; your wise man sees the change or changing in them, and draws them so—the animal in its motion, the tree in its growth,

the cloud in its course, the mountain in its wearing away. Try always, whenever you look at a form, to see the lines in it which have had power over its past fate, and will have power over its futurity. Those are its *awful* lines ; see that you seize on those, whatever else you miss. Thus, the leafage in Fig 16. (p. 89.) grew round the root of a stone pine, on the brow of a crag at Sestri, near Genoa, and all the sprays of it are thrust away in their first budding by the great rude root, and spring out in every direction round it, as water splashes when a heavy stone is thrown into it. Then, when they have got clear of the root, they begin to bend up again ; some of them, being little stone pines themselves, have a great notion of grow-ing upright, if they can ; and this struggle of theirs to recover their straight road towards the sky, after being obliged to grow sideways in their early years, is the effort that will mainly influence their future destiny, and determine if they are to be crabbed, forky pines, striking from that rock of Sestri, whose clefts nourish them, with bared red lightning of angry arms to-wards the sea ; or if they are to be goodly and solemn pines, with trunks like pillars of temples, and the purple burning of their branches sheathed in deep globes of cloudy green. Those, then, are their fateful lines ; see that you give that spring and resilience, whatever you leave ungiven : depend upon it, their chief beauty is in these.

So in trees in general and bushes, large or small, you will notice that, though the boughs spring irregularly and at vari-ous angles, there is a tendency in all to stoop less and less as they near the top of the tree. This structure, typified in the simplest possible terms at *c*, Fig. 17., is common to all trees that I know of, and it gives them a certain plumy cha-racter, and aspect of unity in the hearts of their branches, which are essential to their beauty. The stem does not

merely send off a wild branch here and there to take its
own way, but all the branches share in one great fountain-like
impulse : each has a curve and a path to take which fills a
definite place, and each terminates all its minor branches at its
outer extremity, so as to form a great outer curve, whose cha-
racter and proportion are peculiar for each species ; that is to
say, the general type or idea of a tree is not as *a*, Fig. 17., but

a *b* *c*

Fig. 17.

as *b*, in which, observe, the boughs all carry their minor divi-
sions right out to the bounding curve ; not but that smaller
branches, by thousands, terminate in the heart of the tree, but
the idea and main purpose in every branch are to carry all its
child branches well out to the air and light, and let each of
them, however small, take its part in filling the united flow of

a *b*

Fig. 18.

the bounding curve, so that the type of each separate bough is
again not *a*, but *b*, Fig. 18. ; approximating, that is to say, so
far to the structure of a plant of broccoii as to throw the great

mass of spray and leafage out to a rounded surface ; therefore, beware of getting into a careless habit of drawing boughs with successive sweeps of the pen or brush, one hanging to the other, as in Fig. 19. If you look at the tree-boughs in any

Fig. 19.

painting of Wilson's, you will see this structure, and nearly every other that is to be avoided, in their intensest types. You will also notice that Wilson never conceives a tree as a round mass, but flat, as if it had been pressed and dried. Most people, in drawing pines, seem to fancy, in the same way, that the boughs come out only on two sides of the trunk, instead of all round it ; always, therefore, take more pains in trying to draw the boughs of trees that grow *towards* you, than those that go off to the sides ; anybody can draw the latter, but the foreshortened ones are not so easy. It will help you in drawing them to observe that in most trees the ramification of each branch, though not of the tree itself, is more or less flattened, and approximates, in its position, to the look of a hand held out to receive something, or shelter something. If you take a looking-glass, and hold your hand before it slightly hollowed, with the palm upwards, and the fingers open, as if you were going to support the base of some great bowl, larger than you could easily hold, and sketch your hand as you see it in the glass, with the points of the fingers towards you, it will materially help you in understanding the way trees generally hold out

their hands ; and if then you will turn yours. with its palm
downwards, as if you were going to try to hide something, but
with the fingers expanded, you will get a good type of the
action of the lower boughs in cedars and such other spreading
trees.

Fig. 20. will give you a good idea of the simplest way in
which these and other such facts can be rapidly expressed ; if
you copy it carefully, you will be surprised to find how the
touches all group together, in expressing the plumy toss of the
tree branches, and the springing of the bushes out of the bank,
and the undulation of the ground : note the careful drawing of
the footsteps made by the climbers of the little mound on the
left.[1] It is facsimiled from an etching of Turner's, and is as
good an example as you can have of the use of pure and firm
lines ; it will also show you how the particular action in foliage,
or anything else to which you wish to direct attention, may be
intensified by the adjuncts. The tall and upright trees are
made to look more tall and upright still, because their line is
continued below by the figure of the farmer with his stick ; and
the rounded bushes on the bank are made to look more rounded
because their line is continued in one broad sweep by the black
dog and the boy climbing the wall. These figures are placed
entirely with this object, as we shall see more fully hereafter
when we come to talk about composition ; but, if you please,
we will not talk about that yet awhile. What I have been
telling you about the beautiful lines and action of foliage has
nothing to do with composition, but only with fact, and the
brief and expressive representation of fact. But there will
be no harm in your looking forward, if you like to do so,
to the account, in Letter III. of the " Law of Radiation," and

[1] It is meant, I believe, for " Salt Hill."

Fig. 20.

reading what is said there about tree growth : indeed it would in some respects have been better to have said it here than there, only it would have broken up the account of the principles of composition somewhat awkwardly.

Now, although the lines indicative of action are not always quite so manifest in other things as in trees, a little attention will soon enable you to see that there *are* such lines in everything In an old house roof, a bad observer and bad draughtsman will only see and draw the spotty irregularity of tiles or slates all over ; but a good draughtsman will see all the bends of the under timbers, where they are weakest and the weight is telling on them most, and the tracks of the run of the water in time of rain, where it runs off fastest, and where it lies long and feeds the moss ; and he will be careful, however few slates he draws, to mark the way they bend together towards those hollows (which have the future fate of the roof in them), and crowd gradually together at the top of the gable, partly diminishing in perspective, partly, perhaps, diminished on purpose (they are so in most English old houses) by the slate-layer. So in ground, there is always the direction of the run of the water to be noticed, which rounds the earth and cuts it into hollows ; and, generally, in any bank, or height worth drawing, a trace of bedded or other internal structure besides. The figure 20. will give you some idea of the way in which such facts may be expressed by a few lines. Do you not feel the depression in the ground all down the hill where the footsteps are, and how the people always turn to the left at the top, losing breath a little, and then how the water runs down in that other hollow towards the valley, behind the roots of the trees ?

Now, I want you in your first sketches from nature to aim exclusively at understanding and representing these vital facts of form ; using the pen—not now the steel, but the quill—

firmly and steadily, never scrawling with it, but saying to your-
self before you lay on a single touch,—"*That* leaf is the main
one, *that* bough is the guiding one, and this touch, *so* long, *so*
broad, means that part of it,"—point or side or knot, as the
case may be. Resolve always, as you look at the thing, what
you will take, and what miss of it, and never let your hand run
away with you, or get into any habit or method of touch. If
you want a continuous line, your hand should pass calmly from
one end of it to the other, without a tremor ; if you want a
shaking and broken line, your hand should shake, or break off,
as easily as a musician's finger shakes or stops on a note : only
remember this, that there is no general way of doing *any* thing ;
no recipe can be given you for so much as the drawing of a clus-
ter of grass. The grass may be ragged and stiff, or tender and
flowing; sunburnt and sheep-bitten, or rank and languid; fresh or
dry ; lustrous or dull : look at it, and try to draw it as it is, and
don't think how somebody " told you to *ao* grass." So a stone
may be round or angular, polished or rough, cracked all over
like an ill-glazed teacup, or as united and broad as the breast
of Hercules. It may be as flaky as a wafer, as powdery as a
field puff-ball ; it may be knotted like a ship's hawser, or
kneaded like hammered iron, or knit like a Damascus sabre, or
fused like a glass bottle, or crystalised like hoar-frost, or veined
like a forest leaf: look at it, and don't try to remember how
anybody told you to "do a stone."

As soon as you find that your hand obeys you thoroughly
and that you can render any form with a firmness and truth
approaching that of Turner's or Durer's work,[1] you must add a
simple but equally careful light and shade to your pen drawing,

[1] I do not mean that you can approach Turner or Durer in their
strength, that is to say, in their imagination or power of design. But
you may approach them, by perseverance, in truth of manner.

so as to make each study as complete as possible : for which you must prepare yourself thus. Get, if you have the means, a good impression of one plate of Turner's Liber Studiorum ; if possible, one of the subjects named in the note below.[1] If you cannot obtain, or even borrow for a little while, any of these engravings, you must use a photograph instead (how, I will tell you presently); but, if you can get the Turner, it will be best. You will see that it is composed of a firm etching in line, with mezzotint shadow laid over it. You must first copy the etched part of it accurately ; to which end put the print against the window, and trace slowly with the *greatest* care every black line ; retrace this on smooth drawing-paper ; and, finally, go over the whole with your pen, looking at the original plate always, so that if you err at all, it may be on the right side, not making a line which is too curved or too straight already in the tracing, *more* curved or *more* straight, as you go over it. And in doing this, never work after you are tired, nor to "get the thing done," for if it is badly done, it will be of no use to you. The true zeal and patience of a

[1] The following are the most desirable plates:

Grande Chartreuse.	Pembury Mill.
Æsacus and Hespérie.	Little Devil's Bridge.
Cephalus and Procris.	River Wye (*not* Wye and Severn).
Source of Arveron.	Holy Island.
Ben Arthur.	Clyde.
Watermill.	Lauffenbourg.
Hindhead Hill.	Blair Athol.
Hedging and Ditching.	Alps from Grenoble.
Dumblane Abbey.	Raglan. (Subject with quiet brook,
Morpeth.	trees, and castle on the right.)
Calais Pier.	

·If you cannot get one of these, any of the others will be serviceable, except only the twelve following, which are quite useless:—

quarter of an hour are better than the sulky and inattentive
labour of a whole day. If you have not made the touches right
at the first going over with the pen, retouch them delicately,
with little ink in your pen, thickening or reinforcing them as
they need : you cannot give too much care to the facsimile.
Then keep this etched outline by you, in order to study at your

1. Scene in Italy, with goats on a walled road, and trees above.

2. Interior of church.

3. Scene with bridge, and trees above; figures on left, one playing a pipe.

4. Scene with figure playing on tambourine.

5. Scene on Thames with high trees, and a square tower of a church
seen through them.

6. Fifth Plague of Egypt.

7. Tenth Plague of Egypt.

8. Rivaulx Abbey.

9. Wye and Severn.

10. Scene with castle in centre, cows under trees on the left.

11. Martello Towers.

12. Calm.

It is very unlikely that you should meet with one of the original etch-
ings; if you should, it will be a drawing-master in itself alone, for it is
not only equivalent to a pen-and-ink drawing by Turner, but to a very
careful one: only observe, the Source of Arveron, Raglan, and Dum-
blane were not etched by Turner; and the etchings of those three are
not good for separate study, though it is deeply interesting to see how
Turner, apparently provoked at the failure of the beginnings in the
Arveron and Raglan, took the plates up himself, and either conquered or
brought into use the bad etching by his marvellous engraving. The
Dumblane was, however, well etched by Mr. Lupton, and beautifully
engraved by him. The finest Turner etching is of an aqueduct with a
stork standing in a mountain stream, not in the published series; and
next to it, are the unpublished etchings of the Via Mala and Crowhurst.
Turner seems to have been so fond of these plates that he kept retouch-
ing and finishing them, and never made up his mind to let them go.
The Via Mala is certainly, in the state in which Turner left it, the finest

ease the way in which Turner uses his line as preparatory for
the subsequent shadow [1] ; it is only in getting the two separate
that you will be able to reason on this. Next, copy once more,
though for the fourth time, any part of this etching which you
like, and put on the light and shade with the brush, and any
brown colour that matches that of the plate[2] ; working it with
the point of the brush as delicately as if you were drawing with
pencil, and dotting and cross-hatching as lightly as you can
touch the paper, till you get the gradations of Turner's en-
graving. In this exercise, as in the former one, a quarter of
an inch worked to close resemblance of the copy is worth more
than the whole subject carelessly done. Not that in drawing
afterwards from nature, you are to be obliged to finish every
gradation in this way, but that, once having fully accomplished
the drawing *something* rightly, you will thenceforward feel and
aim at a higher perfection than you could otherwise have con-
ceived, and the brush will obey you, and bring out quickly and
clearly the loveliest results, with a submissiveness which it
would have wholly refused if you had not put it to severest
work. Nothing is more strange in art than the way that chance
and materials seem to favour you, when once you have tho-
roughly conquered them. Make yourself quite independent of

of the whole series : its etching is, as I said, the best after that of the
aqueduct. Figure 20., above, is part of another fine unpublished etching,
"Windsor, from Salt Hill." Of the published etchings, the finest are the
Ben Arthur, Æsacus, Cephalus, and Stone Pines, with the Girl wash-
ng at a Cistern ; the three latter are the more generally instructive
Hndhead Hill, Isis, Jason, and Morpeth, are also very desirable.

[1] You will find more notice of this point in the account of Harding's
tree-drawing, a little farther on.

[2] The impressions vary so much in colour that no brown can be spe
cified.

chance, get your result in spite of it, and from that day for-
ward all things will somehow fall as you would have them
Show the camel's-hair, and the colour in it, that no bending nor
blotting are of any use to escape your will ; that the touch and
the shade *shall* finally be right, if it cost you a year's toil ; and
from that hour of corrective conviction, said camel's-hair will
bend itself to all your wishes, and no blot will dare to trans-
gress its appointed border. If you cannot obtain a print from
the Liber Studiorum, get a photograph [1] of some general land-
scape subject, with high hills and a village, or picturesque town,
in the middle distance, and some calm water of varied charac-
ter (a stream with stones in it, if possible), and copy any part
of it you like, in this same brown colour, working, as I have
just directed you to do from the Liber, a great deal with the
point of the brush. You are under a twofold disadvantage here,
however ; first, there are portions in every photograph too deli-
cately done for you at present to be at all able to copy ; and
secondly, there are portions always more obscure or dark than
there would be in the real scene, and involved in a mystery
which you will not be able, as yet, to decipher. Both these
characters will be advantageous to you for future study, after
you have gained experience, but they are a little against you in
early attempts at tinting ; still you must fight through the diffi-
culty, and get the power of producing delicate gradations with
brown or grey, like those of the photograph.

Now observe ; the perfection of work would be tinted sha-
dow, like photography, *without* any obscurity or exaggerated
darkness ; and as long as your effect depends in anywise on
visible *lines*, your art is not perfect, though it may be first-rate

[1] You had better get such a photograph, even you have a Liber print
as well.

of its kind But to get complete results in tints merely, re-
quires both long time and consummate skill ; aud you will find
that a few well-put pen lines, with a tint dashed over or under
them, get more expression of facts than you could reach in any
other way, by the same expenditure of time. The use of the
Liber Studiorum print to you is chiefly as an example of the sim-
plest shorthand of this kind, a shorthand which is yet capable
of dealing with the most subtle natural effects ; for the firm
etching gets at the expression of complicated details, as leaves
masonry, textures of ground, &c., while the overlaid tint en-
ables you to express the most tender distances of sky, and forms
of playing light, mist or cloud. Most of the best drawings by
the old masters are executed on this principle, the touches of
the pen being useful also to give a look of transparency to sha-
dows, which could not otherwise be attained but by great
finish of tinting ; and if you have access to any ordinarily good
public gallery, or can make friends of any printsellers who have
folios either of old drawings, or facsimiles of them, you will not
be at a loss to find some example of this unity of pen with tint-
ing. Multitudes of photographs also are now taken from the
best drawings by the old masters, and I hope that our Mecha-
nics' Institutes, and other societies organized with a view to
public instruction, will not fail to possess themselves of exam-
ples of these, and to make them accessible to students of draw-
ng in the vicinity ; a single print from Turner's Liber, to show
the unison of tint with pen etching, and the " St. Catherine,"
ately photographed by Thurston Thompson, from Raphael's
drawing in the Louvre, to show the unity of the soft tinting of
the stump with chalk, would be all that is necessary, and would,
I believe, be in many cases more serviceable than a larger col-
lection, and certainly than a whole gallery of second rate prints.
Two such examples are peculiarly desirable, because all other

modes of drawing, with pen separately, or chalk separately, or
colour separately, may be seen by the poorest student in any
cheap illustrated book, or in shop windows. But this unity of
tinting with line he cannot generally see but by some especial
enquiry, and in some out of the way places he could not find a
single example of it. Supposing that this should be so in your
own case, and that you cannot meet with any example of this
kind, try to make the matter out alone, thus :

Take a small and simple photograph ; allow yourself half an
hour to express its subjects with the pen only, using some per-
manent liquid colour instead of ink, outlining its buildings or
trees firmly, and laying in the deeper shadows, as you have
been accustomed to do in your bolder pen drawings ; then,
when this etching is dry, take your sepia or grey, and tint it
over, getting now the finer gradations of the photograph ; and
finally, taking out the higher lights with penknife or blotting-
paper. You will soon find what can be done in this way ; and
by a series of experiments you may ascertain for yourself how
far the pen may be made serviceable to reinforce shadows,
mark characters of texture, outline unintelligible masses, and
so on. The more time you have, the more delicate you may
make the pen drawing, blending it with the tint ; the less you
have, the more distinct you must keep the two. Practice in
this way from one photograph, allowing yourself sometimes
only a quarter of an hour for the whole thing, sometimes an
hour, sometimes two or three hours ; in each case drawing the
whole subject in full depth of light and shade, but with such
degree of finish in the parts as is possible in the given time.
And this exercise, observe, you will do well to repeat frequently
whether you can get prints and drawings as well as photo-
graphs, or not.

And now at last, when you can copy a piece of Liber Stu

diorum, or its photographic substitute, faithfully, you have the
complete means in your power of working from nature on all
subjects that interest you, which you should do in four different
ways.

First. When you have full time, and your subject is one
that will stay quiet for you, make perfect light and shade stu-
dies, or as nearly perfect as you can, with grey or brown colour
of any kind, reinforced and defined with the pen.

Secondly. When your time is short, or the subject is so rich
in detail that you feel you cannot complete it intelligibly in
light and shade, make a hasty study of the effect, and give the
rest of the time to a Dureresque expression of the details. If
the subject seems to you interesting, and there are points about
it which you cannot understand, try to get five spare minutes
to go close up to it, and make a nearer memorandum ; not that
you are ever to bring the details of this nearer sketch into the
farther one, but that you may thus perfect your experience of
the aspect of things, and know that such and such a look of a
tower or cottage at five hundred yards off means *that* sort of
tower or cottage near ; while, also, this nearer sketch will be
useful to prevent any future misinterpretation of your own
work. If you have time, however far your light and shade
study in the distance may have been carried, it is always well,
for these reasons, to make also your Dureresque and your near
memoranda ; for if your light and shade drawing be good
much of the interesting detail must be lost in it, or disguised.

Your hasty study of effect may be made most easily and
quickly with a soft pencil, dashed over when done with one
tolerably deep tone of grey, which will fix the pencil. While
this fixing colour is wet, take out the higher lights with the
dry brush ; and, when it is quite dry, scratch out the highest
lights with the penknife. Five minutes, carefully applied, will

do much by these means. Of course the paper is to be white
I do not like studies on grey paper so well ; for you can get
more gradation by the taking off your wet tint, and laying it
on cunningly a little darker here and there, than you can with
body-colour white, unless you are consummately skilful. There
is no objection to your making your Dureresque memoranda on
grey or yellow paper, and touching or relieving them with
white ; only, do not depend much on your white touches, nor
make the sketch for their sake.

Thirdly. When you have neither time for careful study nor
for Dureresque detail, sketch the outline with pencil, then dash
in the shadows with the brush boldly, trying to do as much as
you possibly can at once, and to get a habit of expedition and
decision ; laying more colour again and again into the tints as
they dry, using every expedient which your practice has sug-
gested to you of carrying out your chiaroscuro in the manage-
able and moist material, taking the colour off here with the dry
brush, scratching out lights in it there with the wooden handle
of the brush, rubbing it in with your fingers, drying it off with
your sponge, &c. Then, when the colour is in, take your pen
and mark the outline characters vigorously, in the manner of
the Liber Studiorum. This kind of study is very convenient
for carrying away pieces of effect which depend not so much
on refinement as on complexity, strange shapes of involved
shadows, sudden effects of sky, &c. ; and it is most useful as a
safeguard against any too servile or slow habits which the
minute copying may induce in you ; for although the endea-
vour to obtain velocity merely for velocity's sake, and dash for
display's sake, is as baneful as it is despicable ; there *are* a
velocity and a dash which not only are compatible with perfect
drawing, but obtain certain results which cannot be had other-
wise And it is perfectly safe for you to study occasionally for

speed and decision, while your continual course of practice is such as to ensure your retaining an accurate judgment and a tender touch. Speed, under such circumstances, is rather fatiguing than tempting ; and you will find yourself always beguiled rather into elaboration than negligence.

Fourthly. You will find it of great use, whatever kind of landscape scenery you are passing through, to get into the habit of making memoranda of the shapes of shadows. You will find that many objects of no essential interest in themselves, and neither deserving a finished study, nor a Dureresque one, may yet become of singular value in consequence of the fantastic shapes of their shadows ; for it happens often, in distant effect, that the shadow is by much a more important element than the substance. Thus, in the Alpine bridge, Fig. 21., seen within a few yards of it, as in the figure, the arrange-

Fig. 21.

ment of timbers to which the shadows are owing is perceptible ; but at half a mile's distance, in bright sunlight, the timbers would not be seen ; and a good painter's expression of the

bridge would be merely the large spot, and the crossed bars, of
pure grey ; wholly without indication of their cause, as in Fig.
22. *a* ; and if we saw it at still greater distances, it would
appear, as in Fig. 22. *b* and *c*,
diminishing at last to a strange, un-
intelligible, spider-like spot of grey
on the light hill-side. A perfectly
great painter, throughout his dis- *a*
tances, continually reduces his ob-
jects to these shadow abstracts ; and
the singular, and to many persons
unaccountable, effect of the con-
fused touches in Turner's distances, *b*
is owing chiefly to this thorough ac-
curacy and intense meaning of the
shadow abstracts.

Studies of this kind are easily
made when you are in haste, with an *c*
F. or HB. pencil : it requires some
hardness of the point to ensure
your drawing delicately enough

Fig. 22.

when the forms of the shadows are very subtle ; they are sure
to be so somewhere, and are generally so everywhere. The
pencil is indeed a very precious instrument after you are
master of the pen and brush, for the pencil, cunningly used, is
both, and will draw a line with the precision of the one and
the gradation of the other ; nevertheless, it is so unsatisfac-
tory to see the sharp touches, on which the best of the detail
depends, getting gradually deadened by time, or to find the
places where force was wanted look shiny, and like a fire-grate,
that I should recommend rather the steady use of the pen, or
brush, and colour, whenever time admits of it ; keeping only a

small memorandum-book in the breast-pocket, with its well-cut, sheathed pencil, ready for notes on passing opportunities : but never being without this.

Thus much, then, respecting the *manner* in which you are at first to draw from nature. But it may perhaps be serviceable to you, if I also note one or two points respecting your *choice* of subjects for study, and the best special methods of treating some of them ; for one of by no means the least difficulties which you have at first to encounter is a peculiar instinct, common, as far as I have noticed, to all beginners, to fix on exactly the most unmanageable feature in the given scene. There are many things in every landscape which can be drawn, if at all, only by the most accomplished artists ; and I have noticed that it is nearly always these which a beginner will dash at ; or, if not these, it will be something which, though pleasing to him in itself, is unfit for a picture, and in which, when he has drawn it, he will have little pleasure. As some slight protection against this evil genius of beginners, the following general warnings may be useful :

1. Do not draw things that you love, on account of their associations ; or at least do not draw them because you love them ; but merely when you cannot get anything else to draw. If you try to draw places that you love, you are sure to be always entangled amongst neat brick walls, iron railings, gravel walks, greenhouses, and quickset hedges ; besides that you will be continually led into some endeavour to make your drawing pretty, or complete, which will be fatal to your progress. You need never hope to get on, if you are the least anxious that the drawing you are actually at work upon should look nice when it is done. All you have to care about is to make it *right*, and to learn as much in doing it as possible. So then, though when you are sitting in your friend's parlour, or

in your own, and have nothing else to do, you may draw any
thing that is there, for practice ; even the fire-irons or the pat
tern on the carpet : be sure that it *is* for practice, and not
because it is a beloved carpet, nor a friendly poker and tongs,
nor because you wish to please your friend by drawing her
room.

Also, never make presents of your drawings. Of course I
am addressing you as a *beginner*—a time may come when your
work will be precious to everybody ; but be resolute not to
give it away till you know that it is worth something (as soon as
it is worth anything you will know that it is so). If anyone
asks you for a present of a drawing, send them a couple of
cakes of colour and a piece of Bristol board : those materials
are, for the present, of more value in that form than if you
had spread the one over the other.

The main reason for this rule is, however, that its observance
will much protect you from the great danger of trying to make
your drawings pretty.

2. Never, by choice, draw anything polished ; especially if
complicated in form. Avoid all brass rods and curtain orna-
ments, chandeliers, plate, glass, and fine steel. A shining knob
of a piece of furniture does not matter if it comes in your way ;
but do not fret yourself if it will not look right, and choose
only things that do not shine.

3. Avoid all very neat things. They are exceedingly difficult
to draw, and very ugly when drawn. Choose rough, worn, and
clumsy-looking things as much as possible ; for instance, you can-
not have a more difficult or profitless study than a newly-painted
Thames wherry, nor a better study than an old empty coal-
barge, lying ashore at low-tide : in general, everything that you
think very ugly will be good for you to draw.

4. Avoid, as much as possible, studies in which one thing is

seen *through* another. You will constantly find a thin tree
standing before your chosen cottage, or between you and the
turn of the river ; its near branches all entangled with the
distance. It is intensely difficult to represent this ; and though,
when the tree *is* there, you must not imaginarily cut it down,
but do it as well as you can, yet always look for subjects that
fall into definite masses, not into network ; that is, rather for a
cottage with a dark tree *beside* it, than for one with a thin tree
in front of it ; rather for a mass of wood, soft, blue, and
rounded, than for a ragged copse, or confusion of intricate
stems.

5. Avoid, as far as possible, country divided by hedges.
Perhaps nothing in the whole compass of landscape is so
utterly unpicturesque and unmanageable as the ordinary Eng-
lish patchwork of field and hedge, with trees dotted over it in
independent spots, gnawed straight at the cattle line.

Still, do not be discouraged if you find you have chosen ill,
and that the subject overmasters you. It is much better that
it should, than that you should think you had entirely mastered
it. But at first, and even for some time, you must be prepared
for very discomfortable failure ; which, nevertheless, will not be
without some wholesome result.

As, however, I have told you what most definitely to avoid,
I may, perhaps, help you a little by saying what to seek. In
general, all *banks* are beautiful things, and will reward work
better than large landscapes. If you live in a lowland country,
you must look for places where the ground is broken to the
river's edges, with decayed posts, or roots of trees ; or, if by
great good luck there should be such things within your reach,
for remnants of stone quays or steps, mossy mill-dams, &c
Nearly every other mile of road in chalk country will present
beautiful bits of broken bank at its sides ; better in form and

colour than high chalk cliffs. In woods, one or two trunks,
with the flowery ground below, are at once the richest and
easiest kind of study : a not very thick trunk, say nine inches
or a foot in diameter, with ivy running up it sparingly, is an
ivy, and always a rewarding subject.

Large nests of buildings in the middle distance are always
beautiful, when drawn carefully, provided they are not modern
rows of pattern cottages, or villas with Ionic and Doric porticos.
Any old English village, or cluster of farm-houses, drawn with
all its ins and outs, and haystacks, and palings, is sure to be
lovely ; much more a French one. French landscape is gene-
rally as much superior to English as Swiss landscape is to
French ; in some respects, the French is incomparable. Such
scenes as that avenue on the Seine, which I have recommended
you to buy the engraving of, admit no rivalship in their expres-
sion of graceful rusticity and cheerful peace, and in the beauty
of component lines.

In drawing villages, take great pains with the gardens ; a
rustic garden is in every way beautiful. If you have time,
draw all the rows of cabbages, and hollyhocks, and broken
fences, and wandering eglantines, and bossy roses : you cannot
have better practice, nor be kept by anything in purer thoughts.

Make intimate friends of all the brooks in your neighbor-
hood, and study them ripple by ripple.

Village churches in England are not often good subjects ;
there is a peculiar meanness about most of them, and awkward-
ness of line. Old manor-houses are often pretty. Ruins are
usually, with us, too prim, and cathedrals too orderly. I do
not think there is a single cathedral in England from which it
is possible to obtain *one* subject for an impressive drawing
There is always some discordant civility, or jarring vergerism
about them.

If you live in a mountain or hill country, your only danger is redundance of subject. Be resolved, in the first, place, to draw a piece of rounded rock, with its variegated lichens, quite rightly, getting its complete roundings, and all the patterns of the lichen in true local colour. Till you can do this, it is of no use your thinking of sketching among hills ; but when once you have done this, the forms of distant hills will be comparatively easy.

When you have practised for a little time from such of these subjects as may be accessible to you, you will certainly find difficulties arising which will make you wish more than ever for a master's help : these difficulties will vary according to the character of your own mind (one question occurring to one person, and one to another), so that it is impossible to anticipate them all ; and it would make this too large a book if I answered all that I *can* anticipate ; you must be content to work on, in good hope that nature will, in her own time, interpret to you much for herself ; that farther experience on your own part will make some difficulties disappear ; and that others will be removed by the occasional observation of such artists' work as may come in your way. Nevertheless, I will not close this letter without a few general remarks, such as may be useful to you after you are somewhat advanced in power ; and these remarks may, I think, be conveniently arranged under three heads, having reference to the drawing of vegetation, water, and skies.

And, first, of vegetation. You may think, perhaps, we have said enough about trees already ; yet if you have done as you were bid, and tried to draw them frequently enough, and carefully enough, you will be ready by this time to hear a little more of them. You will also recollect that we left our question, respecting the mode of expressing intricacy of leafage

partly unsettled in the first letter. I left it so because I wanted you to learn the real structure of leaves, by drawing them for yourself, before I troubled you with the most subtle considerations as to *method* in drawing them. And by this time, I imagine, you must have found out two principle things universal facts, about leaves ; namely, that they always, in the main tendencies of their lines, indicate a beautiful divergence of growth, according to the law of radiation, already referred to ;[1] and the second, that this divergence is never formal, but carried out with endless variety of individual line. I must now press both these facts on your attention a little farther.

You may perhaps have been surprised that I have not yet spoken of the works of J. D. Harding, especially if you happen to have met with the passages referring to them in Modern Painters, in which they are highly praised. They are deservedly praised, for they are the only works by a modern draughtsman which express in any wise the energy of trees, and the laws of growth, of which we have been speaking. There are no lithographic sketches which, for truth of general character, obtained with little cost of time, at all rival Harding's. Calame, Robert, and the other lithographic landscape sketchers are altogether inferior in power, though sometimes a little deeper in meaning. But you must not take even Harding for a model, though you may use his works for occasional reference ; and if you can afford to buy his Lessons on Trees, it will be serviceable to you in various ways, and will at present

[1] See the closing letter in this volume.

[2] Bogue, Fleet Street. If you are not acquainted with Harding's works (an unlikely supposition, considering their popularity), and can-not meet with the one in question, the diagrams given here will enable you to understand all that is needful for our purposes.

help me to explain the point under consideration. And it is well that I should illustrate this point by reference to Harding's works, because their great influence on young students renders it desirable that their real character should be thoroughly understood.

You will find, first, in the title-page of the Lessons on Trees, a pretty woodcut, in which the tree stems are drawn with great truth, and in a very interesting arrangement of lines. Plate 1. is not quite worthy of Mr. Harding, tending too much to make his pupil, at starting, think everything depends on black dots ; still the main lines are good, and very characteristic of tree growth. Then, in Plate 2., we come to the point at issue. The first examples in that plate are given to the pupil that he may practise from them till his hand gets into the habit of arranging lines freely in a similar manner ; and they are stated by Mr. Harding to be universal in application ; " all outlines expressive of foliage," he says, " are but modifications of them." They consist of groups of lines, more or less resembling our Fig. 23. ; and the characters especially insisted upon are, that they " tend at their inner ends to a common centre ;" that " their ends terminate in [are enclosed by] ovoid curves ;" and that " the outer ends are most emphatic."

Fig. 23.

Now, as thus expressive of the great laws of radiation and enclosure, the main principle of this method of execution confirms, in a very interesting way, our conclusions respecting foliage composition. The reason of the last rule, that the outer end of the line is to be most emphatic, does not indeed at first appear ; for the line at one end of a natural leaf is not more emphatic

than the line at the other : but ultimately, in Harding's method, this darker part of the touch stands more or less for the shade at the outer extremity of the leaf mass ; and, as Harding uses these touches, they express as much of tree character as any mere habit of touch *can* express. But, unfortunately, there is another law of tree growth, quite as fixed as the law of radiation, which this and all other conventional modes of execution wholly lose sight of. This second law is, that the radiating tendency shall be carried out only as a ruling spirit in reconcilement with perpetual individual caprice on the part of the separate leaves. So that the moment a touch is monotonous, it must be also false, the liberty of the leaf individually being just as essential a truth, as its unity of growth with its companions in the radiating group.

It does not matter how small or apparently symmetrical the cluster may be, nor how large or vague. You can hardly have a more formal one than *b* in Fig. 9. p. 71., nor a less formal

Fig. 24.

one than this shoot of Spanish chestnut, shedding its leaves, Fig. 24. ; but in either of them, even the general reader, unpractised in any of the previously recommended exercises, must see that there are wandering lines mixed with the radiating ones, and radiating lines with

the wild ones : and if he takes the pen and tries to copy either

of these examples, he will find that neither play of hand to left
nor to right, neither a free touch nor a firm touch, nor any
learnable or describable touch whatsoever, will enable him to
produce, currently, a resemblance of it ; but that he must
either draw it slowly, or give it up. And (which makes the
matter worse still) though gathering the bough, and putting
it close to you, or seeing a piece of near foliage against the sky,
you may draw the entire outline of the leaves, yet if the spray
has light upon it, and is ever so little a way off, you will miss, as
we have seen, a point of a leaf here, and an edge there ; some
of the surfaces will be confused by glitter, and some spotted
with shade ; and if you look carefully through this confusion
for the edges or dark stems which you really *can see*, and put
only those down, the result will be neither like Fig. 9. nor
Fig. 24., but such an interrupted and puzzling piece of work
as Fig. 25.[1]

Fig. 25.

Now, it is in the perfect acknowledgment and expression of
these *three* laws that all good drawing of landscape consists.
There is, first, the organic unity ; the law, whether of radia-

[1] I draw this figure (a young shoot of oak) in outline only, it being
impossible to express the refinements of shade in distant foliage in a
woodcut.

tion, or parallelism, or concurrent action, which rules the
masses of herbs and trees, of rocks, and clouds, and waves;
secondly, the individual liberty of the members subjected to
these laws of unity; and, lastly, the mystery under which the
separate character of each is more or less concealed.

I say, first, there must be observance of the ruling organic
law. This is the first distinction between good artists and bad
artists. Your common sketcher or bad painter pnts his leaves
on the trees as if they were moss tied to sticks; he cannot see
the lines of action or growth; he scatters the shapeless clouds
over his sky, not perceiving the sweeps of associated curves
which the real clouds are following as they fly; and he breaks
his mountain side into rugged fragments, wholly unconscious of
the lines of force with which the real rocks have risen, or of
the lines of couch in which they repose. On the contrary, it is
the main delight of the great draughtsman to trace these laws
of government; and his tendency to error is always in the
exaggeration of their authority rather than in its denial.

Secondly, I say, we have to show the individual character
and liberty of the separate leaves, clouds, or rocks. And
herein the great masters separate themselves finally from the
inferior ones; for if the men of inferior genius ever express law
at all, it is by the sacrifice of individuality. Thus, Salvator
Rosa has great perception of the sweep of foliage and rolling
of clouds, but never draws a single leaflet or mist wreath
accurately. Similarly, Gainsborough, in his landscape, has
great feeling for masses of form and harmony of colour;
but in the detail gives nothing but meaningless touches; not
even so much as the species of tree, much less the variety of/its
leafage, being ever discernible. Now, although both these ex.
pressions of government and individuality are essential to mas-
terly work, the individuality is the *more* essential, and the more

difficult of attainment ; and, therefore, that attainment sepa-
rates the great masters *finally* from the inferior ones. It is the
more essential, because, in these matters of beautiful arrange-
ment in visible things, the same rules hold that hold in moral
things. It is a lamentable and unnatural thing to see a num-
ber of men subject to no government, actuated by no ruling
principle, and associated by no common affection : but it would
be a more lamentable thing still, were it possible, to see a num-
ber of men so oppressed into assimilation as to have no more
any individual hope or character, no differences in aim, no dis-
similarities of passion, no irregularities of judgment ; a society
in which no man could help another, since none would be
feebler than himself ; no man admire another, since none would
be stronger than himself ; no man be grateful to another, since
by none he could be relieved ; no man reverence another, since
by none he could be instructed ; a society in which every soul
would be as the syllable of a stammerer instead of the word of
a speaker, in which every man would walk as in a frightful
dream, seeing spectres of himself, in everlasting multiplication,
gliding helplessly around him in a speechless darkness. There-
fore it is that perpetual difference, play, and change in groups
of form are more essential to them even than their being sub-
dued by some great gathering law : the law is needful to them
for their perfection and their power, but the difference is need-
ful to them for their *life.*

And here it may be noted in passing, that if you enjoy the
pursuit of analogies and types, and have any ingenuity of judg-
ment in discerning them, you may always accurately ascertain
what are the noble characters in a piece of painting, by merely
considering what are the noble characters of man in his associ-
ation with his fellows. What grace of manner and refinement
of habit are in society, grace of line and refinement of form are

in the association of visible objects. What advantage or harm
there may be in sharpness, ruggedness, or quaintness in the
dealings or conversations of men ; precisely that relative degree
of advantage or harm there is in them as elements of pictorial
composition. What power is in liberty or relaxation to
strengthen or relieve human souls ; that power, precisely in
the same relative degree, play and laxity of line have to
strengthen or refresh the expression of a picture. And what
goodness or greatness we can conceive to arise in companies of
men, from chastity of thought, regularity of life, simplicity of
custom, and balance of authority ; precisely that kind of good-
ness and greatness may be given to a picture by the purity of
its colour, the severity of its forms, and the symmetry of its
masses.

You need not be in the least afraid of pushing these analo-
gies too far. They cannot be pushed too far ; they are so pre-
cise and complete, that the farther you pursue them, the clearer,
the more certain, the more useful you will find them. They
will not fail you in one particular, or in any direction of enquiry
There is no moral vice, no moral virtue, which has not its *pre-
cise* prototype in the art of painting ; so that you may at your
will illustrate the moral habit by the art, or the art by the
moral habit. Affection and discord, fretfulness and quietness,
feebleness and firmness, luxury and purity, pride and modesty,
and all other such habits, and every conceivable modification
and mingling of them, may be illustrated, with mathematical
exactness, by conditions of line and colour ; and not merely
these definable vices and virtues, but also every conceivable
shade of human character and passion, from the righteous or
unrighteous majesty of the king, to the innocent or faultful sim-
plicity of the shepherd boy.

The pursuit of this subject belongs properly, however, to the

investigation of the higher branches of composition, matters which it would be quite useless to treat of in this book ; and I only allude to them here, in order that you may understand how the utmost noblenesses of art are concerned in this minute work, to which I have set you in your beginning of it. For it is only by the closest attention, and the most noble execution, that it is possible to express these varieties of individual character, on which all excellence of portraiture depends, whether of masses of mankind, or of groups of leaves.

Now you will be able to understand, among other matters, wherein consists the excellence, and wherein the shortcoming, of the tree-drawing of Harding. It is excellent in so far as it fondly observes, with more truth than any other work of the kind, the great laws of growth and action in trees : it fails— and observe, not in a minor, but in a principal point—because it cannot rightly render any one individual detail or incident of foliage. And in this it fails, not from mere carelessness or in-completion, but of necessity ; the true drawing of detail being for evermore *impossible* to a hand which has contracted a *habit* of execution. The noble draughtsman draws a leaf, and stops, and says calmly—That leaf is of such and such a character ; I will give him a friend who will entirely suit him : then he con-siders what his friend ought to be, and having determined, he draws his friend. This process may be as quick as lightning when the master is great—one of the sons of the giants ; or it may be slow and timid : but the process is always gone through ; no touch or form is ever added to another by a good painter without a mental determination and affirmation. But when the hand has got into a habit, leaf No. 1. necessitates leaf No. 2. ; you cannot stop, your hand is as a horse with the bit in its teeth ; or rather is, for the time, a machine, throwing out leaves to order and pattern, all alike. You must stop that hand of

yours, however painfully ; make it understand that it is not to
have its own way any more, that it shall never more slip from
one touch to another without orders ; otherwise it is not you
who are the master, but your fingers. You may therefore
study Harding's drawing, and take pleasure in it ;[1] and you
may properly admire the dexterity which applies the habit of
the hand so well, and produces results on the whole so satis-
factory : but you must never copy it, otherwise your progress
will be at once arrested. The utmost you can ever hope to do,
would be a sketch in Harding's manner, but of far inferior dex-
terity ; for he has given his life's toil to gain his dexterity, and
you, I suppose, have other things to work at besides drawing.
You would also incapacitate yourself from ever understanding
what truly great work was, or what Nature was ; but by the
earnest and complete study of facts, you will gradually come
to understand the one and love the other more and more,
whether you can draw well yourself or not.

I have yet to say a few words respecting the third law
above stated, that of mystery ; the law, namely, that nothing
is ever seen perfectly, but only by fragments, and under vari-
ous conditions of obscurity.[2] This last fact renders the visible
objects of Nature complete as a type of the human nature.
We have, observe, first, Subordination ; secondly, Individual-
ity ; lastly, and this not the least essential character, Incom-
prehensibility ; a perpetual lesson in every serrated point and
shining vein which escape or deceive our sight among the

[1] His lithographic sketches, those, for instance, in the Park and the
Forest, and his various lessons on foliage, possess greater merit than the
more ambitious engravings in his Principles and Practice of Art. There
are many useful remarks, however, dispersed through this latter work.

[2] On this law you will do well, if you can get access to it, to look at
the fourth chapter of the fourth volume of Modern Painters.

forest leaves, how little we may hope to discern clearly, or judge justly, the rents and veins of the human heart ; how much of all that is round us, in men's actions or spirits, which we at first think we understand, a closer and more loving watchfulness would show to be full of mystery, never to be either fathomed or withdrawn.

The expression of this final character in landscape has never been completely reached by any except Turner ; nor can you hope to reach it at all until you have given much time to the practice of art. Only try always when you are sketching any object with a view to completion in light and shade, to draw only those parts of it which you really see definitely ; *preparing* for the after development of the forms by chiaroscuro. It is this preparation by isolated touches for a future arrangement of superimposed light and shade which renders the etchings of

Fig. 26.

the Liber Studiorum so inestimable as examples and so peculiar. The character exists more or less in them exactly in proportion to the pains that Turner has taken. Thus the Æsacus and Hespérie was wrought out with the greatest possible care ; and the principal branch on the near tree is etched as in Fig. 26. The work looks at first like a scholar's instead of a

master's ; but when the light and shade are added, every touch

falls into its place, and a perfect expression of grace and complexity results. Nay even before the light and shade are added, you ought to be able to see that these irregular and broken lines, especially where the expression is given of the way the stem loses itself in the leaves, are more true than the monotonous though graceful leaf-drawing which, before Turner's time, had been employed, even by the best masters, in their distant masses. Fig. 27. is sufficiently characteristic of the

Fig. 27.

manner of the old woodcuts after Titian ; in which, you see, the leaves are too much of one shape, like bunches of fruit ; and the boughs too completely seen, besides being somewhat soft and leathery in aspect, owing to the want of angles in their outline. By great men like Titian, this somewhat conventional structure was only given in haste to distant masses ; and their exquisite delineation of the foreground, kept their conventionalism from degeneracy : but in the drawing of the Caracci and other derivative masters, the conventionalism prevails everywhere, and sinks gradually into scrawled work, like Fig. 28, about the worst which it is possible to get into the habit of using, though an ignorant person might perhaps suppose it more "free," and therefore better than Fig. 26. Note, also, that in noble outline drawing, it does not follow that a bough is wrongly drawn, because it looks contracted unnaturally somewhere, as in Fig. 26., just above the foliage. Very often the muscular action which is *to* be expressed by the line, runs into the *middle* of the branch, and the actual

outline of the branch at that place may be dimly seen, or not at all ; and it is then only by the future shade that its actual shape, or the cause of its disappearance, will be indicated.

One point more remains to be noted about trees, and I have done. In the minds of our ordinary water-colour artists, a distant tree seems only to be conceived as a flat green blot, grouping pleasantly with other masses, and giving cool colour to the landscape, but differing nowise, in *texture*, from the blots of other shapes, which these painters use to express

Fig. 28.

stones, or water, or figures. But as soon as you have drawn trees carefully a little while, you will be impressed, and impressed more strongly the better you draw them, with the idea of their *softness* of surface. A distant tree is not a flat and even piece of colour, but a more or less globular mass of a downy or bloomy texture, partly passing into a misty vagueness. I find, practically, this lovely softness of far-away trees the most difficult of all characters to reach, because it cannot be got by mere scratching or roughening the surface, but is always associated with such delicate expressions of form and growth as are only imitable by very careful drawing. The penknife passed lightly *over* this careful drawing, will do a good deal ; but you must accustom yourself, from the beginning, to aim much at

this softness in the lines of the drawing itself, by crossing them delicately, and more or less effacing and confusing the edges. You must invent, according to the character of tree, various modes of execution adapted to express its texture ; but always keep this character of softness in your mind, and in your scope of aim ; for in most landscapes it is the intention of nature that the tenderness and transparent infinitude of her foliage should be felt, even at the far distance, in the most distinct opposition to the solid masses and flat surfaces of rocks or buildings.

II. We were, in the second place, to consider a little the modes of representing water, of which important feature of landscape I have hardly said anything yet.

Water is expressed, in common drawings, by conventional lines, whose horizontality is supposed to convey the idea of its surface. In paintings, white dashes or bars of light are used for the same purpose.

But these and all other such expedients are vain and absurd. A piece of calm water always contains a picture in itself, an exquisite reflection of the objects above it. If you give the time necessary to draw these reflections, disturbing them here and there as you see the breeze or current disturb them, you will get the effect of the water ; but if you have not patience to draw the reflections, no expedient will give you a true effect. The picture in the pool needs nearly as much delicate drawing as the picture above the pool ; except only that if there be the least motion on the water, the horizontal lines of the images will be diffused and broken, while the vertical ones will remain decisive, and the oblique ones decisive in proportion to their steepness.

A few close studies will soon teach you this : the only thing

you need to be told is to watch carefully the lines of *disturbance* on the surface, as when a bird swims across it, or a fish rises, or the current plays round a stone, reed, or other obstacle. Take the greatest pains to get the *curves* of these lines true; the whole value of your careful drawing of the reflections may be lost by your admitting a single false curve of ripple from a wild duck's breast. And (as in other subjects) if you are dissatisfied with your result, always try for more unity and delicacy: if your reflections are only soft and gradated enough, they are nearly sure to give you a pleasant effect. When you are taking pains, work the softer reflections, where they are drawn out by motion in the water, with touches as nearly horizontal as may be; but when you are in a hurry, indicate the place and play of the images with vertical lines. The actual *construction* of a calm elongated reflection is with horizontal lines: but it is often impossible to draw the descending shades delicately enough with a horizontal touch; and it is best always when you are in a hurry, and sometimes when you are not, to use the vertical touch. When the ripples are large, the reflections become shaken, and must be drawn with bold undulatory descending lines.

I need not, I should think, tell you that it is of the greatest possible importance to draw the curves of the shore rightly. Their perspective is, if not more subtle, at least more stringent than that of any other lines in Nature. It will not be detected by the general observer, if you miss the curve of a branch, or the sweep of a cloud, or the perspective of a building;[1] but every intelligent spectator will feel the difference between a rightly drawn bend of shore or shingle, and a false one. *Absolutely*

[1] The student may hardly at first believe that the perspective of buildings is of little consequence: but he will find it so ultimately. See the remarks on this point in the Preface.

right, in difficult river perspectives seen from heights, I believe no one but Turner ever has been yet ; and observe, there is NO rule for them. To develope the curve mathematically would require a knowledge of the exact quantity of water in the river, the shape of its bed, and the hardness of the rock or shore ; and even with these data, the problem would be one which no mathematician could solve but approximatively. The instinct of the eye can do it ; nothing else.

If, after a little study from Nature, you get puzzled by the great differences between the aspect of the reflected image and that of the object casting it ; and if you wish to know the law of reflection, it is simply this : Suppose all the objects above the water *actually* reversed (not in appearance, but in fact) beneath the water, and precisely the same in form and in relative position, only all topsy-turvy. Then, whatever you can see, from the place in which you stand, of the solid objects so reversed under the water, you will see in the reflection, always in the true perspective of the solid objects so reversed.

If you cannot quite understand this in looking at water, take a mirror, lay it horizontally on the table, put some books and papers upon it, and draw them and their reflections ; moving them about, and watching how their reflections alter, and chiefly how their reflected colours and shades differ from their own colours and shades, by being brought into other oppositions. This difference in chiaroscuro is a more important character in water painting than mere difference in form.

When you are drawing shallow or muddy water, you will see shadows on the bottom, or on the surface, continually modifying the reflections ; and in a clear mountain stream, the most wonderful complications of effect resulting from the shadows and reflections of the stones in it, mingling with the aspect of the stones themselves seen through the water. Do not be

frightened at the complexity ; but, on the other hand, do not
hope to render it hastily. Look at it well, making out every
thing that you see, and distinguishing each component part of
the effect. There will be, first, the stones seen through the
water, distorted always by refraction, so that if the genera
structure of the stone shows straight parallel lines above the
water, you may be sure they will be bent where they enter it ;
then the reflection of the part of the stone above the water
crosses and interferes with the part that is seen through it, so
that you can hardly tell which is which ; and wherever the
reflection is darkest, you will see through the water best, and
vice versâ. Then the real shadow of the stone crosses both
these images, and where that shadow falls, it makes the water
more reflective, and where the sunshine falls, you will see more
of the surface of the water, and of any dust or motes that
may be floating on it : but whether you are to see, at the same
spot, most of the bottom of the water, or of the reflection of
the objects above, depends on the position of the eye. The
more you look down into the water, the better you see
objects through it ; the more you look along it, the eye
being low, the more you see the reflection of objects above it.
Hence the colour of a given space of surface in a stream will
entirely change while you stand still in the same spot, merely
as you stoop or raise your head ; and thus the colours with
which water is painted are an indication of the position of the
spectator, and connected inseparably with the perspective of
the shores. The most beautiful of all results that I know in
mountain streams is when the water is shallow, and the stones
at the bottom are rich reddish-orange and black, and the water
is seen at an angle which exactly divides the visible colours
between those of the stones and that of the sky, and the sky
is of clear, full blue. The resulting purple obtained by the

blending of the blue and the orange-red, broken by the play of innumerable gradations in the stones, is indescribably lovely.

All this seems complicated enough already ; but if there be a strong colour in the clear water itself, as of green or blue in the Swiss lakes, all these phenomena are doubly involved ; for the darker reflections now become of the colour of the water The reflection of a black gondola, for instance, at Venice, is never black, but pure dark green. And, farther, the colour of the water itself is of three kinds : one, seen on the surface, is a kind of milky bloom ; the next is seen where the waves let light through them, at their edges ; and the third, shown as a change of colour on the objects seen through the water. Thus, the same wave that makes a white object look of a clear blue, when seen through it, will take a red or violet-coloured bloom on its surface, and will be made pure emerald green by transmitted sunshine through its edges. With all this, however, you are not much concerned at present, but I tell it you partly as a preparation for what we have afterwards to say about colour, and partly that you may approach lakes and streams with reverence, and study them as carefully as other things, not hoping to express them by a few horizontal dashes of white, or a few tremulous blots.[1] Not but that much may be done by tremulous blots, when you know precisely what you

[1] It is a useful piece of study to dissolve some Prussian blue in water so as to make the liquid definitely blue : fill a large white basin with the solution, and put anything you like to float on it, or lie in it ; walnut shells, bits of wood, leaves of flowers, &c. Then study the effects of the reflections, and of the stems of the flowers or submerged portions of the floating objects, as they appear through the blue liquid ; noting especially how, as you lower your head and look along the surface, you see the reflections clearly ; and how, as you raise your head, you lose the reflections, and see the submerged stems clearly.

mean by them, as you will see by many of the Turner sketches, which are now framed at the National Gallery ; but you must have painted water many and many a day—yes, and all day long—before you can hope to do anything like those.

III. Lastly You may perhaps wonder why, before passing to the clouds, I say nothing special about *ground*.[1] But there is too much to be said about that to admit of my saying it here. You will find the principal laws of its structure examined at length in the fourth volume of Modern Painters ; and if you can get that volume, and copy carefully Plate 21., which I have etched after Turner with great pains, it will give you as much help as you need in the linear expression of ground-surface. Strive to get the retirement and succession of masses in irregular ground : much may be done in this way by careful watching of the perspective diminutions of its herbage, as well as by contour ; and much also by shadows. If you draw the shadows of leaves and tree trunks on any undulating ground with entire carefulness, you will be surprised to find how much they explain of the form and distance of the earth on which they fall.

Passing then to skies, note that there is this great peculiarity about sky subject, as distinguished from earth subject ;— that the clouds, not being much liable to man's interference, are always beautifully arranged. You cannot be sure of this in any other features of landscape. The rock on which the effect of a mountain scene especially depends is always precisely that which the roadmaker blasts or the landlord quarries ; and the spot of green which Nature left with a special purpose by her

[1] Respecting Architectural Drawing, see the notice of the works of Prout in the Appendix.

dark forest sides, and finished with her most delicate grasses, is always that which the farmer ploughs or builds upon. But the clouds, though we can hide them with smoke, and mix them with poison, cannot be quarried nor built over, and they are always therefore gloriously arranged; so gloriously, that unless you have notable powers of memory you need not hope to approach the effect of any sky that interests you. For both its grace and its glow depend upon the united influence of every cloud within its compass : they all move and burn together in a marvellous harmony ; not a cloud of them is out of its appointed place, or fails of its part in the choir : and if you are not able to recollect (which in the case of a complicated sky it is impossible you should) precisely the form and position of all the clouds at a given moment, you cannot draw the sky at all ; for the clouds will not fit if you draw one part of them three or four minutes before another. You must try therefore to help what memory you have, by sketching at the utmost possible speed the whole range of the clouds ; marking, by any shorthand or symbolic work you can hit upon, the peculiar character of each, as transparent, or fleecy, or linear, or undulatory ; giving afterwards such completion to the parts as your recollection will enable you to do. This, however, only when the sky is interesting from its general aspect ; at other times, do not try to draw all the sky, but a single cloud : sometimes a ound cumulus will stay five or six minutes quite steady enough to let you mark out his principal masses ; and one or two white or crimson lines which cross the sunrise will often stay without serious change for as long. And in order to be the readier in drawing them, practise occasionally drawing lumps of cotton, which will teach you better than any other stable thing the kind of softness there is in clouds. For you will find when you have made a few genuine studies of sky, and then look at any an·

cient or modern painting, that ordinary artists have always
fallen into one of two faults : either, in rounding the clouds,
they make them as solid and hard-edged as a heap of stones
tied up in a sack, or they represent them not as rounded at all,
but as vague wreaths of mist or flat lights in the sky ; and
think they have done enough in leaving a little white paper be-
tween dashes of blue, or in taking an irregular space out with
the sponge. Now clouds are not as solid as flour-sacks ; but,
on the other hand, they are neither spongy nor flat. They are
definite and very beautiful forms of sculptured mist ; sculptured
is a perfectly accurate word ; they are not more *drifted* into
form than they are *carved* into form, the warm air around them
cutting them into shape by absorbing the visible vapour beyond
certain limits ; hence their angular and fantastic outlines, as
different from a swollen, spherical, or globular formation, on the
one hand, as from that of flat films or shapeless mists on the
other. And the worst of all is, that while these forms are dif-
ficult enough to draw on any terms, especially considering that
they never stay quiet, they must be drawn also at greater dis-
advantage of light and shade than any others, the force of
light in clouds being wholly unattainable by art ; so that if we
put shade enough to express their form as positively as it is
expressed in reality, we must make them painfully too dark on
the dark sides. Nevertheless, they are so beautiful, if you in
the least succeed with them, that you will hardly, I think, lose
courage. Outline them often with the pen, as you can catch
them here and there ; one of the chief uses of doing this will
be, not so much the memorandum so obtained as the lesson you
will get respecting the softness of the cloud-outlines. You will
always find yourself at a loss to see where the outline really is;
and when drawn it will always look hard and false, and will
assuredly be either too round or too square, however often you

alter it, merely passing from the one fault to the other and
back again, the real cloud striking an inexpressible mean be-
tween roundness and squareness in all its coils or battlements.
I speak at present, of course, only of the cumulus cloud : the
lighter wreaths and flakes of the upper sky cannot be outlined;
—they can only be sketched, like locks of hair, by many lines
of the pen. Firmly developed bars of cloud on the horizon are
in general easy enough, and may be drawn with decision.
When you have thus accustomed yourself a little to the plac-
ing and action of clouds, try to work out their light and shade,
just as carefully as you do that of other things, looking *exclu-
sively* for examples of treatment to the vignettes in Rogers's
Italy and Poems, and to the Liber Studiorum, unless you have
access to some examples of Turner's own work. No other
artist ever yet drew the sky : even Titian's clouds, and Tinto-
ret's, are conventional. The clouds in the " Ben Arthur,"
" Source of Arveron," and " Calais Pier," are among the best of
Turner's storm studies ; and of the upper clouds, the vignettes
to Rogers's Poems furnish as many examples as you need.

And now, as our first lesson was taken from the sky, so, for
the present, let our last be. I do not advise you to be in any
haste to master the contents of my next letter. If you have
any real talent for drawing, you will take delight in the discov-
eries of natural loveliness, which the studies I have already
proposed will lead you into, among the fields and hills ; and be
assured that the more quietly and single-heartedly you take
each step in the art, the quicker, on the whole, will your pro-
gress be. I would rather, indeed, have discussed the subjects
of the following letter at greater length, and in a separate
work addressed to more advanced students ; but as there are
one or two things to be said on composition which may set the
young artist's mind somewhat more at rest, or furnish him with

defence from the urgency of ill-advisers, I will glance over the main heads of the matter here ; trusting that my doing so may not beguile you, my dear reader, from your serious work, or lead you to think me, in occupying part of this book with talk not altogether relevant to it, less entirely or

<div align="center">Faithfully yours,</div>

<div align="right">J. RUSKIN.</div>

LETTER III.

ON COLOUR AND COMPOSITION,

My dear Reader :—

If you have been obedient, and have hitherto done all
that I have told you, I trust it has not been without much
subdued remonstrance, and some serious vexation. For I should
be sorry if, when you were led by the course of your study to
observe closely such things as are beautiful in colour, you had
not longed to paint them, and felt considerable difficulty in
complying with your restriction to the use of black, or blue, or
grey. You *ought* to love colour, and to think nothing quite
beautiful or perfect without it ; and if you really do love it,
for its own sake, and are not merely desirous to colour because
you think painting a finer thing than drawing, there is some
chance you may colour well. Nevertheless, you need not hope
ever to produce anything more than pleasant helps to memory,
or useful and suggestive sketches in colour, unless you mean to
be wholly an artist. You may, in the time which other voca-
tions leave at your disposal, produce finished, beautiful, and
masterly drawings in light and shade. But to colour well,
requires your life. It cannot be done cheaper. The difficulty
of doing right is increased—not twofold nor threefold, but a
thousandfold, and more—by the addition of colour to your
work. For the chances are more than a thousand to one
against your being right both in form and colour with a given

touch : it is difficult enough to be right in form, if you attend
to that only ; but when you have to attend, at the same
moment, to a much more subtle thing than the form, the diffi-
culty is strangely increased—and multiplied almost to infinity
by this great fact, that, while form is absolute, so that you
can say at the moment you draw any line that it is eithe.
right or wrong, colour is wholly *relative*. Every hue through-
out your work is altered by every touch that you add in other
places ; so that what was warm a minute ago, becomes cold
when you have put a hotter colour in another place, and what
was in harmony when you left it, becomes discordant as you set
other colours beside it ; so that every touch must be laid, not
with a view to its effect at the time, but with a view to its
effect in futurity, the result upon it of all that is afterwards to
be done being previously considered. You may easily under-
stand that, this being so, nothing but the devotion of life, and
great genius besides, can make a colourist.

But though you cannot produce finished coloured drawings
of any value, you may give yourself much pleasure, and be of
great use to other people, by occasionally sketching with a
view to colour only ; and preserving distinct statements of cer-
tain colour facts—as that the harvest-moon at rising was of
such and such a red, and surrounded by clouds of such and
such a rosy grey; that the mountains at evening were in truth
so deep in purple ; and the waves by the boat's side were
indeed of that incredible green. This only, observe, if you
have an eye for colour ; but you may presume that you have
this, if you enjoy colour.

And, though of course you should always give as much form
to your subject as your attention to its colour will admit of,
remember that the whole value of what you are about depends,
in a coloured sketch, on the colour *merely*. If the colour is

wrong, everything is wrong : just as, if you are singing, and sing false notes, it does not matter how true the words are. If you sing at all, you must sing sweetly ; and if you colour at all, you must colour rightly. Give up *all* the form, rather than the slightest part of the colour : just as, if you felt yourself in danger of a false note, you would give up the word, and sing a meaningless sound, if you felt that so you could save the note. Never mind though your houses are all tumbling down—though your clouds are mere blots, and your trees mere knobs, and your sun and moon like crooked sixpences—so only that trees clouds, houses, and sun or moon, are of the right colours. Of course, the discipline you have gone through will enable you to hint something of form, even in the fastest sweep of the brush ; but do not let the thought of form hamper you in the least, when you begin to make coloured memoranda. If you want the form of the subject, draw it in black and white. If you want its colour, take its colour, and be sure you *have* it, and not a spurious, treacherous, half-measured piece of mutual con. cession, with the colours all wrong, and the forms still anything but right. It is best to get into the habit of considering the coloured work merely as supplementary to your other studies ; making your careful drawings of the subject first, and then a coloured memorandum separately, as shapeless as you like, but faithful in hue, and entirely minding its own business. This principle, however, bears chiefly on large and distant subjects ; in foregrounds and near studies, the colour cannot be had without a good deal of definition of form. For if you do not map the mosses on the stones accurately, you will not have the right quantity of colour in each bit of moss pattern, and then none of the colours will look right ; but it always simplifies the work much if you are clear as to your point of aim, and satis-fied, when necessary, to fail of all but that.

Now, of course, if I were to enter into detail respecting colouring, which is the beginning and end of a painter's craft, I should need to make this a work in three volumes instead of three letters, and to illustrate it in the costliest way. I only hope at present to set you pleasantly and profitably to work, leaving you, within the tethering of certain leading-strings, to gather what advantages you can from the works of art of which every year brings a greater number within your reach ;—and from the instruction which, every year, our rising artists will be more ready to give kindly, and better able to give wisely.

And, first, of materials. Use hard cake colours, not moist colours : grind a sufficient quantity of each on your palette every morning, keeping a separate plate, large and deep, for colours to be used in broad washes, and wash both plate and palette every evening, so as to be able always to get good and pure colour when you need it ; and force yourself into cleanly and orderly habits about your colours. The two best colourists of modern times, Turner and Rossetti,[1] afford us, I am sorry to say, no confirmation of this precept by their practice. Turner was, and Rossetti is, as slovenly in all their procedures as men can well be ; but the result of this was, with Turner, that the colours have altered in all his pictures, and in many of his drawings ; and the result of it with Rossetti is, that, though his colours are safe, he has sometimes to throw aside work that was half done, and begin over again. William

[1] I give Rossetti this preëminence, because, though the leading Pre-Raphaelites have all about equal power over colour in the abstract, Rossetti and Holman Hunt are distinguished above the rest for rendering colour under effects of light; and of these two, Rossetti composes with richer fancy, and with a deeper sense of beauty, Hunt's stern realism leading him continually into harshness. Rossetti's carelessness, to do him justice, is only in water-colour, never in oil.

Hunt, of the Old Water-colour, is very neat in his practice; so, I believe, is Mulready; so is John Lewis; and so are the leading Pre-Raphaelites, Rossetti only excepted. And there can be no doubt about the goodness of the advice, if it were only for this reason, that the more particular you are about your colours the more you will get into a deliberate and methodical habit in using them, and all true *speed* in colouring comes of this deliberation.

Use Chinese white, well ground, to mix with your colours in order to pale them, instead of a quantity of water. You will thus be able to shape your masses more quietly, and play the colours about with more ease; they will not damp your paper so much, and you will be able to go on continually, and lay forms of passing cloud and other fugitive or delicately shaped lights, otherwise unattainable except by time.

This mixing of white with the pigments, so as to render them opaque, constitutes *body*-colour drawing as opposed to *transparent*-colour drawing and you will, perhaps, have it often said to you that this body-colour is "illegitimate." It is just as legitimate as oil-painting, being, so far as handling is concerned, the same process, only without its uncleanliness, its unwholesomeness, or its inconvenience; for oil will not dry quickly, nor carry safely, nor give the same effects of atmosphere without tenfold labour. And if you hear it said that the body-colour looks chalky or opaque, and, as is very likely, think so yourself, be yet assured of this, that though certain effects of glow and transparencies of gloom are not to be reached without transparent colour, those glows and glooms are *not* the noblest aim of art. After many years' study of the various results of fresco and oil painting in Italy, and of body-colour and transparent colour in England, I am now entirely convinced that the greatest things that are to be done in art must be done in

dead colour. The habit of depending on varnish or on lucid tints for transparency, makes the painter comparatively lose sight of the nobler translucence which is obtained by breaking various colours amidst each other : and even when, as by Correggio, exquisite play of hue is joined with exquisite transparency, the delight in the depth almost always leads the painter into mean and false chiaroscuro ; it leads him to like dark backgrounds instead of luminous ones,[1] and to enjoy, in general, quality of colour more than grandeur of composition, and confined light rather than open sunshine : so that the really greatest thoughts of the greatest men have always, so far as I remember, been reached in dead colour, and the

[1] All the degradation of art which was brought about, after the rise of the Dutch school, by asphaltum, yellow varnish, and brown trees, would have been prevented, if only painters had been forced to work in dead colour. Any colour will do for some people, if it is browned and shining ; but fallacy in dead colour is detected on the instant. I even believe that whenever a painter begins to *wish* that he could touch any portion of his work with gum, he is going wrong.

It is necessary, however, in this matter, carefully to distinguish between translucency and lustre. Translucency, though, as I have said above, a dangerous temptation, is, in its place, beautiful ; but lustre, or *shininess*, is always, in painting, a defect. Nay, one of my best painter-friends (the " best " being understood to attach to both divisions of that awkward compound word), tried the other day to persuade me that lustre was an ignobleness in *anything ;* and it was only the fear of treason to ladies' eyes, and to mountain streams, and to morning dew, which kept me from yielding the point to him. One is apt always to generalise too quickly in such matters ; but there can be no question that lustre is destructive of loveliness in colour, as it is of intelligibility in form. Whatever may be the pride of a young beauty in the knowledge that her eyes shine (though perhaps even eyes are most beautiful in dimness), she would be sorry if her cheeks did; and which of us would wish to polish a rose ?

noblest oil pictures of Tintoret and Veronese are those which are likest frescos

Besides all this, the fact is, that though sometimes a little chalky and coarse-looking, body-colour is, in a sketch, infinitely liker nature than transparent colour : the bloom and mist of distance are accurately and instantly represented by the film of opaque blue (*quite* accurately, I think, by *nothing* else); and for ground, rocks, and buildings, the earthy and solid surface is, of course, always truer than the most finished and carefully wrought work in transparent tints can ever be.

Against one thing, however, I must steadily caution you. All kinds of colour are equally illegitimate, if you think they will allow you to alter at your pleasure, or blunder at your ease. There is *no* vehicle or method of colour which admits of alteration or repentance ; you must be right at once, or never; and you might as well hope to catch a rifle bullet in your hand, and put it straight, when it was going wrong, as to recover a tint once spoiled. The secret of all good colour in oil, water, or anything else, lies primarily in that sentence spoken to me by Mulready : " Know what you have to do." The process may be a long one, perhaps : you may have to ground with one colour ; to touch it with fragments of a second ; to crumble a third into the interstices ; a fourth into the interstices of the third ; to glaze the whole with a fifth ; and to reinforce in points with a sixth : but whether you have one, or ten, or twenty processes to go through, you must go *straight* through them, knowingly and foreseeingly all the way ; and if you get the thing once wrong, there is no hope for you but in washing or scraping boldly down to the white ground, and beginning again.

The drawing in body-colour will tend to teach you all this, more than any other method, and above all it will prevent you

from falling into the pestilent habit of sponging to get texture ; a trick which has nearly ruined our modern water colour school of art. There are sometimes places in which a skilful artist will roughen his paper a little to get certain conditions of dusty colour with more ease than he could other wise ; and sometimes a skilfully rased piece of paper will, in the midst of transparent tints, answer nearly the purpose of chalky body-colour in representing the surfaces of rocks or buildings. But artifices of this kind are always treacherous in a tyro's hands, tempting him to trust in them ; and you had better always work on white or grey paper as smooth as silk ; [1] and never disturb the surface of your colour or paper, except finally to scratch out the very highest lights. if you are using transparent colours.

I have said above that body-colour drawing will teach you the use of colour better than working with merely transparent tints ; but this is not because the process is an easier one, but because it is a more *complete* one, and also because it involves *some* working with transparent tints in the best way. You are not to think that because you use body-colour you may make any kind of mess that you like, and yet get out of it. But you are to avail yourself of the characters of your material, which enable you most nearly to imitate the pro cesses of Nature. Thus, suppose you have a red rocky cliff to sketch, with blue clouds floating over it. You paint your cliff first firmly, then take your blue, mixing it to such a tint

[1] But not shiny or greasy. Bristol board, or hot-pressed imperial, or grey paper that feels slightly adhesive to the hand, is best. Coarse, gritty, and sandy papers are fit only for blotters and blunderers ; no good draughtsman would lay a line on them. Turner worked much on a thin tough paper, dead in surface ; rolling up his sketches in tight bundles that would go deep into his pockets.

(and here is a great part of the skill needed), that when it is laid over the red, in the thickness required for the effect of the mist, the warm rock-colour showing through the blue cloud-colour, may bring it to exactly the hue you want ; (your upper tint, therefore, must be mixed colder than you want it ;) then you lay it on, varying it as you strike it, getting the forms of the mist at once, and, if it be rightly done, with exquisite quality of colour, from the warm tint's showing through and between the particles of the other. When it is dry, you may add a little colour to retouch the edges where they want shape, or heighten the lights where they want roundness, or put another tone over the whole ; but you can take none away. If you touch or disturb the surface, or by any untoward accident mix the under and upper colours together, all is lost irrecoverably. Begin your drawing from the ground again if you like, or throw it into the fire if you like. But do not waste time in trying to mend it.[1]

This discussion of the relative merits of transparent and opaque colour has, however, led us a little beyond the point where we should have begun ; we must go back to our palette, if you please. Get a cake of each of the hard colours named in the note below[2] and try experiments on their simple combinations, by mixing each colour with every other. If you like to do it in an orderly way, you may prepare a squared piece of pastebord, and put the pure colours in columns at the top

[1] I insist upon this unalterability of colour the more because I address you as a beginner, or an amateur; a great artist can sometimes get out of a difficulty with credit, or repent without confession. Yet even Titian's alterations usually show as stains on his work.

[2] It is, I think, a piece of affectation to try to work with few colours; it saves time to have enough tints prepared without mixing, and you may at once allow yourself these twenty-four. If you arrange them

7

and side ; the mixed tints being given at the intersections, thus (the letters standing for colours) :

	b	c	d	e	f	&c.
a	a b	a c	a d	a e	a f	
b	—	b c	b d	b e	b f	
c	—	—	c d	c e	c f	
d	—	—	—	d e	d f	
e	—	—	—	—	c f	
&c.						

This will give you some general notion of the characters of mixed tints of two colours only, and it is better in practice

in your colour-box in the order I have set them down, you will alway: easily put your finger on the one you want.

Cobalt.	Smalt.	Antwerp blue.	Prussian blue.
Black.	Gamboge.	Emerald green.	Hooker's green.
Lemon yellow	Cadmium yellow.	Yellow ochre.	Roman ochre.
Raw sienna.	Burnt sienna.	Light red.	Indian red.
Mars orange.	Extract of vermil- lion	Carmine.	
			Violet carmine.
Brown madder.	Burnt umber.	Vandyke brown.	Sepia.

Antwerp blue and Prussian blue are not very permanent colours, but you need not care much about permanence in your own work as yet and they are both beautiful; while Indigo is marked by Field as more fugitive still, and is very ugly. Hooker's green is a mixed colour, put in the box merely to save you loss of time in mixing gamboge and Prussian blue. No. 1. is the best tint of it. Violet carmine is a noble colour for laying broken shadows with, to be worked into afterwards with other colours.

If you wish to take up colouring seriously, you had better get Field's "Chromatography" at once; only do not attend to anything it says about principles or harmonies of colour; but only to its statements of practical serviceableness in pigments, and of their operations on each other when mixed, &c.

to confine yourself as much as possible to these, and to get more complicated colours, either by putting a third *over* the first blended tint, or by putting the third into its interstices. Nothing but watchful practice will teach you the effects that colors have on each other when thus put over, or beside, each other.

When you have got a little used to the principal combinations, place yourself at a window which the sun does not shine in at, commanding some simple piece of landscape ; outline this landscape roughly ; then take a piece of white cardboard, cut out a hole in it about the size of a large pea ; and supposing R is the room, $a\,d$ the window, and you are

sitting at a, Fig. 29., hold this cardboard a little outside of the window, upright, and in the direction $b\,d$, parallel a little turned to the side of the window, or so as to catch more light, as at $a\,d$, never turned as at $c\,d$, or the paper will be dark. Then you will see the landscape, bit by bit, through the circular hole. Match the colours of each im-

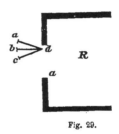

Fig. 29.

portant bit as nearly as you can, mixing your tints with white, beside the aperture. When matched, put a touch of the same tint at the top of your paper, writing under it : "dark tree colour," "hill colour," "field colour," as the case may be. Then wash the tint away from beside the opening, and the cardboard will be ready to match another piece of the landscape.[1] When you have got the colours of the principal

[1] A more methodical, though, under general circumstances, uselessly prolix way, is to cut a square hole, some half an inch wide, in the sheet of cardboard, and a series of small circular holes in a slip of cardboard

masses thus indicated, lay on a piece of each in your sketch in its right place, and then proceed to complete the sketch in harmony with them, by your eye.

In the course of your early experiments, you will be much struck by two things : the first, the inimitable brilliancy of light in sky and in sun-lighted things ; and the second, that among the tints which you can imitate, those which you thought the darkest will continually turn out to be in reality the lightest. Darkness of objects is estimated by us, under ordinary circumstances, much more by *knowledge* than by sight ; thus, a cedar or Scotch fir, at 200 yards off, will be thought of darker green than an elm or oak near us ; because we know by experience that the peculiar colour they exhibit, at that distance, is the *sign* of darkness of foliage. But when we try them through the cardboard, the near oak will be found, indeed, rather dark green, and the distant cedar, perhaps, pale grey-purple. The quantity of purple and grey in Nature is, by the way, another somewhat surprising subject of discovery.

Well, having ascertained thus your principal tints, you may proceed to fill up your sketch ; in doing which observe these following particulars :

1. Many portions of your subject appeared through the aperture in the paper brighter than the paper, as sky, sun-lighted grass, &c. Leave these portions, for the present, . white ; and proceed with the parts of which you can match the tints.

· an inch wide. Pass the slip over the square opening, and match each colour beside one of the circular openings. You will thus have no occasion to wash any of the colours away. But the first rough method is generally all you want, as after a little practice, you only need to *look* at the hue through the opening in order to be able to transfer it to your drawing at once.

2. As you tried your subject with the cardboard, you must have observed how many changes of hue took place over small spaces. In filling up your work, try to educate your eye to perceive these differences of hue without the help of the cardboard, and lay them deliberately, like a mosaic-worker, as separate colours, preparing each carefully on your palette, and laying it as if it were a patch of coloured cloth, cut out, to be fitted neatly by its edge to the next patch ; so that the *fault* of your work may be, not a slurred or misty look, but a patched bed-cover look, as if it had all been cut out with scissors. For instance, in drawing the trunk of a birch tree, there will be probably white high lights, then a pale rosy grey round them on the light side, then a (probably greenish) deeper grey on the dark side, varied by reflected colours, and over all, rich black strips of bark and brown spots of moss. Lay first the rosy grey, leaving white for the high lights *and for the spots of moss*, and not touching the dark side. Then lay the grey for the dark side, fitting it well up to the rosy grey of the light, leaving also in this darker grey the white paper in the places for the black and brown moss ; then prepare the moss colours separately for each spot, and lay each in the white place left for it.. Not one grain of white, except that purposely left for the high lights, must be visible when the work is done, even through a magnifying-glass, so cunningly must you fit the edges to each other. Finally, take your background colours, and put them on each side of the tree-trunk, fitting them carefully to its edge.

Fine work you would make of this, wouldn't you, if you had not learned to draw first, and could not now draw a good outline for the stem, much less terminate a colour mass in the outline you wanted ? ·

Your work will look very odd for some time, when you first

begin to paint in this way, and before you can modify it, as I shall tell you presently how ; but never mind ; it is of the greatest possible importance that you should practise this sepa rate laying on of the hues, for all good colouring finally depends on it It is, indeed, often necessary, and sometimes desirable, to lay one colour and form boldly over another : thus, in laying leaves on blue sky, it is impossible always in large pic tures, or when pressed for time, to fill in the blue through the interstices of the leaves; and the great Venetians constantly lay their blue ground first, and then, having let it dry, strike the golden brown over it in the form of the leaf, leaving the under blue to shine through the gold, and subdue it to the olive green they want. . But in the most precious and perfect work each leaf is inlaid, and the blue worked round it; and, whether you use one or other mode of getting your result, it is equally. necessary to be absolute and decisive in your laying the colour. Either your ground must be laid firmly first, and then your upper colour struck upon it in perfect form, for ever, thencefor ward, unalterable; or else the two colours must be individually put in their places, and led up to each other till they meet at their appointed border, equally, thenceforward, unchangeable. Either process, you see, involves *absolute* decision. If you once begin to slur, or change, or sketch, or try this way and that with your colour, it is all over with it and with you. You will ccntinually see bad copyists trying to imitate the Venetians, by daubing their colours about, and retouching, and finishing, and softening : when every touch and every added hue only lead them farther into chaos. There is a dog between two children in a Veronese in the Louvre, which g'ves the copyist much employment. He has a dark ground behind him, which Vero nese has painted first, and then when it was dry, or nearly so, struck the locks of the dog's white hair over it with some half

dozen curling sweeps of his brush, right at once, and forever. Had·one line or hair of them gone wrong, it would have been wrong forever ; no retouching could have mended it. The poor copyists daub in first some background, and then some dog's hair ; then retouch the background, then the hair work for hours at it, expecting it always to come right to-morow—" when it is finished." They *may* work for cen. turies at it, and they will never do it. If they can do it with Veronese's allowance of work, half a dozen sweeps of the hand over the dark background, well ; if not, they may ask the dog himself whether it will ever come right, and get true answer from him—on Launce's conditions : " If he say ' ay,' it will ; if he say ' no,' it will ; if he shake his tail and say nothing, it will."

3. Whenever you lay on a mass of colour, be sure that however large it may be, or however small, it shall be gradated. No colour exists in Nature under ordinary circumstances without gradation. If you do not see this, it is the fault of your inexperience : you *will* see it in due time, if you practise enough. But in general you may see it at once. In the birch trunk, for instance, the rosy grey *must* be gradated by the roundness of the stem till it meets the shaded side ; similarly the shaded side is gradated by reflected light. Accordingly, whether by adding water, or white paint, or by unequal force of touch (this you will do at pleasure, according to the texture you wish to produce), you must, in every tint you lay on, make it a little paler at one part than another, and get an even gra dation between the two depths. This is very like laying down a formal law or recipe for you ; but you will find it is merely the assertion of a natural fact. It is not indeed physically impossible to meet with an ungradated piece of colour, but it is so supremely improbable, that you had better get into the

habit of asking yourself invariably, when you are going to copy a tint,—not " *Is* that gradated ?" but "*Which way* is it gradated ?" and at least in ninety-nine out of a hundred instances, you will be able to answer decisively after a careful glance, though the gradation may have been so subtle that you did not see it at first. And it does not matter how small the touch of colour may be, though not larger than the smallest pin's head, if one part of it is not darker than the rest, it is a bad touch ; for it is not merely because the natural fact is so, that your colour should be gradated ; the preciousness and pleasantness of the colour itself depends more on this than on any other of its qualities, for gradation is to colours just what curvature is to lines, both being felt to be beautiful by the pure instinct of every human mind, and both, considered as types, expressing the law of gradual change and progress in the human soul itself. What the difference is in mere beauty between a gradated and ungradated colour, may be seen easily by laying an even tint of rose-colour on paper, and putting a rose leaf beside it. The victorious beauty of the rose as compared with other flowers, depends wholly on the delicacy and quantity of its colour gradations, all other flowers being either less rich in gradation, not having so many folds of leaf ; or less tender, being patched and veined instead of flushed.

4. But observe, it is not enough in general that colour should be gradated by being made merely paler or darker at one place than another. Generally colour *changes* as it *diminishes*, and is not merely *darker* at one spot, but also *purer* at one spot than anywhere else. It does not in the least follow that the darkest spot should be the purest ; still less so that the lightest should be the purest. Very often the two gradations more or less cross each other, one passing in one direction from paleness to darkness, another in another direction from purity to dull-

ness, but there will almost always be both of them, however reconciled ; and you must never be satisfied with a piece of colour until you have got both : that is to say, every piece of blue that you lay on must be *quite* blue only at some given spot, nor that a large spot ; and must be gradated from that into less pure blue—greyish blue, or greenish blue, or purplish blue, over all the rest of the space it occupies. And this you must do in one of three ways : either, while the colour is wet, mix with it the colour which is to subdue it, adding gradually a little more and a little more ; or else, when the colour is quite dry, strike a gradated touch of another colour over it, leaving only a point of the first tint visible ; or else, lay the subduing tints on in small touches, as in the exercise of tinting the chess-board. Of each of these methods I have something to tell you separately : but that is distinct from the subject of gradation, which I must not quit without once more pressing upon you the preëminent necessity of introducing it everywhere. I have profound dislike of anything like *habit* of hand, and yet, in this one instance, I feel almost tempted to encourage you to get into a habit of never touching paper with colour, without securing a gradation. You will not, in Turner's largest oil pictures, perhaps six or seven feet long by four or five high, find one spot of colour as large as a grain of wheat ungradated: and you will find in practice, that brilliancy of hue, and vigour of light, and even the aspect of transparency in shade, are essentially dependent on this character alone ; hardness, coldness, and opacity resulting far more from *equality* of colour than from nature of colour. Give me some mud off a city crossing, some ochre out of a gravel pit, a little whitening, and some coal-dust, and I will paint you a luminous picture, if you give me time to gradate my mud, and subdue my dust : but though you had the red of the ruby, the blue of the gentian, snow for

the light, and amber for the gold, you cannot paint a luminous picture, if you keep the masses of those colours unbroken in purity, and unvarying in depth.

5. Next note the three processes by which gradation and other characters are to be obtained :

A. Mixing while the colour is wet.

You may be confused by my first telling you to lay on the hues in separate patches, and then telling you to mix hues together as you lay them on : but the separate masses are to be laid, when colours distinctly oppose each other at a given limit; the hues to be mixed, when they palpitate one through the other, or fade one into the other. It is better to err a little on the distinct side. Thus I told you to paint the dark and light sides of the birch trunk separately, though, in reality, the two tints change, as the trunk turns away from the light, gradually one into the other ; and, after being laid separately on, will need some farther touching to harmonize them : but they do so in a very narrow space, marked distinctly all the way up the trunk ; and it is easier and safer, therefore, to keep them separate at first. Whereas it often happens that the whole beauty of two colours will depend on the one being continued well through the other, and playing in the midst of it : blue and green often do so in water : blue and grey, or purple and scarlet, in sky ; in hundreds of such instances the most beautiful and truthful results may be obtained by laying one colour into the other while wet ; judging wisely how far it will spread, or blending it with the brush in somewhat thicker consistence of wet body-colour ; only observe, never mix in this way two *mixtures ;* let the colour you lay into the other be always a simple, not a compound tint.

B. Laying one colour over another.

If you lay on a solid touch of vermilion, and, after it is quite

dry, strike a little very wet carmine quickly over it, you will obtain a much more brilliant red than by mixing the carmine and vermilion. Similarly, if you lay a dark colour first, and strike a little blue or white body-colour lightly over it, you will get a more beautiful grey than by mixing the colour and the blue or white. In very perfect painting, artifices of this kind are continually used ; but I would not have you trust much to them : they are apt to make you think too much of quality of colour. I should like you to depend on little more than the dead colours, simply laid on, only observe always this, that the *less* colour you do the work with, the better it will always be :[1] so that if you have laid a red colour, and you want a purple one above, do not mix the purple on your palette and lay it on so thick as to overpower the red, but take a little thin blue from your palette, and lay it lightly over the red, so as to let the red be seen through, and thus produce the required purple ; and if you want a green hue over a blue one, do not lay a quantity of green on the blue, but a *little* yellow, and so on, always bringing the under colour into service as far as you possibly can. If, however, the colour beneath is wholly opposed to the one you have to lay on, as, suppose, if green is to be laid over scarlet, you must either remove the required parts of the under colour daintily first with your knife, or with water ; or else, lay solid white over it massively, and leave that to dry, and then glaze the white with the upper colour. This is better, in general, than laying the upper colour itself so thick as to conquer

[1] If colours were twenty times as costly as they are, we should have many more good painters. If I were Chancellor of the Exchequer I would lay a tax of twenty shillings a cake on all colours except black, Prussian blue, Vandyke brown, and Chinese white, which I would leave for students. I don't say this jestingly ; I believe such a tax would do more to advance real art than a great many schools of design.

the ground, which, in fact, if it be a transparent colour, you cannot do. Thus, if you have to strike warm boughs and leaves of trees over blue sky, and they are too intricate to have their places left for them in laying the blue, it is etter to lay them first in solid white, and then glaze with ienna and ochre, than to mix the sienna and white ; though, of course, the process is longer and more troublesome. Never· theless, if the forms of touches required are very delicate, the after glazing is impossible. You must then mix the warm colour thick at once, and so use it : and this is often necessary for delicate grasses, and such other fine threads of light in fore ground work.

C Breaking one colour in small points through or over another.

This is the most important of all processes in good modern[1] oil and water-colour painting, but you need not hope to attain very great skill in it. To do it well is very laborious, and requires such skill and delicacy of hand as can only be acquired by unceasing practice. But you will find advantage in noting the following points :

(*a*.) In distant effects of rich subject, wood, or rippled water, or broken clouds, much may be done by touches or crumbling dashes of rather dry colour, with other colours afterwards put cunningly into the interstices. The more you practise this, when the subject evidently calls for it, the more your eye will enjoy the. higher qualities of colour. The process is, in fact, the carrying out of the principle of separate colours to the utmost possible refinement ; using atoms of colour in juxtaposition, instead of large spaces. And note, in filling up minute interstices of this

[1] I say *modern*, because Titian's quiet way of blending colours, which is the perfectly right one, is not understood now by any artist. The best colour we reach is got l v stippling ; but this is not quite right.

kind, that if you want the colour you fill them with to show brightly, it is better to put a rather positive point of it, with a little white left beside or round it in the interstice, than to put a pale tint of the colour over the whole interstice. Yellow or orange will hardly show, if pale, in small spaces; but they show brightly in firm touches, however small, with white beside them.

(*b.*) If a colour is to be darkened by superimposed portions of another, it is, in many cases, better to lay the uppermost colour in rather vigorous small touches, like finely chopped straw, over the under one, than to lay it on as a tint, for two reasons: the first, that the play of the two colours together is pleasant to the eye; the second, that much expression of form may be got by wise administration of the upper dark touches. In distant mountains they may be made pines of, or broken crags, or villages, or stones, or whatever you choose; in clouds they may indicate the direction of the rain, the roll and outline of the cloud masses; and in water, the minor waves. All noble effects of dark atmosphere are got in good water-colour drawing by these two expedients, interlacing the colours, or retouching the lower one with fine darker drawing in an upper. Sponging and washing for dark atmospheric effect is barbarous, and mere tyro's work, though it is often useful for passages of delicate atmospheric light.

(*c.*) When you have time, practise the production of mixed tints by interlaced touches of the pure colours out of which they are formed, and use the process at the parts of your sketches where you wish to get rich and luscious effects. Study the works of William Hunt, of the Old Water-colour Society, in this respect, continually, and make frequent memoranda of the variegations in flowers; not painting the flower completely, but laying the ground colour of one petal, and

painting the spots on it with studious precision : a series of single petals of lilies, geraniums, tulips, &c., numbered with proper reference to their position in the flower, will be interesting to you on many grounds besides those of art. Be careful to get the *gradated* distribution of the spots well followed in the calceolarias, foxgloves, and the like ; and work out the odd, indefinite hues of the spots themselves with minute grains of pure interlaced colour, otherwise you will never get their richness or bloom. You will be surprised to find, as you do this, first, the universality of the law of gradation we have so much insisted upon ; secondly, that Nature is just as economical of *her* fine colours as I have told you to be of yours. You would think, by the way she paints, that her colours cost her something enormous : she will only give you a single pure touch, just where the petal turns into light ; but down in the bell all is subdued, and under the petal all is subdued, even in the showiest flower. What you thought was bright blue is, when you look close, only dusty grey, or green, or purple, or every colour in the world at once, only a single gleam or streak of pure blue in the centre of it. And so with all her colours. Sometimes I have really thought her miserliness intolerable : in a gentian, for instance, the way she economises her ultramarine down in the bell is a little too bad.

Next, respecting general tone. I said, just now, that, for the sake of students, my tax should not be laid on black or on white pigments ; but if you mean to be a colourist, you must lay a tax on them yourself when you begin to use true colour ; that is to say, you must use them little, and make of them much. There is no better test of your colour tones being good, than your having made the white in your picture precious, and the black conspicuous.

I say, first, the white precious. I do not mean merely glit

tering or brilliant ; it is easy to scratch white sea-gulls out of black clouds, and dot clumsy foliage with chalky dew ; but, when white is well managed, it ought to be strangely delicious —tender as well as bright—like inlaid mother of pearl, or white roses washed in milk. The eye ought to seek it for rest, brilliant though it may be ; and to feel it as a space of strange, heavenly paleness in the midst of the flushing of the colours This effect you can only reach by general depth of middle tint, by absolutely refusing to allow any white to exist except where you need it, and by keeping the white itself subdued by grey, except at a few points of chief lustre.

Secondly, you must make the black conspicuous. However small a point of black may be, it ought to catch the eye, otherwise your work is too heavy in the shadow. All the ordinary shadows should be of some *colour*—never black, nor approaching black, they should be evidently and always of a luminous nature, and the black should look strange among them ; never occurring except in a black object, or in small points indicative of intense shade in the very centre of masses of shadow. Shadows of absolutely negative grey, however, may be beautifully used with white, or with gold ; but still though the black thus, in subdued strength, becomes *spacious*, it should always be *conspicuous* ; the spectator should notice this grey neutrality with some wonder, and enjoy, all the more intensely on account of it, the gold colour and the white which it relieves Of all the great colourists Velasquez is the greatest master of the black chords. His black is more precious than most other people's crimson.

It is not, however, only white and black which you must make valuable ; you must give rare worth to every colour you use ; but the white and black ought to separate themselves quaintly from the rest, while the other colours should be con

tinually passing one into the other, being all evidently compa-
nions in the same gay world ; while the white, black, and
neutral grey should stand monkishly aloof in the midst of them
You may melt your crimson into purple, your purple into blue,
and your blue into green, but you must not melt any of them
into black. You should, however, try, as I said, to give *pre-
ciousness* to all your colours ; and this especially by never using
a grain more than will just do the work, and giving each hue the
highest value by opposition. All fine colouring, like fine draw
ing, is *delicate* ; and so delicate that if, at last, you *see* the colour
you are putting on, you are putting on too much. You ought
to feel a change wrought in the general tone, by touches of
colour which individually are too pale to be seen ; and if there is
one atom of any colour in the whole picture which is unneces-
sary to it, that atom hurts it.

Notice also, that nearly all good compound colours are *odd*
colours. You shall look at a hue in a good painter's work ten
minutes before you know what to call it. You thought it was
brown, presently you feel that it is red ; next that there is,
somehow, yellow in it ; presently afterwards that there is blue
in it. If you try to copy it you will always find your colour
too warm or too cold—no colour in the box will seem to have
any affinity with it ; and yet it will be as pure as if it were laid
at a single touch with a single colour.

As to the choice and harmony of colours in general, if you
cannot choose and harmonize them by instinct, you will never
do it at all. If you need examples of utterly harsh and horri-
ble colour, you may find plenty given in treatises upon colour-
ing, to illustrate the laws of harmony ; and if you want to
colour beautifully, colour as best pleases yourself at *quiet times*,
not so as to catch the eye, nor to look as if it were clever or
difficult to colour in that way, but so that the colour may be

pleasant to you when you are happy, or thoughtful Look much at the morning and evening sky, and much at simple flowers—dog-roses, wood hyacinths, violets, poppies, thistles, heather, and such like—as Nature arranges them in the woods and fields. If ever any scientific person tells you that two colours are " discordant," make a note of the two colours, and put them together whenever you can. I have actually heard people say that blue and green were discordant ; the two colours which Nature seems to intend never to be separated, and never to be felt, either of them, in its full beauty without the other !—a peacock's neck, or a blue sky through green leaves, or a blue wave with green lights though it, being precisely the loveliest things, next to clouds at sunrise, in this coloured world of ours. If you have a good eye for colours, you will soon find out how constantly Nature puts purple and green together, purple and scarlet, green and blue, yellow and neutral grey, and the like ; and how she strikes these colour concords for general tones, and then works into them with innumerable subordinate ones ; and you will gradually come to like what she does, and find out new and beautiful chords of colour in her work every day. If you *enjoy* them, depend upon it you will paint them to a certain point right : or, at least, if you do not enjoy them, you are certain to paint them wrong. If colour does not give you *intense* pleasure, let it alone ; depend upon it, you are only tormenting the eyes and senses of people who feel colour, whenever you touch it ; and that is unkind and improper. You will find, also, your power of colouring depend much on your state of health and right balance of mind ; when you are fatigued or ill you will not see colours well, and when you are ill-tempered you will not choose them well : thus, though not infallibly a test of character in individuals, colour power is a great sign of mental health in

nations; when they are in a state of intellectual decline, their colouring always gets dull.[1] You must also take great care not to be misled by affected talk about colour from people who have not the gift of it : numbers are eager and voluble about it who probably never in all their lives received one genuine colour sensation. The modern religionists of the school of Overbeck are just like people who eat slate-pencil and chalk, and assure everybody that they are nicer and purer than strawberries and plums.

Take care also never to be misled into any idea that colour can help or display *form;* colour[2] always disguises form, and is meant to do so.

It is a favourite dogma among modern writers on colour that " warm colours " (reds and yellows) " approach " or express nearness, and " cold colours " (blue and grey) " retire " or ex-

[1] The worst general character that colour can possibly have is a prevalent tendency to a dirty yellowish green, like that of a decaying heap of vegetables ; this colour is *accurately* indicative of decline or paralysis in missal-painting.

[2] That is to say, local colour inherent in the object. The gradations of colour in the various shadows belonging to various lights exhibit form, and therefore no one but a colourist can ever draw *forms* perfectly (see Modern Painters, vol. iv. chap. iii. at the end); but all notions of explaining form by superimposed colour, as in architectural mouldings, are absurd. Colour adorns form, but does not interpret it. An apple is prettier, because it is striped, but it does not look a bit rounder; and a cheek is prettier because it is flushed, but you would see the form of the cheek bone better if it were not. Colour may, indeed, detach one shape from another, as in grounding a bas-relief, but it always diminishes the appearance of projection, and whether you put blue, purple, red, yellow, or green, for your ground, the bas-relief will be just as clearly or just as imperfectly relieved, as long as the colours are of equal depth. The blue ground will not retire the hundredth part of an inch more than the red one.

press distance. So far is this from being the case, that no expression of distance in the world is so great as that of the gold and orange in twilight sky. Colours, as such, are ABSO LUTELY inexpressive respecting distance. It is their *quality* (as depth, delicacy, &c.) which expresses distance, not thei. tint. A blue bandbox set on the same shelf with a yellow one will not look an inch farther off, but a red or orange cloud, in the upper sky, will always appear to be beyond a blue cloud close to us, as it is in reality. It is quite true that in certain objects, blue is a *sign* of distance ; but that is not because blue is a retiring colour, but because the mist in the air is blue, and therefore any warm colour which has not strength of light enough to pierce the mist is lost or subdued in its blue : but blue is no more, on this account, a " retiring colour," than brown is a retiring colour, because, when stones are seen through brown water, the deeper they lie the browner they look; or than yellow is a retiring colour, because, when objects are seen through a London fog, the farther off they are the yellower they look. Neither blue, nor yellow, nor red, can have, as such, the *smallest* power of expressing either nearness or distance : they express them only under the peculiar circumstances which render them at the moment, or in that place, *signs* of nearness or distance. Thus, vivid orange in an orange is a sign of nearness, for if you put the orange a great way off, its colour will not look so bright ; but vivid orange in sky is a sign of distance, because you cannot get the colour of orange in a cloud near you. So purple in a violet or a hyacinth is a sign of nearness, because the closer you look at them the more purple you see. But purple in a mountain is a sign of distance, because a mountain close to you is not purple, but green or grey. It may, indeed, be generally assumed that a tender or pale colour will more or less express distance, and a powerful

or dark colour nearness ; but even this is not always so.
Heathery hills will usually give a pale and tender purple near
and an intense and dark purple far away ; the rose colour of
sunset on snow is pale on the snow rt your feet, deep and full
on the snow in the distance ; and the green of a Swiss lake is
pale in the clear waves on the beach, but intense as an emeralc
in the sunstreak, six miles from shore. And in any case, when
the foreground is in strong light, with much water about it, or
white surface, casting intense reflections, all its colours may be
perfectly delicate, pale, and faint ; while the distance, when it
is in shadow, may relieve the whole foreground with intense
darks of purple, blue green, or ultramarine blue. So that, on
the whole, it is quite hopeless and absurd to expect any help
from laws of " aërial perspective." Look for the natural effects,
and set them down as fully as you can, and as faithfully, and
never alter a colour because it wo'n't look in its right place.
Put the colour strong, if it be strong, though far off ; faint, if
it be faint, though close to you. Why should you suppose that
Nature always means you to know exactly how far one thing is
from another ? She certainly intends you always to e¬joy her
colouring, but she does not wish you always to measure her
space. You would be hard put to it, every time you painted
the sun setting, if you had to express his 95,000,000 miles of
distance in " aërial perspective."

There is, however, I think, one law about distance, which
has some claims to be considered a constant one : namely, that
dullness and heaviness of colour are more or less indicative of
nearness. All distant colour is *pure* colour : it may not be
bright, but it is clear and lovely, not opaque nor soiled, for the
air and light coming between us and any earthy or imperfect
colour, purify or harmonise it; hence a bad colourist is peculiarly
incapable of expressi ng distance. I do not of course mean

that you are to use bad colours in your foreground by way of making it come forward ; but only that a failure in colour, there, will not put it out of its place ; while a failure in colour in the distance will at once do away with its remoteness : your dull-coloured foreground will still be a foreground, though ill-painted ; but your ill-painted distance will not be merely a dull distance,—it will be no distance at all.

I have only one thing more to advise you, namely, never to colour petulantly or hurriedly. You will not, indeed, be able, if you attend properly to your colouring, to get anything like the quantity of form you could in a chiaroscuro sketch ; nevertheless. if you do not dash or rush at your work, nor do it lazily, you may always get enough form to be satisfactory. An extra quarter of an hour, distributed in quietness over the course of the whole study, may just make the difference between a quite intelligible drawing, and a slovenly and obscure one. If you determine well beforehand what outline each piece of colour is to have ; and, when it is on the paper, guide it without nervousness, as far as you can, into the form required ; and then, after it is dry, consider thoroughly what touches are needed to complete it, before laying one of them on ; you will be surprised to find how masterly the work will soon look, as compared with a hurried or ill-considered sketch. In no process that I know of—least of all in sketching—can time be really gained by precipitation. It is gained only by caution; and gained in all sorts of ways : for not only truth of form, but force of light, is always added by an intelligent and shapely laying of the shadow colours. You may often make a simple flat tint, rightly gradated and edged, express a complicated piece of subject without a single retouch. The two Swiss cottages, for instance, with their balconies, and glittering windows, and general character of shingly eaves, are expressed in Fig 30

with one tint of grey, and a few dispersed spots and lines of it; all of which you ought to be able to lay on without more than thrice dipping your brush, and without a single touch after the tint is dry.

Here, then, for I cannot without coloured illustrations tell you more, I must leave you to follow out the subject for yourself, with such help as you may receive from the

Fig. 80.

water-colour drawings accessible to you ; or from any of the little treatises on their art which have been published lately by our water-colour painters.[1] But do not trust much to works of this kind. You may get valuable hints from them as to mixture of colours ; and here and there you will find a useful artifice or process explained; but nearly all such books are written only to help idle amateurs to a meretricious skill, and they are full of precepts and principles which may, for the most part, be interpreted by their *precise* negatives, and then acted upon with advantage. Most of them praise boldness, when the only safe attendant spirit of a beginner is caution ;—advise velocity, when the first condition of success is deliberation ;—and plead for generalisation, when all the foundations of power must be laid in knowledge of speciality.

[1] See, however, at the close of this letter, the notice of one more point connected with the management of colour, under the head " Law of Harmony."

And now, in the last place, I have a few things to tell you respecting that dangerous nobleness of consummate art,—COMPOSITION. For though it is quite unnecessary for you yet awhile to attempt it, and it *may* be inexpedient for you to attempt it at all, you ought to know what it means, and to ook for and enjoy it in the art of others.

Composition means, literally and simply, putting several things together, so as to make *one* thing out of them ; the nature and goodness of which they all have a share in producing. Thus a musician composes an air, by putting notes together in certain relations ; a poet composes a poem, by putting thoughts and words in pleasant order ; and a painter a picture, by putting thoughts, forms, and colours in pleasant order.

In all these cases, observe, an intended unity must be the result of composition. A paviour cannot be said to compose the heap of stones which he empties from his cart, nor the sower the handful of seed which he scatters from his hand. It is the essence of composition that everything should be in a determined place, perform an intended part, and act, in that part, advantageously for everything that is connected with it.

Composition, understood in this pure sense, is the type, in the arts of mankind, of the Providential government of the world.[1] It is an exhibition, in the order given to notes, or colours, or forms, of the advantage of perfect fellowship, discipline, and contentment. In a well-composed air, no note, however short or low, can be spared, but the least is as necessary as the greatest : no note, however prolonged, is tedious ; but the others prepare for, and are benefited by, its duration : no note, however high, is tyrannous ; the others prepare for and are bene-

See farther, on this subject, Modern Painters, vol. iv. chap. viii. § 6

fited by, its exaltation : no note, however low, is overpowered, the others prepare for, and sympathise with, its humility : and the result is, that each and every note has a value in the position assigned to it, which, by itself, it never possessed, and of which, by separation from the others, it would instantly be deprived.

Similarly, in a good poem, each word and thought enhances the value of those which precede and follow it ; and every syllable has a loveliness which depends not so much on its abstract sound as on its position. Look at the same word in a dictionary, and you will hardly recognise it.

Much more in a great picture ; every line and colour is so arranged as to advantage the rest. None are inessential, however slight ; and none are independent, however forcible. It is not enough that they truly represent natural objects ; but they must fit into certain places, and gather into certain harmonious groups : so that, for instance, the red chimney of a cottage is not merely set in its place as a chimney, but that it may affect, in a certain way pleasurable to the eye, the pieces of green or blue in other parts of the picture ; and we ought to see that the work is masterly, merely by the positions and quantities of these patches of green, red, and blue, even at a distance which renders it perfectly impossible to determine what the colours represent : or to see whether the red is a chimney, or an old woman's cloak ; and whether the blue is smoke, sky, or water.

It seems to be appointed, in order to remind us, in all we do, of the great laws of Divine government and human polity, that composition in the arts should strongly affect every order of mind, however unlearned or thoughtless. Hence the popular delight in rhythm and metre, and in simple musical melodies. But it is also appointed that *power* of composition in the fine arts

should be an exclusive attribute of great intellect. All men can more or less copy what they see, and, more or less, remember it : powers of reflection and investigation are also common to us all, so that the decision of inferiority in these rests only on questions of *degree.* A. has a better memory than B., and C. reflects more profoundly than D. But the gift of composition is not given *at all* to more than one man in a thousand ; in its highest range, it does not occur above three or four times in a century.

It follows, from these general truths, that it is impossible to give rules which will enable you to compose. You might much more easily receive rules to enable you to be witty. If it were possible to be witty by rule, wit would cease to be either admirable or amusing : if it were possible to compose melody by rule, Mozart and Cimarosa need not have been born : if it were possible to compose pictures by rule, Titian and Veronese would be ordinary men. The essence of composition lies precisely in the fact of its being unteachable, in its being the operation of an individual mind of range and power exalted above others.

But though no one can *invent* by rule, there are some simple laws of arrangement which it is well for you to know, because, though they will not enable you to produce a good picture, they will often assist you to set forth what goodness may be in your work in a more telling way than you could have done otherwise ; and by tracing them in the work of good composers, you may better understand the grasp of their imagination, and the power it possesses over their materials. I shall briefly state the chief of these laws.

1. THE LAW OF PRINCIPALITY.

The great object of composition being always to secure

unity ; that is, to make out of many things one whole ; the
first mode in which this can be effected is, by determining that
one feature shall be more important than all the rest, and that
the others shall group with it in subordinate positions.

This is the simplest law of ordinary ornamentation. Thus
the group of two leaves, *a*, Fig. 31., is unsatisfactory, because
it has no leading leaf ; but that
at *b* *is* prettier, because it has
a head or master leaf ; and *c*
more satisfactory still, because
the subordination of the other
members to this head leaf is

Fig. 81.

made more manifest by their gradual loss of size as they fall
back from it. Hence part of the pleasure we have in the
Greek honeysuckle ornament, and such others.

Thus, also, good pictures have always one light larger or
brighter than the other lights, or one figure more prominent
than the other figures, or one mass of colour dominant over all
the other masses ; and in general you will find it much benefit
your sketch if you manage that there shall be one light on the
cottage wall, or one blue cloud in the sky, which may attract
the eye as leading light, or leading gloom, above all others.
But the observance of the rule is often so cunningly concealed
by the great composers, that its force is hardly at first trace-
able ; and you will generally find they are vulgar pictures in
which the law is *strikingly* manifest. This may be simply illus-
trated by musical melody ; for instance, in such phrases as
this :

one note (here the upper G) rules the whole passage, and has the full energy of it concentrated in itself. Such passages, corresponding to completely subordinated compositions in painting, are apt to be wearisome if often repeated. But in such a phrase as this:

it is very difficult to say which is the principal note. The A in the last bar is slightly dominant, but there is a very equal current of power running through the whole ; and such passages rarely weary. And this principle holds through vast scales of arrangement; so that in the grandest compositions, such as Paul Veronese's Marriage in Cana, or Raphael's Disputa, it is not easy to fix at once on the principal figure ; and very commonly the figure which is really chief does not catch the eye at first, but is gradually felt to be more and more conspicuous as we gaze. Thus in Titian's grand composition of the Cornaro Family, the figure meant to be principal is a youth of fifteen or sixteen, whose portrait it was evidently the painter's object to make as interesting as possible. But a grand Madonna, and a St. George with a drifting banner, and many figures more, occupy the centre of the picture, and first catch the eye ; little by little we are led away from them to a gleam of pearly light in the lower corner, and find that, from the head which it shines upon, we can turn our eyes no more.

As, in every good picture, nearly all laws of design are more or less exemplified, it will, on the whole, be an easier way of explaining them to analyse one composition thoroughly, than to

give instances from various works. I shall therefore take one
of Turner's simplest ; which will allow us, so to speak, easily to
decompose it, and illustrate each law by it as we proceed.

Figure 32. is a rude sketch of the arrangement of the whole
subject ; the old bridge over the Moselle at Coblentz, the

Fig. 32.

town of Coblentz on the right, Ehrenbreitstein on the left. The
leading or master feature is, of course the tower on the bridge.
It is kept from being *too* principal by an important group on
each side of it ; the boats, on the right, and Ehrenbreitstein
beyond. The boats are large in mass, and more forcible in
colour, but they are broken into small divisions, while the
tower is simple, and therefore it still leads. Ehrenbreitstein is
noble in its mass, but so reduced by aërial perspective of colour
that it cannot contend with the tower, which therefore holds
the eye, and becomes the key of the picture. We shall see
presently how the very objects which seem at first to contend
with it for the mastery are made, occultly, to increase its
preëminence.

2. THE LAW OF REPETITION.

Another important means of expressing unity is to mark some kind of sympathy among the different objects, and perhaps the pleasantest, because most surprising, kind of sympathy, is when one group imitates or repeats another ; not in the way of balance or symmetry, but subordinately, like a far-away and broken echo of it. Prout has insisted much on this law in all his writings on composition ; and I think it is even more authoritatively present in the minds of most great composers than the law of principality. It is quite curious to see the pains that Turner sometimes takes to echo an important passage of colour ; in the Pembroke Castle for instance, there are two fishing-boats, one with a red, and another with a white sail. In a line with them, on the beach, are two fish in precisely the same relative positions ; one red and one white. It is observable that he uses the artifice chiefly in pictures where he wishes to obtain an expression of repose : in my notice of the plate of Scarborough, in the series of the Harbours of England, I have already had occasion to dwell on this point ; and I extract in the note[1] one or two sentences which explain the principle. In the composition I have chosen for our illus-

[1] " In general, throughout Nature, reflection and repetition are peaceful things, associated with the idea of quiet succession in events, that one day should be like another day, or one history the repetition of another history, being more or less results of quietness, while dissimi- milarity and non-succession are results of interference and disquietude. Thus, though an echo actually increases the quantity of sound heard, its repetition of the note or syllable gives an idea of calmness attainable in no other way ; hence also the feeling of calm given to a landscape by the voice of a cuckoo."

tration, this reduplication is employed to a singular extent. The tower, or leading feature, is first repeated by the low echo of it to the left; put your finger over this lower tower, and see how the picture is spoiled. Then the spires of Coblentz are all arranged in couples (how they are arranged in reality does not matter ; when we are composing a great picture, we must play the towers about till they come right, as fearlessly as if they were chessmen instead of cathedrals). The dual arrangement of these towers would have been too easily seen, were it not for a little one which pretends to make a triad of the last group on the right, but is so faint as hardly to be discernible : it just takes off the attention from the artifice, helped in doing so by the mast at the head of the boat, which, however, has instantly its own duplicate put at the stern.[1] Then there is the large boat near, and its echo beyond it. That echo is divided into two again, and each of those two smaller boats has two figures in it ; while two figures are also sitting together on the great rudder that lies half in the water, and half aground. Then, finally, the great mass of Ehrenbreitstein, which appears at first to have no answering form, has almost its *facsimile* in the bank on which the girl is sitting ; this bank is as absolutely essential to the completion of the picture as any object in the whole series. All this is done to deepen the effect of repose.

Symmetry or the balance of parts or masses in nearly equal opposition, is one of the conditions of treatment under the law of Repetition. For the opposition, in a symmetrical object, is of like things reflecting each other ; it is not the balance of contrary natures (like that of day and night)

[1] This is obscure in the rude woodcut, the masts being so delicate that they are confused among the lines of reflection. In the original they have orange light upon them, relieved against purple behind.

but of like natures or like forms ; one side of a leaf being
set like the reflection of the other in water.

Symmetry in Nature is, however, never formal nor accurate.
She takes the greatest care to secure some difference between
the corresponding things or parts of things ; and an approx
imation to accurate symmetry is only permitted in animals
because their motions secure perpetual difference between the
balancing parts. Stand before a mirror ; hold your arms in
precisely the same position at each side, your head upright
your body straight ; divide your hair exactly in the middle,
and get it as nearly as you can into exactly the same shape
over each ear, and you will see the effect of accurate sym-
metry ; you will see, no less, how all grace and power in the
human form result from the interference of motion and life
with symmetry, and from the reconciliation of its balance with
its changefulness. Your position, as seen in the mirror, is
the highest type of symmetry as understood by modern ar-
chitects.

In many sacred compositions, living symmetry, the balance
of harmonious opposites, is one of the profoundest sources of
their power : almost any works of the early painters, Angelico,
Perugino, Giotto, &c., will furnish you with notable instances
of it. The Madonna of Perugino in the National Gallery,
with the angel Michael on one side and Raphael on the other,
is as beautiful an example as you can have.

In landscape, the principle of balance is more or less carried
out, in proportion to the wish of the painter to expres
disciplined calmness. In bad compositions, as in bad archi
tecture, it is formal, a tree on one side answering a tree on
the other ; but in good compositions, as in graceful statues, it
is always easy, and sometimes hardly traceable. In the
Coblentz, however, you cannot have much difficulty in seeing

how the boats on one side of the tower and the figures on
the other are set in nearly equal balance ; the tower, as a
central mass uniting both.

8. THE LAW OF CONTINUITY.

Another important and pleasurable way of expressing unity
is by giving some orderly succession to a number of objects
more or less similar. And this succession is most interesting
when it is connected with some gradual change in the aspect
or character of the objects. Thus the succession of the pillars
of a cathedral aisle is most interesting when they retire in
perspective, becoming more and more obscure in distance ;
so the succession of mountain promontories one behind another,
on the flanks of a valley ; so the succession of clouds, fading
farther and farther towards the horizon ; each promontory
and each cloud being of different shape, yet all evidently fol-
lowing in a calm and appointed order. If there be no change
at all in the shape or size of the objects, there is no continuity ;
there is only repetition—monotony. It is the change in shape
which suggests the idea of their being individually free, and
able to escape, if they liked, from the law that rules them,
and yet submitting to it. I will leave our chosen illustrative
composition for a moment to take up another, still more ex-
pressive of this law. It is one of Turner's most tender studies,
a sketch on Calais Sands at sunset ; so delicate in the expres-
ion of wave and cloud, that it is of no use for me to try
to reach it with any kind of outline in a woodcut ; but the
rough sketch, Fig. 33., is enough to give an idea of its ar-
rangement. The aim of the painter has been to give the
intensest expression of repose, together with the enchanted

lulling, monotonous motion of cloud and wave. All the clouds

Fig. 88.

are moving in innumerable ranks after the sun, meeting to-
wards the point in the horizon where he has set ; and the
tidal waves gain in winding currents upon the sand, with
that stealthy haste in which they cross each other so quietly,
at their edges : just folding one over another as they meet,
like a little piece of ruffled silk, and leaping up a little as
two children kiss and clap their hands, and then going on
again, each in its silent hurry, drawing pointed arches on
the sand as their thin edges intersect in parting ; but all this
would not have been enough expressed without the line of
the old pier-timbers, black with weeds, strained and bent by
the storm waves, and now seeming to stoop in following one
another, like dark ghosts escaping slowly from the cruelty of
the pursuing sea.

I need not, I hope, point out to the reader the illustration
of this law of continuance in the subject chosen for our general
illustration. It was simply that gradual succession of the

retiring arches of the bridge which induced Turner to paint
the subject at all ; and it was this same principle which led
him always to seize on subjects including long bridges where-
ever he could find them ; but especially, observe, unequal
bridges, having the highest arch at one side rather than at
the centre. There is a reason for this, irrespective of general
laws of composition, and connected with the nature of rivers,
which I may as well stop a minute to tell you about, and
let you rest from the study of composition.

All rivers, small or large, agree in one character, they like
to lean a little on one side : they cannot bear to have their
channels deepest in the middle, but will always, if they can,
have one bank to sun themselves upon, and another to get
cool under ; one shingly shore to play over, where they may
be shallow, and foolish, and childlike, and another steep shore,
under which they can pause, and purify themselves, and get
their strength of waves fully together for due occasion. Rivers
in this way are just like wise men, who keep one side of their
life for play, and another for work ; and can be brilliant,
and chattering, and transparent, when they are at ease, and
yet take deep counsel on the other side when they set them-
selves to their main purpose. And rivers are just in this
divided, also, like wicked and good men : the good rivers have
serviceable deep places all along their banks, that ships can
sail in ; but the wicked rivers go scoopingly irregularly under
their banks until they get full of strangling eddies, which no
boat can row over without being twisted against the rocks ;
and pools like wells, which no one can get out of but the
water-kelpie that lives at the bottom ;—but, wicked or good,
the rivers all agree in having two kinds of sides. Now the
natural way in which a village stonemason therefore throws
a bridge over a strong stream is, of course, to build a great

door to let the cat through, and little doors to let the kittens through ; a great arch for the great current, to give it room in flood time, and little arches for the little currents along the shallow shore. This, even without any prudential respect for the floods of the great current, he would do in simple economy of work and stone ; for the smaller your arches are, the less material you want on their flanks. Two arches over the same span of river, supposing the butments are at the same depth, are cheaper than one, and that by a great deal ; so that, where the current is shallow, the village mason makes his arches many and low ; as the water gets deeper, and it becomes troublesome to build his piers up from the bottom, he throws his arches wider ; at last he comes to the deep stream, and, as he cannot build at the bottom of that, he throws his largest arch over it with a leap, and with another little one or so gains the opposite shore. Of course as arches are wider they must be higher, or they will not stand ; so the roadway must rise as the arches widen. And thus we have the general type of bridge, with its highest and widest arch towards one side, and a train of minor arches running over the flat shore on the other ; usually a steep bank at the river-side next the large arch ; always, of course, a flat shore on the side of the small ones ; and the bend of the river assuredly concave towards this flat, cutting round, with a sweep into the steep bank ; or, if there is no steep bank, still assuredly cutting into the shore at the steep end of the bridge.

Now this kind of bridge, sympathising, as it does, with the spirit of the river, and marking the nature of the thing it has to deal with and conquer, is the ideal of a bridge ; and all endeavours to do the thing in a grand engineer's manner, with a level roadway and equal arches, are barbarous ; not only because all monotonous forms are ugly in themselves, but

because the mind perceives at once that there has been cost uselessly thrown away for the sake of formality.[1]

Well, to return to our continuity. We see that the Turnerian bridge in Fig. 32. is of the absolutely perfect type, and is still farther interesting by having its main arch crowned by a watch-tower. But as I want you to note especially what perhaps was not the case in the real bridge, but is entirely Turner's doing, you will find that though the arches diminish gradually, not one is *regularly* diminished—they are all of different shapes and sizes : you cannot see this clearly in Fig. 32., but in the larger diagram, Fig. 34., over leaf, you will with ease. This is indeed also part of the ideal of a bridge, because the lateral currents near the shore are of course irregular in

[1] The cost of art in getting a bridge level is *always* lost, for you must get up to the height of the central arch at any rate, and you only can make the whole bridge level by putting the hill farther back, and pretending to have got rid of it when you have not, but have only wasted money in building an unnecessary embankment. Of course, the bridge should not be difficultly or dangerously steep, but the necessary slope, whatever it may be, should be in the bridge itself, as far as the bridge can take it, and not pushed aside into the approach, as in our Waterloo road; the only rational excuse for doing which is that when the slope must be long it is inconvenient to put on a drag at the top of the bridge, and that any restiveness of the horse is more dangerous on the bridge than on the embankment. To this I answer: first, it is not more dangerous in reality, though it looks so, for the bridge is always guarded by an effective parapet, but the embankment is sure to have no parapet, or only a useless rail; and secondly, that it is better to have the slope on the bridge, and make the roadway wide in proportion, so as to be quite safe, because a little waste of space on the river is no loss, but your wide embankment at the side loses good ground; and so my picturesque bridges are right as well as beautiful, and I hope to see them built again some day, instead of the frightful straight-backed things which we fancy are fine, and accept from the pontifical rigidities of the engineering mind.

size, and a simple builder would naturally vary his arches accordingly ; and also, if the bottom was rocky, build his piers where the rocks came. But it is not as a part of bridge ideal, but as a necessity of all noble composition, that this irregularity is introduced by Turner. It at once raises the object thus treated from the lower or vulgar unity of rigid law to the greater unity of clouds, and waves, and trees, and human souls each different, each obedient, and each in harmonious service

4. THE LAW OF CURVATURE.

There is, however, another point to be noticed in this bridge of Turner's. Not only does it slope away unequally at its sides, but it slopes in a gradual though very subtle curve. And if you substitute a straight line for this curve (drawing one with a rule from the base of the tower on each side to the ends of the bridge, in Fig. 34., and effacing the curve), you will instantly see that the design has suffered grievously. You may ascertain, by experiment, that all beautiful objects whatsoever are thus terminated by delicately curved lines, except where the straight line is indispensable to their use or stability : and that when a complete system of straight lines, throughout the form, is necessary to that stability, as in crystals, the beauty, if any exists, is in colour and transparency, not in form Cut out the shape of any crystal you like, in white wax or wood, and put it beside a white lily, and you will feel the force of the curvature in its purity, irrespective of added colour, or other interfering elements of beauty.

Well, as curves are more beautiful than straight lines, it is necessary to a good composition that its continuities of object, mass, or colour should be, if possible, in curves, rather than straight lines or angular ones. Perhaps one of the simplest and prettiest examples of a graceful continuity of this kind is

Fig. 34.

in the line traced at any moment by the corks of a net as it is
being drawn : nearly every person is more or less attracted by
the beauty of the dotted line. Now it is almost always possi-
ble, not only to secure such a continuity in the arrangement or
boundaries of objects which, like these bridge arches or the
corks of the net, are actually connected with each other, but—
and this is a still more noble and interesting kind of continuity

Fig. 35.

—among features which appear at first entirely separate. Thus
the towers of Ehrenbreitstein, on the left, in Fig. 32., appear
at first independent of each other ; but when I give their pro-
file, on a larger scale, Fig. 35., the reader may easily perceive
that there is a subtle cadence and harmony among them. The
reason of this is, that they are all bounded by one grand curve,
traced by the dotted line ; out of the seven towers, four pre-

cisely touch this curve, the others only falling back from it
here and there to keep the eye from discovering it too easily

And it is not only always *possible* to obtain continuities of
this kind : it is, in drawing large forest or mountain forms
essential to truth. The towers of Ehrenbreitstein might or
might not in reality fall into such a curve, but assuredly the
basalt rock on which they stand did ; for all mountain forms
not cloven into absolute precipice, nor covered by straight
slopes of shales, are more or less governed by these great
curves, it being one of the aims of Nature in all her work to
produce them. The reader must already know this, if he has
been able to sketch at all among the mountains ; if not, let
him merely draw for himself, carefully, the outlines of any low
hills accessible to him, where they are tolerably steep, or of the
woods which grow on them. The steeper shore of the Thames
at Maidenhead, or any of the downs at Brighton or Dover, or,
even nearer, about Croydon (as Addington Hills), are easily
accessible to a Londoner ; and he will soon find not only how
constant, but how graceful the curvature is. Graceful curva-
ture is distinguished from ungraceful by two characters : first,
its moderation, that is to say, its close approach to straightness
in some part of its course ;[1] and, secondly, by its variation
that is to say, its never remaining equal in degree at different
parts of its course.

This variation is itself twofold in all good curves.

A. There is, first, a steady change through the whole line
from less to more curvature, or more to less, so that *no* part of
the line is a segment of a circle, or can be drawn by compasses
in any way whatever. Thus, in Fig. 36., *a* is a bad curve,

I cannot waste space here by reprinting what I have said in other
books : but the reader ought, if possible, to refer to the notices of this
part of our subject in Modern Painters, vol. iv. chap. xvii. ; and Stones
of Venice, vol. iii. chap. i. § 8.

because it is part of a circle, and is therefore monotonous

<center>Fig. 36.</center>

throughout ; but *b* is a good curve, because it continually changes its direction as it proceeds.

The *first* difference between good and bad drawing of tree boughs consists in observance of this

<center>Fig. 87.</center>

fact. Thus, when I put leaves on the line *b*, as in Fig. 37., you can immediately feel the springiness of character dependent on the changefulness of the curve. You may put leaves on the other line for yourself, but you will find you cannot make a right tree-spray of it. For *all* tree boughs, large or small, as well as all noble natural lines whatsoever, agree in this character ; and it is a point of primal necessity that your eye should always seize and your hand trace it. Here are two more portions of good curves, with leaves put on them at the extremities instead of the flanks, Fig. 38.; and two showing the arrangement of masses of foliage seen a little farther off, Fig. 39., which you may in like manner

<center>Fig. 88.</center>

amuse yourself by turning into segments of circles—you will see with what result. I hope, however, you have beside you,

Fig. 39.

by this time, many good studies of tree boughs carefully made, in which you may study variations of curvature in their most complicated and lovely forms.[1]

B. Not only does every good curve vary in general tendency, but it is modulated, as it proceeds, by myriads of subordinate curves. Thus the outlines of a tree trunk are never as at *a*, Fig. 40., but as at *b*. So also in waves, clouds, and all other nobly formed masses. Thus another essential difference between good and bad drawing, or good and bad sculpture, depends on the quantity and refinement of minor curvatures carried, by good work, into the great lines. Strictly speaking, however,- this is not variation in large curves, but composition of large curves out of small ones ; it is an increase in the quantity of the beautiful element, *but not a change in its nature.*

5. THE LAW OF RADIATION.

We have hitherto been concerned only with the binding of our various objects into beautiful lines or pro- cessions. The next point we have to

a *b*

Fig. 40.

[1] If you happen to be reading at this part of the book, without having

consider is, how we may unite these lines or processions them-selves, so as to make groups of *them*.

Now, there are two kinds of harmonies of lines. One in which, moving more or less side by side, they variously, but evidently with consent, retire from or approach each other intersect or oppose each other: currents of melody in music, for different voices, thus approach and cross, fall and rise, in harmony ; so the waves of the sea, as they approach the shore, flow into one another or cross, but with a great unity through all ; and so various lines of composition often flow harmoniously through and across each other in a picture. But the most sim-ple and perfect connexion of lines is by radiation ; that is, by their all springing from one point, or closing towards it : and this harmony is often, in Nature almost always, united with the other ; as the boughs of trees, though they intersect and play amongst each other irregularly, indicate by their general tendency their origin from one root. An essential part of the beauty of all vegetable form is in this radiation : it is seen most simply in a single flower or leaf, as in a convolvulus bell, or chestnut leaf ; but more beautifully in the complicated arrangements of the large boughs and sprays. For a leaf is only a flat piece of radiation ; but the tree throws its branches on all sides, and even in every profile view of it, which presents a radiation more or less correspondent to that of its leaves, it is more beautiful, because varied by the freedom of the sepa-rate branches. I believe it has been ascertained that, in all trees, the angle at which, in their leaves, the lateral ribs are

goo through any previous practice, turn back to the sketch of the ramification of stone pine, Fig. 4. p. 38., and examine the curves of its boughs one by one, trying them by the conditions here stated under the heads A and B.

set on their central rib is approximately the same at which the
branches leave the great stem ; and thus each section of the
tree would present a kind of magnified view of its own leaf,
were it not for the interfering force of gravity on the masses of
foliage. This force in proportion to their age, and the lateral
leverage upon them, bears them downwards at the extremities,
so that, as before noticed, the lower the bough grows on the
stem, the more it droops (Fig. 17. p. 94.); besides this, nearly

all beautiful trees have a tendency to
divide into two or more principal masses,
which give a prettier and more compli-
cated symmetry than if one stem ran all
the way up the centre. Fig. 41. may thus
be considered the simplest type of tree
radiation, as opposed to leaf radiation.
In this figure, however, all secondary
ramification is unrepresented, for the sake
of simplicity ; but if we take one half of

Fig. 41.

such a tree, and merely give two secondary branches to each
main branch (as represented in the general branch structure
shown at *b*, Fig. 18. p. 94.), we shall have the form, Fig. 42.

This I consider the perfect general type of tree
structure ; and it is curiously connected with cer-
tain forms of Greek, Byzantine, and Gothic orna-
mentation, into the discussion of which, however,
we must not enter here. It will be observed, that
both in Figures 41. and 42. all the branches so
spring from the main stem as very nearly to sug-
gest their united radiation from the root R. This
is by no means universally the case ; but if the

Fig. 42.

branches do not bend towards a point in the root, they at least
converge to some point or other. In the examples in Fig. 43.,

Fig. 43.

the mathematical centre of curvature, *a*, is thus, in one case, on the ground at some distance from the root, and in the other, near the top of the tree. Half, only, of each tree is given, for the sake of clearness : Fig. 44. gives both sides of another example, in which the origins of curvature are below the root. As the positions of such points may be varied without end, and as the arrangement of the lines is also farther complicated by the fact of the boughs springing for the most part in a spiral order round the tree, and at proportionate distances, the systems of curvature which regulate the form of vegetation are quite infinite. Infinite is a word easily said, and easily written, and people do not always mean it when they say it ; in this case I *do* mean it ; the number of systems is incalculable, and even to furnish anything like a representative number of types, I should have to give several hundreds of figures such as Fig. 44.[1]

Fig. 44.

Thus far, however, we have only been speaking of the great relations of stem and branches. The forms of the branches themselves are regulated by still more subtle laws, for they occupy an intermediate position between the form of the tree and of the leaf. The leaf has a flat ramification ; the tree a

[1] The reader, I hope, observes always that every line in these figures is itself one of varying curvature, and cannot be drawn by compasses.

completely rounded one ; the bough is neither rounded nor
flat, but has a structure exactly balanced between the two, in
a half-flattened, half-rounded flake, closely resembling in shape
one of the thick leaves of an artichoke or the flake of a fir
cone ; by combination forming the solid mass of the tree, as
the leaves compose the artichoke head. I have before pointed
out to you the general resemblance of these branch flakes to
an extended hand ; but they may be more accurately repre-
sented by the ribs of a boat. If you can imagine a very
broad-headed and flattened boat applied by its keel to the end

of a main branch,[1] as in
Fig. 45., the lines which
its ribs will take, and
the general contour of
it, as seen in different
directions, from above
and below ; and from

Fig. 45.

one side and another, will give you the closest approximation
to the perspectives and foreshortenings of a well-grown branch-
flake. Fig. 25. above, page 118., is an unharmed and unre-
strained shoot of healthy young oak ; and, if you compare it
with Fig. 45., you will understand at once the action of the
lines of leafage ; the boat only failing as a type in that its ribs
are too nearly parallel to each other at the sides, while the
bough sends all its ramification well forwards, rounding to the
head, that it may accomplish its part in the outer form of the

[1] I hope the reader understands that these woodcuts are merely fac-
similes of the sketches I make at the side of my paper to illustrate my
meaning as I write—often sadly scrawled if I want to get on to some-
thing else. This one is really a little too careless ; but it would take
more time and trouble to make a proper drawing of so odd a boat than
the matter is worth. It will answer the purpose well enough as it is.

whole tree, yet always securing the compliance with the great
universal law that the branches nearest the root bend most
back ; and, of course, throwing *some* always back as well as
forwards ; the appearance of reversed action being much
increased, and rendered more striking and beautiful, by per-
spective. Figure 25. shows
the perspective of such a bough
as it is seen from below ; Fig.
46. gives rudely the look it
would have from above.

Fig. 46.

You may suppose, if you
have not already discovered,
what subtleties of perspective
and light and shade are involved in the drawing of these
branch-flakes, as you see them in different directions and
actions ; now raised, now depressed ; touched on the edges by
the wind, or lifted up and bent back so as to show all the
white under surfaces of the leaves shivering in light, as the
bottom of a boat rises white with spray at the surge-crest ; or
drooping in quietness towards the dew of the grass beneath
them in windless mornings, or bowed down under oppressive
grace of deep-charged snow. Snow time, by the way, is one
of the best for practice in the placing of tree masses ; but you
will only be able to understand them thoroughly by beginning
with a single bough and a few leaves placed tolerably even, as
in Fig. 38. p. 185. First one with three leaves, a central and
two lateral ones, as at *a* ; then with five, as at *b*, and so on ;
directing your whole attention to the expression, both by con-
tour and light and shade, of the boat-like arrangements, which,
in your earlier studies, will have been a good deal confused,
partly owing to your inexperience, and partly to the depth of
shade, or absolute blackness of mass required in those studies.

One thing more remains to be noted, and I will let you out of the wood. You see that in every generally representative figure I have surrounded the radiating branches with a dotted line : such lines do indeed terminate every vegetable form ; and you see that they are themselves beautiful curves, which, according to their flow, and the width or narrowness of the spaces they enclose, characterize the species of tree or leaf, and express its free or formal action, its grace of youth or weight of age. So that, throughout all the freedom of her wildest foliage, Nature is resolved on expressing an encompassing limit ; and marking a unity in the whole tree, caused not only by the rising of its branches from a common root, but by their joining in one work, and being bound by a common law. And having ascertained this, let us turn back for a moment to a point in leaf structure which, I doubt not, you must already have observed in your earlier studies, but which it is well to state here, as connected with the unity of the branches in the great trees. You must have noticed, I should think, that whenever a leaf is compound,—that is to say, divided into other leaflets which in any way repeat or imitate the form of the whole leaf,—those leaflets are not symmetrical, as the whole leaf is, but always smaller on the side towards the point of the great leaf, so as to express their subordination to it, and show, even when they are pulled off, that they are not small independent leaves, but members of one large leaf.

Fig. 47., which is a block-plan of a leaf of columbine, without its minor divisions on the edges, will illustrate the principle clearly. It is composed of a central large mass, A, and two lateral ones, of which the one on the right only is lettered, B Each of these masses is again composed of three others, a central and two lateral ones ; but observe, the minor one, a of A, is balanced equally by its opposite ; but the minor b 1 of B is

larger than its opposite *b* 2. Again, each of these minor

Fig. 47.

masses is divided into three ; but while the central mass, A of
A, is symmetrically divided, the B of B is unsymmetrical, its
largest side-lobe being lowest. Again *b* 2, the lobe *c* 1 (its
lowest lobe in relation to B) is larger than *c* 2 ; and so also in
b 1. So that universally one lobe of a lateral leaf is always
larger than the other, and the smaller lobe is that which is
nearer the central mass ; the lower leaf, as it were by cour-
tesy, subduing some of its own dignity or power, in the imme-
diate presence of the greater or captain leaf ; and always
expressing, therefore, its own subordination and secondary
character. This law is carried out even in single leaves. As
far as I know, the upper half, towards the point of the spray,
is always the smaller ; and a slightly different curve, more
convex at the springing, is used for the lower side, giving an
exquisite variety to the form of the whole leaf ; so that one

9

of the chief elements in the beauty of every subordinate leaf throughout the tree, is made to depend on its confession of its own lowliness and subjection.

And now, if we bring together in one view the principles we have ascertained in trees, we shall find they may be summed under four great laws ; and that all perfect [1] vegetable form is appointed to express these four laws in noble balance of authority.

1. Support from one living root.

2. Radiation, or tendency of force from some one given point, either in the root, or in some stated connexion with it.

3. Liberty of each bough to seek its own livelihood and happiness according to its needs, by irregularities of action both in its play and its work, either stretching out to get its required nourishment from light and rain, by finding some sufficient breathing-place among the other branches, or knotting and gathering itself up to get strength for any load which its fruitful blossoms may lay upon it, and for any stress of its storm-tossed luxuriance of leaves ; or playing hither and thither as the fitful sunshine may tempt its young shoots, in their undecided states of mind about their future life.

4. Imperative requirement of each bough to stop within certain limits, expressive of its kindly fellowship and fraternity with the boughs in its neighbourhood ; and to work with them according to its power, magnitude, and state of health, to

[1] Imperfect vegetable form I consider that which is in its nature dependent, as in runners and climbers ; or which is susceptible of continual injury without materially losing the power of giving pleasure by its aspect, as in the case of the smaller grasses. I have not, of course, space here to explain these minor distinctions, but the laws above stated apply to all the more important trees and shrubs likely to be familiar to the student.

bring out the general perfectness of the great curve, and circumferent stateliness of the whole tree.

I think I may leave you, unhelped, to work out the moral analogies of these laws; you may, perhaps, however, be a little puzzled to see the meeting of the second one. It typically expresses that healthy human actions should spring radiantly (like rays) from some single heart motive; the most beautiful systems of action taking place when this motive lies at the root of the whole life, and the action is clearly seen to proceed from it; while also many beautiful secondary systems of action taking place from motives not so deep or central, but in some beautiful subordinate connexion with the central or life motive

The other laws, if you think over them, you will find equally significative; and as you draw trees more and more in their various states of health and hardship, you will be every day more struck by the beauty of the types they present of the truths most essential for mankind to know;[1] and you will see what this vegetation of the earth, which is necessary to our life, first,

[1] There is a very tender lesson of this kind in the shadows of leaves upon the ground; shadows which are the most likely of all to attract attention, by their pretty play and change. If you examine them, you will find that the shadows do not take the forms of the leaves, but that, through each interstice, the light falls, at a little distance, in the form of a round or oval spot; that is to say, it produces the image of the sun itself, cast either vertically or obliquely, in circle or ellipse according to the slope of the ground. Of course the sun's rays produce the same effect, when they fall through any small aperture: but the openings between leaves are the only ones likely to show it to an ordinary observer, or to attract his attention to it by its frequency, and lead him to think what this type may signify respecting the greater Sun; and how it may show us that, even when the opening through which the earth receives light is too small to let us see the Sun himself, the ray of light that enters, if it comes straight from Him, will still bear with it His image.

as purifying the air for us and then as food, and just as neces-
sary to our joy in all places of the earth,—what these trees
and leaves, I say, are meant to teach us as we contemplate
them, and read or hear their lovely language, written or spoken
for us, not in frightful black letters, nor in dull sentences, but
in fair green and shadowy shapes of waving words, and blos-
somed brightness of odoriferous wit, and sweet whispers of un-
intrusive wisdom, and playful morality.

Well, I am sorry myself to leave the wood, whatever my
reader may be ; but leave it we must, or we shall compose no
more pictures to-day.

This law of radiation, then, enforcing unison of action in
arising from, or proceeding to, some given point, is perhaps, of
all principles of composition, the most influential in producing
the beauty of groups of form. Other laws make them forcible
or interesting, but this generally is chief in rendering them
beautiful. In the arrangement of masses in pictures, it is con-
stantly obeyed by the great composers ; but, like the law of
principality, with careful concealment of its imperativeness, the
point to which the lines of main curvature are directed being
very often far away out of the picture. Sometimes, however,
a system of curves will be employed definitely to exalt, by their
concurrence, the value of some leading object, and then the law
becomes traceable enough.

In the instance before us, the principal object being, as we
have seen, the tower on the bridge, Turner has determined that
his system of curvature should have its origin in the top of this
tower. The diagram Fig. 34. p. 182., compared with Fig. 32
p. 172., will show how this is done. One curve joins the two
towers, and is continued by the back of the figure sitting on
the bank into the piece of bent timber. This is a limiting curve
of great importance, and Turner has drawn a considerable part

of it with the edge of the timber very carefully, and then led
the eye up to the sitting girl by some white spots and indica
tions of a ledge in the bank ; then the passage to the tops of
the towers cannot be missed.

The next curve is begun and drawn carefully for half an inch
of its course by the rudder ; it is then taken up by the basket
and the heads of the figures, and leads accurately to the tower
angle. The gunwales of both the boats begin the next two
curves, which meet in the same point ; and all are centralised
by the long reflection which continues the vertical lines.

Subordinated to this first system of curves there is another,
begun by the small crossing bar of wood inserted in the angle
behind the rudder ; continued by the bottom of the bank on
which the figure sits, interrupted forcibly beyond it,[1] but taken
up again by the water-line leading to the bridge foot, and pass-
ing on in delicate shadows under the arches, not easily shown
in so rude a diagram, towards the other extremity of the bridge.
This is a most important curve, indicating that the force and
sweep of the river have indeed been in old times under the
large arches ; while the antiquity of the bridge is told us by
the long tongue of land, either of carted rubbish, or washed
down by some minor stream, which has interrupted this curve,
and is now used as a landing-place for the boats, and for em-
barkation of merchandise, of which some bales and bundles are
laid in a heap, immediately beneath the great tower. A com

[1] In the smaller figure (32.), it will be seen that this interruption is
caused by a cart coming down to the water's edge ; and this object is ser-
viceable as beginning another system of curves leading out of the picture
on the right, but so obscurely drawn as not to be easily represented in
outline. As it is unnecessary to the explanation of our point here, it has
been omitted in the larger diagram, the direction of the curve it begins
being indicated by the dashes only.

mon composer would have put these bales to one side or the other, but Turner knows better ; he uses them as a foundation for his tower, adding to its importance precisely as the sculptured base adorns a pillar ; and he farther increases the aspect of its height by throwing the reflection of it far down in the nearer water. All the great composers have this same feeling about sustaining their vertical masses : you will constantly find Prout using the artifice most dexterously (see, for instance, the figure with the wheelbarrow under the great tower, in the sketch of St. Nicolas, at Prague, and the white group of figures under the tower in the sketch of Augsburg [1]) ; and Veronese, Titian, and Tintoret continually put their principal figures at bases of pillars. Turner found out their secret very early, the most prominent instance of his composition on this principle being the drawing of Turin from the Superga, in Hakewell's Italy. I chose Fig. 20., already given to illustrate foliage drawing, chiefly because, being another instance of precisely the same arrangement, it will serve to convince you of its being intentional. There, the vertical, formed by the larger tree, is continued by the figure of the farmer, and that of one of the smaller trees by his stick. The lines of the interior mass of the bushes radiate, under the law of radiation, from a point behind the farmer's head ; but their outline curves are carried on and repeated, under the law of continuity, by the curves of the dog and boy—by the way, note the remarkable instance in these of the use of darkest lines towards the light ;—all more or less guiding the eye up to the right, in order to bring it finally to the Keep of Windsor, which is the central object of the picture, as the bridge tower is in the Coblentz. The wall on which the boy climbs answers the purpose of contrasting, both

[1] Both in the Sketches in Flanders and Germany.

in direction and character, with these greater curves ; thus corresponding as nearly as possible to the minor tongue of land in the Coblentz. This, however, introduces us to another law, which we must consider separately.

6. THE LAW OF CONTRAST.

Of course the character of everything is best manifested by Contrast. Rest can only be enjoyed after labour ; sound, to be heard clearly, must rise out of silence ; light is exhibited by darkness, darkness by light ; and so on in all things. Now in art every colour has an opponent colour, which, if brought near it, will relieve it more completely than any other ; so, also, every form and line may be made more striking to the eye by an opponent form or line near them ; a curved line is set off by a straight one, a massy form by a slight one, and so on ; and in all good work nearly double the value, which any given colour or form would have uncombined, is given to each by contrast.[1]

In this case again, however, a too manifest use of the artifice vulgarises a picture. Great painters do not commonly, or very visibly, admit violent contrast. They introduce it by stealth and with intermediate links of tender change ; allowing, indeed, the opposition to tell upon the mind as a surprise, but not as a shock.[2]

[1] If you happen to meet with the plate of Durer's representing a coat of arms with a skull in the shield, note the value given to the concave curves and sharp point of the helmet by the convex leafage carried round it in front ; and the use of the blank white part of the shield in opposing the rich folds of the dress.

[2] Turner hardly ever, as far as I remember, allows a strong light to oppose a full dark, without some intervening tint. His suns never set behind dark mountains without a film of cloud above the mountain's edge.

Thus in the rock of Ehrenbreitstein, Fig. 35., the main current of the lines being downwards, in a convex swell, they are suddenly stopped at the lowest tower by a counter series of beds, directed nearly straight across them. This adverse force sets off and relieves the great curvature, but it is reconciled to it by a series of radiating lines below, which at first sympathize with the oblique bar, then gradually get steeper, till they meet and join in the fall of the great curve. No passage, however intentionally monotonous, is ever introduced by a good artist without *some* slight counter current of this kind ; so much, indeed, do the great composers feel the necessity of it, that they will even do things purposely ill or unsatisfactorily, in order to give greater value to their well-doing in other places. In a skilful poet's versification the so-called bad or inferior lines are not inferior because he could not do them better, but because he feels that if all were equally weighty, there would be no real sense of weight anywhere ; if all were equally melodious, the melody itself would be fatiguing ; and he purposely introduces the labouring or discordant verse, that the full ring may be felt in his main sentence, and the finished sweetness in his chosen rhythm.[1] And continually in painting, inferior artists destroy their work by giving too much of all that they think is good, while the great painter gives just enough to be enjoyed, and passes to an opposite kind of enjoyment, or to an inferior state of enjoyment : he gives a passage of rich, involved, ex-

[1] " A prudent chief not always must display
His powers in equal ranks and fair array,
But with the occasion and the place comply,
Conceal his force ; nay, seem sometimes to fly.
Those oft are stratagems which errors seem,
Nor is it Homer nods, but we that dream."

Essay on Criticism.

quisitely wrought colour, then passes away into slight, and
pale, and simple colour ; he paints for a minute or two with
intense decision, then suddenly becomes, as the spectator thinks,
slovenly ; but he is not slovenly : you could not have *taken*
any more decision from him just then ; you have had as much
as is good for you ; he paints over a great space of his picture
forms of the most rounded and melting tenderness, and sud-
denly, as you think by a freak, gives you a bit as jagged and
sharp as a leafless blackthorn. Perhaps the most exquisite piece
of subtle contrast in the world of painting is the arrow point,
laid sharp against the white side and among the flowing hair
of Correggio's Antiope. It is quite singular how very little con-
trast will sometimes serve to make an entire group of forms
interesting which would otherwise have been valueless. There
is a good deal of picturesque material, for instance, in this top
of an old tower, Fig. 48., tiles and stones and sloping roof not

Fig. 48.

disagreeably mingled ; but all would have been unsatisfac-
tory if there had not happened to be that iron ring on the inner

9*

wall, which by its vigorous black *circular* line precisely opposes
all the square and angular characters of the battlements and
roof. Draw the tower without the ring, and see what a differ-
ence it will make.

One of the most important applications of the law of con
trast is in association with the law of continuity, causing an
unexpected but gentle break in a continuous series. This arti-
fice is perpetual in music, and perpetual also in good illumina-
tion ; the way in which little surprises of change are prepared
in any current borders, or chains of ornamental design, being
one of the most subtle characteristics of the work of the good
periods. We take, for instance, a bar of ornament between two
written columns of an early 14th century MS., and at the first
glance we suppose it to be quite monotonous all the way up,
composed of a winding tendril, with alternately a blue leaf and
a scarlet bud. Presently, however, we see that, in order to
observe the law of principality, there is one large scarlet leaf
instead of a bud, nearly half-way up, which forms a centre to
the whole rod ; and when we begin to examine the order of
the leaves, we find it varied carefully. Let ▲ stand for scarlet
bud, *b* for blue leaf, *c* for two blue leaves on one stalk, *s* for a
stalk without a leaf, and ʀ for the large red leaf. Then count-
ing from the ground, the order begins as follows :

b, b, ▲ ; *b, s, b,* ▲ ; *b, b,* ▲ ; *b, b,* ▲ ; and we think we shall
have two *b*'s and an ▲ all the way up, when suddenly it becomes *b,*
▲ ; *b,* ʀ ; *b,* ▲ ; *b,* ▲ ; *b,* ▲ ; and we think we are going to
have *b,* ▲ continued ; but no : here it becomes *b, s* ; *b, s* ; *b,*
▲ ; *b, s* ; *b, s* ; *c, s* ; *b, s* ; *b, s* ; and we think we are surely
going to have *b, s* continued, but behold it runs away to the
end with a quick *b, b,* ▲ ; *b, b, b, b* ![1] Very often, however,

[1] I am describing from an MS., *circa* 1300, of Gregory's Decretalia, in
my own possession.

the designer is satisfied with *one* surprise, but I never saw a
good illuminated border without one at least ; and no series of
any kind is ever introduced by a great composer in a painting
without a snap somewhere. There is a pretty one in Turner's
drawing of Rome, with the large balustrade for a foreground
in the Hakewell's Italy series : the single baluster struck out
of the line, and showing the street below through the gap,
simply makes the whole composition right, when otherwise, it
would have been stiff and absurd.

If you look back to Fig. 48. you will see, in the arrangement
of the battlements, a simple instance of the use of such vari-
ation. The whole top of the tower, though actually three sides
of a square, strikes the eye as a continuous series of five masses.
The first two, on the left, somewhat square and blank ; then
the next two higher and richer, the tiles being seen on their
slopes. Both these groups being couples, there is enough
monotony in the series to make a change pleasant ; and the
last battlement, therefore, is a little higher than the first two,
—a little lower than the second two,—and different in shape
from either. Hide it with your finger, and see how ugly and
formal the other four battlements look.

There are in this figure several other simple illustrations of
the laws we have been tracing. Thus the whole shape of the
walls' mass being square, it is well, still for the sake of contrast,
to oppose it not only by the element of curvature, in the ring,
and lines of the roof below, but by that of sharpness; hence the
pleasure which the eye takes in the projecting point of the roof.
Also because the walls are thick and sturdy, it is well to
contrast their strength with weakness ; therefore we enjoy the
evident decrepitude of this roof as it sinks between them. The
whole mass being nearly white, we want a contrasting shadow
somewhere ; and get it, under our piece of decrepitude. This

shade, with the tiles of the wall below, forms another pointed mass, necessary to the first by the law of repetition. Hide this inferior angle with your finger, and see how ugly the other looks. A sense of the law of symmetry, though you might hardly suppose it, has some share in the feeling with which you look at the battlements ; there is a certain pleasure in the opposed slopes of their top, on one side down to the left, on the other to the right. Still less would you think the law of radiation had anything to do with the matter : but if you take the extreme point of the black shadow on the left for a centre, and follow first the low curve of the eaves of the wall, it will lead you, if you continue it, to the point of the tower cornice ; follow the second curve, the top of the tiles of the wall, and it will strike the top of the right-hand battlement ; then draw a curve from the highest point of the angle battlement on the left, through the points of the roof and its dark echo ; and you will see how the whole top of the tower radiates from this lowest dark point. There are other curvatures crossing these main ones, to keep them from being too conspicuous. Follow the curve of the upper roof, it will take you to the top of the highest battlement ; and the stones indicated at the right-hand side of the tower are more extended at the bottom, in order to get some less direct expression of sympathy, such as irregular stones may be capable of, with the general flow of the curves from left to right.

You may not readily believe, at first, that all these laws are indeed involved in so trifling a piece of composition. But as you study longer, you will discover that these laws, and many more, are obeyed by the powerful composers in every *touch* : that literally, there is never a dash of their pencil which is not carrying out appointed purposes of this kind in twenty various ways at once ; and that there is as much difference, in

way of intention and authority, between one of the great com-
posers ruling his colours, and a common painter confused by
them, as there is between a general directing the march of an
rmy, and an old lady carried off her feet by a mob.

7. THE LAW OF INTERCHANGE

Closely connected with the law of contrast is a law which
enforces the unity of opposite things, by giving to each a
portion of the character of the other. If, for instance, you
divide a shield into two masses of colour, all the way down—
suppose blue and white, and put a bar, or figure of an animal,
partly on one division, partly on the other, you will find it plea-
sant to the eye if you make the part of the animal blue which
comes upon the white half, and white which comes upon the
blue half. This is done in heraldry, partly for the sake of
perfect intelligibility, but yet more for the sake of delight in
interchange of colour, since, in all ornamentation whatever, the
practice is continual, in the ages of good design.

Sometimes this alternation is merely a reversal of contrasts ;
as that, after red has been for some time on one side, and blue
on the other, red shall pass to blue's side and blue to red's.
This kind of alternation takes place simply in four-quartered
shields ; in more subtle pieces of treatment, a little bit only of
each colour is carried into the other, and they are as it were
dovetailed together. One of the most curious facts which will
impress itself upon you, when you have drawn some time care-
fully from Nature in light and shade, is the appearance of
intentional artifice with which contrasts of this alternate kind
are produced by her ; the artistry with which she will darken
a tree trunk as long as it comes against light sky, and

throw sunlight on it precisely at the spot where it comes against a dark hill, and similarly treat all her masses of shade and colour, is so great, that if you only follow her closely, every one who looks at your drawing with attention will think that you have been inventing the most artificially and unnaturally delightful interchanges of shadow that could possibly be devised by human wit.

You will find this law of interchange insisted upon at length by Prout in his Lessons on Light and Shade : it seems, of all his principles of composition, to be the one he is most conscious of ; many others he obeys by instinct, but this he formally accepts and forcibly declares.

The typical purpose of the law of interchange is, of course, to teach us how opposite natures may be helped and strengthened by receiving each, as far as they can, some impress or imparted power, from the other.

8. THE LAW OF CONSISTENCY.

It is to be remembered, in the next place, that while contrast exhibits the *characters* of things, it very often neutralises or paralyses their *power*. A number of white things may be shown to be clearly white by opposition of a black thing, but if we want the full power of their gathered light, the black thing may be seriously in our way. Thus, while contrast displays things, it is unity and sympathy which employ them, concentrating the power of several into a mass. And, not in art merely, but in all the affairs of life, the wisdom of man is continually called upon to reconcile these opposite methods of exhibiting, or using, the materials in his power. By change he gives them pleasantness, and by consistency value ; by change he is refreshed, and by perseverance strengthened.

Hence many compositions address themselves to the specta
tor by aggregate force of colour or line, more than by contrasts
of either ; many noble pictures are painted almost exclusively
in various tones of red, or grey, or gold, so as to be instantly
striking by their breadth of flush, or glow, or tender coldness,
these qualities being exhibited only by slight and subtle use of
contrast. Similarly as to form ; some compositions associate
massive and rugged forms, others slight and graceful ones, each
with few interruptions by lines of contrary character. And, i:
general, such compositions possess higher sublimity than those
which are more mingled in their elements. They tell a special
tale, and summon a definite state of feeling, while the grand
compositions merely please the eye.

This unity or breadth of character generally attaches most
to the works of the greatest men ; their separate pictures have
all separate aims. We have not, in each, grey colour set
against sombre, and sharp forms against soft, and loud passages
against low : but we have the bright picture, with its delicate
sadness ; the sombre picture, with its single ray of relief ; the
stern picture, with only one tender group of lines ; the soft and
calm picture, with only one rock angle at its flank ; and so on.
Hence the variety of their work, as well as its impressiveness.
The principal bearing of this law, however, is on the separate
masses or divisions of a picture : the character of the whole
composition may be broken or various, if we please, but there
must certainly be a tendency to consistent assemblage in its
divisions. As an army may act on several points at once, but
can only act effectually by having somewhere formed and regu-
lar masses, and not wholly by skirmishers ; so a picture may
be various in its tendencies, but must be somewhere united and
coherent in its masses. Good composers are always associating
their colours in great groups ; binding their forms together by

encompassing lines, and securing, by various dexterities of
expedient, what they themselves call " breadth :" that is to say,
a large gathering of each kind of thing into one place ; light
being gathered to light, darkness to darkness, and colour to
colour. If, however, this be done by introducing false lights or
false colours, it is absurd and monstrous ; the skill of a painter
consists in obtaining breadth by rational arrangement of his
objects, not by forced or wanton treatment of them. It is an
easy matter to paint one thing all white, and another all black
or brown ; but not an easy matter to assemble all the circum-
stances which will naturally produce white in one place, and
brown in another. Generally speaking, however, breadth will
result in sufficient degree from fidelity of study : Nature is
always broad ; and if you paint her colours in true relations,
you will paint them in majestic masses. If you find your work
look broken and scattered, it is, in all probability, not only ill
composed, but untrue.

The opposite quality to breadth, that of division or scatter-
ing of light and colour, has a certain contrasting charm, and is
occasionally introduced with exquisite effect by good com-
posers.[1] Still, it is never the mere scattering, but the order
discernible through this scattering, which is the real source of
pleasure ; not the mere multitude, but the constellation of
multitude. The broken lights in the work of a good painter
wander like flocks upon the hills, not unshepherded ; speaking
of life and peace : the broken lights of a bad painter fall like

[1] One of the most wonderful compositions of Tintoret in Venice, is
little more than a field of subdued crimson, spotted with flakes of scat-
tered gold. The upper clouds in the most beautiful skies owe great part
of their power to infinitude of division ; order being marked through this
division.

hailstones, and are capable only of mischief, leaving it to be wished they were also of dissolution.

9. THE LAW OF HARMONY.

This last law is not, strictly speaking, so much one of composition as of truth, but it must guide composition, and is properly, therefore, to be stated in this place.

Good drawing is, as we have seen, an *abstract* of natural facts ; you cannot represent all that you would, but must continually be falling short, whether you will or no, of the force, or quantity, of Nature. Now, suppose that your means and time do not admit of your giving the depth of colour in the scene, and that you are obliged to paint it paler. If you paint all the colours proportionately paler, as if an equal quantity of tint had been washed away from each of them, you still obtain a harmonious, though not an equally forcible statement of natural fact. But if you take away the colours unequally, and leave some tints nearly as deep as they are in Nature, while others are much subdued, you have no longer a true statement. You cannot say to the observer, "Fancy all those colours a little deeper, and you will have the actual fact." However he adds in imagination, or takes away, something is sure to be still wrong. The picture is out of harmony.

It will happen, however, much more frequently, that you have to darken the whole system of colours, than to make them paler. You remember, in your first studies of colour from Nature, you were to leave the passages of light which were too bright to be imitated, as white paper. But, in completing the picture, it becomes necessary to put colour into them ; and then the other colours must be made darker, in some fixed

relation to them. If you deepen all proportionately, though the whole scene is darker than reality, it is only as if you were looking at the reality in a lower light : but if, while you darken some of the tints, you leave others undarkened, the picture is out of harmony, and will not give the impression of truth.

It is not, indeed, possible to deepen *all* the colours so much as to relieve the lights in their natural degree ; you would merely sink most of your colours, if you tried to do so, into a broad mass of blackness : but it is quite possible to lower them harmoniously, and yet more in some parts of the picture than in others, so as to allow you to show the light you want in a visible relief. In well-harmonised pictures this is done by gradually deepening the tone of the picture towards the lighter parts of it, without materially lowering it in the very dark parts ; the tendency in such pictures being, of course, to include large masses of middle tints. But the principal point to be observed in doing this, is to deepen the individual tints without dirtying or obscuring them. It is easy to lower the tone of the picture by washing it over with grey or brown ; and easy to see the effect of the landscape, when its colours are thus universally polluted with black, by using the black convex mirror, one of the most pestilent inventions for falsifying nature and degrading art which ever was put into an artist's nnd.[1] For the thing required is not to darken pale yellow by mixing grey with it, but to deepen the pure yellow ; not to darken crimson by mixing black with it, but by making it

I fully believe that the strange grey gloom, accompanied by conside rable power of effect, which prevails in modern French art, must be owing to the use of this mischievous instrument; the French landscape always gives me the idea of Nature seen carelessly in the dark mirror and painted coarsely, but scientifically, through the veil of its perversion

deeper and richer crimson : and thus the required effect could only be seen in Nature, if you had pieces of glass of the colour of every object in your landscape, and of every minor hue that made up those colours, and then could see the real landscape through this deep gorgeousness of the varied glass. You can-not do this with glass, but you can do it for yourself as you work ; that is to say, you can put deep blue for pale blue, deep gold for pale gold, and so on, in the proportion you need , and then you may paint as forcibly as you choose, but your work will still be in the manner of Titian, not of Caravaggio or or Spagnoletto, or any other of the black slaves of paint-ing.[1]

Supposing those scales of colour, which I told you to prepare in order to show you the relations of colour to grey, were quite accurately made, and numerous enough, you would have nothing more to do, in order to obtain a deeper tone in any given mass of colour, than to substitute for each of its hues the hue as many degrees deeper in the scale as you wanted, that is to say, if you want to deepen the whole two degrees, substituting for the yellow No. 5. the yellow No. 7., and for the red No. 9. the red No. 11., and so on : but the hues of any object in Nature are far too numerous, and their degrees too subtle, to admit of so mechanical a process. Still, you may see the principle of the whole matter clearly by taking a group of colours out of your scale, arranging them prettily, and then washing them all over with grey : that represents the treatment of Nature by the black mirror. Then arrange the same group of colours, with the tints five or six degrees deeper in the scale ; and that will represent the treatment of Nature by Titian.

[1] Various other parts of this subject are entered into, especially in their bearing on the ideal of painting, in Modern Painters, vol. iv. chap. iii.

You can only, however, feel your way fully to the right of the thing by working from Nature.

The best subject on which to begin a piece of study of this kind is a good thick tree trunk, seen against blue sky with some white clouds in it. Paint the clouds in true and tenderly gradated white ; then give the sky a bold full blue, bringing them well out ; then paint the trunk and leaves grandly dark against all, but in such glowing dark green and brown as you see they will bear. Afterwards proceed to more complicated studies, matching the colours carefully first by your old method ; then deepening each colour with its own tint, and being careful, above all things, to keep truth of equal change when the colours are connected with each other, as in dark and light sides of the same object. Much more aspect and sense of harmony are gained by the precision with which you observe the relation of colours in dark sides and light sides, and the influence of modifying reflections, than by mere accuracy of added depth in independent colours.

This harmony of tone, as it is generally called, is the most important of those which the artist has to regard. But there are all kinds of harmonies in a picture, according to its mode of production There is even a harmony of *touch*. If you paint one part of it very rapidly and forcibly, and another part slowly and delicately, each division of the picture may be right separately, but they will not agree together : the whole will be effectless and valueless, out of harmony. Similarly, if you paint one part of it by a yellow light in a warm day, and another by a grey light in a cold day, though both may have been sunlight, and both may be well toned, and have their relative shadows truly cast, neither will look like light : they will destroy each other's power, by being out of harmony. These are only broad and definable instances of discordance ; but there is an extent

of harmony in all good work much too subtle for definition ;
depending on the draughtsman's carrying everything he draws
up to just the balancing and harmonious point, in finish, and
colour, and depth of tone, and intensity of moral feeling, and
style of touch, all considered at once ; and never allowing him-
self to lean too emphatically on detached parts, or exalt on
thing at the expense of another, or feel acutely in one place
and coldly in another. If you have got some of Cruikshank's
etchings, you will be able, I think, to feel the nature of harmo-
nious treatment in a simple kind, by comparing them with any
of Richter's illustrations to the numerous German story-books
lately published at Christmas, with all the German stories
spoiled. Cruikshank's work is often incomplete in character
and poor in incident, but, as drawing, it is *perfect* in harmony.
The pure and simple effects of daylight which he gets by his
thorough mastery of treatment in this respect, are quite unri-
valled, as far as I know, by any other work executed with so
few touches. His vignettes to Grimm's German stories,
already recommended, are the most remarkable in this quality
Richter's illustrations, on the contrary, are of a very high
stamp as respects understanding of human character, with infi-
nite playfulness and tenderness of fancy ; but, as drawings,
they are almost unendurably out of harmony, violent blacks in
one place being continually opposed to trenchant white in
another ; and, as is almost sure to be the case with bad har-
monists, the local colour hardly felt anywhere. All German
work is apt to be out of harmony, in consequence of its too fre-
quent conditions of affectation, and its wilful refusals of fact ;
as well as by reason of a feverish kind of excitement, which
dwells violently on particular points, and makes all the lines of
thought in the picture to stand on end, as it were, like a cat's

fur electrified ; while good work is always as quiet as a couchant leopard and as strong.

I have now stated to you all the laws of composition which occur to me as capable of being illustrated or defined ; but there are multitudes of others which, in the present state of my knowledge, I cannot define, and others which I never hope to define ; and these the most important, and connected with the deepest powers of the art. Among those which I hope to be able to explain when I have thought of them more, are the laws which relate to nobleness and ignobleness ; that ignobleness especially which we commonly call " vulgarity," and which, in its essence, is one of the most curious subjects of inquiry connected with human feeling. Among those which I never hope to explain, are chiefly laws of expression, and others bearing simply on simple matters ; but, for that very reason, more influential than any others. These are, from the first, as inexplicable as our bodily sensations are ; it being just as impossible, I think, to explain why one succession of musical notes [1] shall be noble and pathetic, and such as might have been sung by Casella to Dante, and why another succession is base and ridiculous, and would be fit only for the reasonably good ear of Bottom, as to explain why we like sweetness, and dislike bitterness. The best part of every great work is always inexplicable : it is good because it is good ; and innocently

[1] In all the best arrangements of colour, the delight occasioned by their mode of succession is entirely inexplicable, nor can it be reasoned about ; we like it just as we like an air in music, but cannot reason any refractory person into liking it, if they do not : and yet there is distinctly a right and a wrong in it, and a good taste and bad taste respecting it as also in music.

gracious, opening as the green of the earth, or falling as the dew of heaven.

But though you cannot explain them, you may always render yourself more and more sensitive to these higher qualities by the discipline which you generally give to your character, and this especially with regard to the choice of incidents ; a kind of composition in some sort easier than the artistical arrangements of lines and colours, but in every sort nobler, because addressed to deeper feelings.

For instance, in the " Datur Hora Quieti," the last vignette to Roger's Poems, the plough in the foreground has three purposes. The first purpose is to meet the stream of sunlight on the river, and make it brighter by opposition; but any dark object whatever would have done this. Its second purpose is, by its two arms, to repeat the cadence of the group of the two ships, and thus give a greater expression of repose ; but two sitting figures would have done this. Its third and chief, or pathetic, purpose is, as it lies abandoned in the furrow (the vessels also being moored, and having their sails down), to be a type of human labour closed with the close of day. The parts of it on which the hand leans are brought most clearly into sight ; and they are the chief dark of the picture, because the tillage of the ground is required of man as a punishment ; but they make the soft light of the setting sun brighter, because rest is sweetest after toil. These thoughts may never occur to us as we glance carelessly at the design ; and yet their under current assuredly affects the feelings, and increases, as the painter meant it should, the impression of melancholy, and of peace.

Again, in the " Lancaster Sands," which is one of the plates I have marked as most desirable for your possession ; the stream of light which falls from the setting sun on the advancing tide stands similarly in need of some force of near object to

relieve its brightness. But the incident which Turner has here adopted is the swoop of an angry seagull at a dog, who yelps at it, drawing back as the wave rises over his feet, and the bird shrieks within a foot of his face. Its unexpected boldness is a type of the anger of its ocean element, and warns us of the sea's advance just as surely as the abandoned plough told us of the ceased labour of the day.

It is not, however, so much in the selection of single incidents of this kind as in the feeling which regulates the arrangement of the whole subject that the mind of a great composer is known. A single incident may be suggested by a felicitous chance, as a pretty motto might be for the heading a chapter. But the great composers so arrange *all* their designs that one incident illustrates another, just as one colour relieves another. Perhaps the "Heysham," of the Yorkshire series which, as to its locality, may be considered a companion to the last drawing we have spoken of, the "Lancaster Sands," presents as interesting an example as we could find of Turner's feeling in this respect. The subject is a simple north-country village, on the shore of Morecambe Bay ; not in the common sense, a picturesque village : there are no pretty bow-windows, or red roofs, or rocky steps of entrance to the rustic doors, or quaint gables ; nothing but a single street of thatched and chiefly clay-built cottages, ranged in a somewhat monotonous line, the roofs so green with moss that at first we hardly discern the houses from the fields and trees. The village street is closed at the end by a wooden gate, indicating the little traffic there is on the road through it, and giving it something the look of a large farmstead, in which a right of way lies through the yard. The road which leads to this gate is full of ruts, and winds down a bad bit of hill between two broken banks of moor ground, succeeding immediately

to the few enclosures which surround the village , they can
hardly be called gardens ; but a decayed fragment or two of
fencing fill the gaps in the bank ; and a clothes-line, with some
clothes on it, striped blue and red, and a smock-frock, is
stretched between the trunks of some stunted willows ; a *very*
small haystack and pigstye being seen at the back of the cot
tage beyond. An empty, two-wheeled, lumbering cart, drawn
by a pair of horses with huge wooden collars, the driver sitting
lazily in the sun, sideways on the leader, is going slowly home
along the rough road, it being about country dinner-time.
At the end of the village there is a better house, with three
chimneys and a dormer window in its roof, and the roof is
of stone shingle instead of thatch, but very rough. This
house is no doubt the clergyman's ; there is some smoke from
one of its chimneys, none from any other in the village ; this
smoke is from the lowest chimney at the back, evidently that
of the kitchen, and it is rather thick, the fire not having been
long lighted. A few hundred yards from the clergyman's
house, nearer the shore, is the church, discernible from the
cottage only by its low-arched belfry, a little neater than
one would expect in such a village ; perhaps lately built by
the Puseyite incumbent ;[1] and beyond the church, close to
the sea, are two fragments of a border war-tower, standing
on their circular mound, worn on its brow deep into edges
and furrows by the feet of the village children. On the

[1] " Puseyism " was unknown in the days when this drawing was made ;
but the kindly and helpful influences of what may be called ecclesiastical
sentiment, which, in a morbidly exaggerated condition, forms one of the
principal elements of " Puseyism,"—I use this word regretfully, no other
existing which will serve for it,—had been known and felt in our wild
northern districts long before.

bank of moor, which forms the foreground, are a few cows,
the carter's dog barking at a vixenish one : the milkmaid
is feeding another, a gentle white one, which turns its head
to her, expectant of a handful of fresh hay, which she has
brought for it in her blue apron, fastened up round her waist ;
she stands with her pail on her head, evidently the village
coquette, for she has a neat bodice, and pretty striped petticoat
under the blue apron, and red stockings. Nearer us, the
cowherd, barefooted, stands on a piece of the limestone rock
(for the ground is thistly and not pleasurable to bare feet) ;—
whether boy or girl we are not sure ; it may be a boy, with
a girl's worn-out bonnet on, or a girl with a pair of ragged
trowsers on ; probably the first, as the old bonnet is evidently
useful to keep the sun out of our eyes when we are looking
for strayed cows among the moorland hollows, and helps us
at present to watch (holding the bonnet's edge down) the
quarrel of the vixenish cow with the dog, which, leaning on
our long stick, we allow to proceed without any interference.
A little to the right the hay is being got in, of which the
milkmaid has just taken her apronful to the white cow ; but
the hay is very thin, and cannot well be raked up because
of the rocks ; we must glean it like corn, hence the smallness
of our stack behind the willows ; and a woman is pressing
a bundle of it hard together, kneeling against the rock's
edge, to carry it safely to the hay-cart without dropping
any. Beyond the village is a rocky hill, deep set with brush-
wood, a square crag or two of limestone emerging here and
there, with pleasant turf on their brows, heaved in russet and
mossy mounds against the sky, which, clear and calm, and
as golden as the moss, stretches down behind it towards
the sea. A single cottage just shows its roof over the edge
of the hill, looking seaward ; perhaps one of the village shep-

herds is a sea captain now, and may have built it there, that his mother may first see the sails of his ship whenever it runs into the bay. Then under the hill, and beyond the border tower, is the blue sea itself, the waves flowing in over the sand in long curved lines, slowly ; shadows of cloud ̄ and gleams of shallow water on white sand alternating—miles away ; but no sail is visible, not one fisherboat on the beach, not one dark speck on the quiet horizon. Beyond all are the Cumberland mountains, clear in the sun, with rosy light on all their crags.

I should think the reader cannot but feel the kind of harmony there is in this composition ; the entire purpose of the painter to give us the impression of wild, yet gentle, country life, monotonous as the succession of the noiseless waves, patient and enduring as the rocks ; but peaceful, and full of health and quiet hope, and sanctified by the pure mountain air and baptismal dew of heaven, falling softly between days of toil and nights of innocence.

All noble composition of this kind can be reached only by instinct : you cannot set yourself to arrange such a subject ; you may see it, and seize it, at all times, but never laboriously invent it. And your power of discerning what is best in expression, among natural subjects, depends wholly on the temper in which you keep your own mind ; above all, on your living so much alone as to allow it to become acutely sensitive in its own stillness. The noisy life of modern days is wholly incompatible with any true perception of natural beauty. If you go down into Cumberland by the railroad, live in some frequented hotel, and explore the hills with merry companions, however much you may enjoy your tour or their conversation, depend upon it you will never choose so much as one pictorial subject rightly ; you will not see into the depth of any. But

take knapsack and stick, walk towards the hills by short day's journeys—ten or twelve miles a day—taking a week from some starting-place sixty or seventy miles away : sleep at the pretty little wayside inns, or the rough village ones ; then take the hills as they tempt you, following glen or shore as your eye glances or your heart guides, wholly scornful of local fame or fashion, and of everything which it is the ordinary traveller's duty to see, or pride to do. Never force yourself to admire anything when you are not in the humour ; but never force yourself away from what you feel to be lovely, in search of anything better : and gradually the deeper scenes of the natural world will unfold themselves to you in still increasing fulness of passionate power ; and your difficulty will be no more to seek or to compose subjects, but only to choose one from among the multitude of melodious thoughts with which you will be haunted, thoughts which will of course be noble or original in proportion to your own depth of character and general power of mind : for it is not so much by the consideration you give to any single drawing, as by the previous discipline of your powers of thought, that the character of your composition will be determined. Simplicity of life will make you sensitive to the refinement and modesty of scenery, just as inordinate excitement and pomp of daily life will make you enjoy coarse colours and affected forms. Habits of patient comparison and accurate judgment will make your art precious, as they will make your actions wise ; and every increase of noble enthusiasm in your living spirit will be measured by the reflection of its light upon the works of your hands.

Faithfully yours.

J. RUSKIN

APPENDIX.

THINGS TO BE STUDIED

THE worst danger by far, to which a solitary student is exposed, is that of liking things that he should not. It is not so much his difficulties, as his tastes, which he must set himself to conquer ; and although, under the guidance of a master, many works of art may be made instructive, which are only of partial excellence (the good and bad of them being duly distinguished), his safeguard, as long as he studies alone, will be in allowing himself to possess only things, in their way, so free from faults, that nothing he copies in them can seriously mislead him, and to contemplate only those works of art which he knows to be either perfect or noble in their errors. I will therefore set down in clear order, the names of the masters whom you may safely admire, and a few of the books which you may safely possess. In these days of cheap illustration, the danger is always rather of your possessing too much than too little. It may admit of some question, how far the looking at bad art may set off and illustrate the characters of the good ; but, on the whole, I believe it is best to live always on quite wholesome food, and that our taste of it will not be made more

acute by feeding, however temporarily, on ashes. Of course the works of the great masters can only be serviceable to the student after he has made considerable progress himself. It only wastes the time and dulls the feelings of young persons, to drag them through picture galleries ; at least, unless they them-selves wish to look at particular pictures. Generally, young people only care to enter a picture gallery when there is a chance of getting leave to run a race to the other end of it ; and they had better do that in the garden below. If, however, they have any real enjoyment of pictures, and want to look at this one or that, the principal point is never to disturb them in looking at what interests them, and never to make them look at what does not. Nothing is of the least use to young people (nor, by the way, of much use to old ones), but what interests them ; and therefore, though it is of great importance to put nothing but good art into their possession, yet when they are passing through great houses or galleries, they should be allow-ed to look precisely at what pleases them : if it is not useful to them as art, it will be in some other way ; and the healthiest way in which art can interest them is when they look at it, not as art, but because it represents something they like in nature. If a boy has had his heart filled by the life of some great man, and goes up thirstily to a Vandyck portrait of him, to see what he was like, that is the wholesomest way in which he can begin the study of portraiture ; if he love mountains, and dwell on a Turner drawing because he sees in it a likeness to a Yorkshire scar, or an Alpine pass, that is the wholesomest way in which he can begin the study of landscape ; and if a girl's mind is filled with dreams of angels and saints, and she pauses before an Angelico because she thinks it must surely be indeed like heaven, that is the wholesomest way for her to begin the study of religious art.

When, however, the student has made some definite progress, and every picture becomes really a guide to him, false or true, in his own work, it is of great importance that he should never so much as look at bad art ; and then, if the reader is willing to trust me in the matter, the following advice will be useful to him. In which, with his permission, I will quit the indirect and return to the epistolary address, as being the more co·venient.

First, in Galleries of Pictures :

1. You may look, with trust in their being always right, at Titian, Veronese, Tintoret, Giorgione, John Bellini, and Velas quez ; the authenticity of the picture being of course estab lished for you by proper authority.

2. You may look with admiration, admitting, however, question of right and wrong,[1] at Van Eyck, Holbein, Perugino, Francia, Angelico,. Leonardo da Vinci, Correggio, Vandyck, Rembrandt, Reynolds, Gainsborough, Turner, and the modern Pre-Raphaelites.[2] You had better look at no other painters than these, for you run a chance, otherwise, of being led far off the road, or into grievous faults, by some of the other great ones, as Michael Angelo, Raphael, and Rubens ; and of being, besides, corrupted in taste by the base ones, as Murillo, Sal·vator, Claude, Gasper Poussin, Teniers, and such others. You may look, however, for examples of evil, with safe universality

[1] I do not mean necessarily to imply inferiority of rank, in saying that this second class of painters have questionable qualities. The greates men have often many faults, and sometimes their faults are a part of their greatness; but such men are not, of course, to be looked upon by the student with absolute implicituess of faith.

[2] Including under this term, John Lewis, and William Hunt of the Old Water-colour, who, take him all in all, is the best painter of still life, I believe, that ever existed.

of reprobation, being sure that everything you see is bad, at Domenichino, the Caracci, Bronzino, and the figure pieces of Salvator.

Among those named for study under question, you cannot ook too much at, nor grow too enthusiastically fond of, An gelico, Correggio, Reynolds, Turner, and the Pre-Raphaelites ; but, if you find yourself getting especially fond of any of the others, leave off looking at them, for you must be going wrong some way or other. If, for instance, you begin to like Rem· brandt or Leonardo especially, you are losing your feeling for colour ; if you like Van Eyck or Perugino especially, you must be getting too fond of rigid detail ; and if you like Vandyck or Gainsborough especially, you must be too much attracted by gentlemanly flimsiness.

Secondly, of published, or otherwise multiplied, art, such as you may be able to get yourself, or to see at private houses or in shops, the works of the following masters are the most desirable, after the Turners, Rembrandts, and Durers, which I have asked you to get first :

1. Samuel Prout.

All his published lithographic sketches are of the greatest value, wholly unrivalled in power of composition, and in love and feeling of architectural subject. His somewhat mannered linear execution, though not to be imitated in your own sketches from Nature, may be occasionally copied, for discipline's sake, with great advantage ; it will give you a peculiar steadiness of hand, not quickly attainable in any other way ; and there is no fear of your getting into any faultful mannerism as long as you carry out the different modes of more delicate study above recommended.

If you are interested in architecture, and wish to make it

your chief study, you should draw much from photographs of it ; and then from the architecture itself, with the same com pletion of detail and gradation, only keeping the shadows of due paleness, in photographs they are always about four times as dark as they ought to be ; and treat buildings with as much care and love as artists do their rock foregrounds, drawing all the moss and weeds, and stains upon them. But if, without caring to understand architecture, you merely want the pictu-resque character of it, and to be able to sketch it fast, you cannot do better than take Prout for your *exclusive* master ; only do not think that you are copying Prout by drawing straight lines with dots at the end of them. Get first his " Rhine," and draw the subjects that have most hills, and least architecture in them, with chalk on smooth paper, till you can lay on his broad flat tints, and get his gradations of light, which are very wonderful ; then take up the architectural sub-jects in the " Rhine," and draw again and again the groups of figures, &c., in his " Microcosm," and " Lessons on Light and Shadow." After that, proceed to copy the grand subjects in the sketches in " Flanders and Germany ;" or in " Switzer-land and Italy," if you cannot get the Flanders ; but the Swit-zerland is very far inferior. Then work from Nature, not trying to Proutise Nature, by breaking smooth buildings into rough ones, but only drawing *what you see*, with Prout's simple method and firm lines. Don't copy his coloured works. They are good, but not at all equal to his chalk and pencil drawings, and you will become a mere imitator, and a very feeble imitator, if you use colour at all in Prout's method. I have not space to explain why this is so, it would take a long piece of reasoning ; trust me for the statement.

2. John Lewis.

His sketches in Spain, lithographed by himself, are very valuable. Get them, if you can, and also some engravings (about eight or ten, I think, altogether) of wild beasts, exe-cuted by his own hand a long time ago; they are very precious in every way, The series of the " Alhambra " is rather slight, and few of the subjects are lithographed by himself; still it is well worth having.

But let *no* lithographic work come into the house, if you can help it, nor even look at any, except Prout's, and those sketches of Lewis's.

3. George Crnikshank.

If you ever happen to meet with the two volumes of ' Grimm's German Stories," which were illustrated by him long ago, pounce upon them instantly; the etchings in them are the finest things, next to Rembrandt's, that, as far as I know, have been done since etching was invented. You cannot look at them too much, nor copy them too often.

All his works are very valuable, though disagreeable when they touch on the worst vulgarities of modern life; and often much spoiled by a curiously mistaken type of face, divided so as to give too much to the mouth and eyes, and leave too little for forehead, the eyes being set about two thirds up, instead of at half the height of the head. But his manner of work is always right; and his tragic power, though rarely developed, and warped by habits of caricature, is, in reality, as great as his grotesque power.

There is no fear of his hurting your taste, as long as your principal work lies among art of so totally different a charac ter as most of that which I have recommended to you; and you may, therefore, get great good by copying almost anything

of his that may come in your way; except only his illustrations, lately published to "Cinderella," and "Jack and the Bean-stalk," and "Tom Thumb," which are much over-laboured, and confused in line. You should get them, but do not copy them

4. Alfred Rethel

I only know two publications by him; one, the "Dance of Death," with text by Reinick, published in Leipsic, but to be had now of any London bookseller for the sum, I believe, of eighteen pence, and containing six plates full of instructive character; the other, of two plates only, "Death the Avenger," and "Death the Friend." These two are far superior to the "Todtentanz," and, if you can get them, will be enough in themselves, to show all that Rethel can teach you. If you dislike ghastly subjects, get "Death the Friend" only.

5. Bewick.

The execution of the plumage in Bewick's birds is the most masterly thing ever yet done in wood-cutting; it is just worked as Paul Veronese would have worked in wood, had he taken to it. His vignettes, though too coarse in execution, and vulgar in types of form, to be good copies, show, nevertheless, intellectual power of the highest order; and there are pieces of sentiment in them, either pathetic or satirical, which have never since been equalled in illustrations of this simple kind; the bitter intensity of the feeling being just like that which characterises some of the leading Pre-Raphaelites. Bewick is the Burns of painting.

6. Blake.

The "Book of Job," engraved by himself, is of the highest rank in certain characters of imagination and expression; in

the mode of obtaining certain effects of light it will also be a
very useful example to you. In expressing conditions of glaring
and flickering light, Blake is greater than Rembrandt.

7. Richter.

I have already told you what to guard against in looking at
nis works. I am a little doubtful whether I have done well
in including them in this catalogue at all ; but the fancies in
them are so pretty and numberless, that I must risk, for their
sake, the chance of hurting you a little in judgment of style.
If you want to make presents of story-books to children, his
are the best you can now get.

8. Rossetti.

An edition of Tennyson, lately published, contains woodcuts
from drawings by Rossetti and other chief Pre-Raphaelite mas-
ters. They are terribly spoiled in the cutting, and generally
the best part, the expression of feature, *entirely* lost ;[1] still they
are full of instruction, and cannot be studied too closely. But,
observe, respecting these wood-cuts, that if you have been in
the habit of looking at much spurious work, in which sentiment,
action, and style are borrowed or artificial, you will assuredly
be offended at first by all genuine work, which is intense in
feeling. Genuine art, which is merely art, such as Veronese's
or Titian's, may not offend you, though the chances are that
you will not care about it : but genuine works of feeling, such

[1] This is especially the case in the St. Cecily, Rossetti's first illustra
tion to the " palace of art," which would have been the best in the book
nad it been well engraved. The whole work should be taken up again,
and done by line engraving, perfectly ; and wholly from Pre-Raphaelite
designs, with which no other modern work can bear the least compari
son.

as Maude and Aurora Leigh in poetry, or the grand Pre-Ra-
phaelite designs in painting, are sure to offend you ; and if you
cease to work hard, and persist in looking at vicious and false
art, they will continue to offend you. It will be well, therefore,
to have one type of entirely false art, in order to know what to
guard against. Flaxman's outlines to Dante contain, I think,
examples of almost every kind of falsehood and feebleness
which it is possible for a trained artist, not base in thought, to
commit or admit, both in design and execution. Base or de-
graded choice of subject, such as you will constantly find in
Teniers and others of the Dutch painters, I need not, I hope,
warn you against ; you will simply turn away from it in dis-
gust ; while mere bad or feeble drawing, which makes mistakes
in every direction at once, cannot teach you the particular sort
of educated fallacy in question. But, in these designs of Flax-
man's, you have gentlemanly feeling, and fair knowledge of
anatomy, and firm setting down of lines, all applied in the
foolishest and worst possible way ; you cannot have a more
finished example of learned error, amiable want of meaning,
and bad drawing with a steady hand.[1] Retsch's outlines have

[1] The praise I have given incidentally to Flaxman's sculpture in the
Seven Lamps, and elsewhere, refers wholly to his studies from Nature,
and simple groups in marble, which were always good and interesting.
Still, I have overrated him, even in this respect; and it is generally to
be remembered that, in speaking of artists whose works I cannot be sup-
posed to have specially studied, the errors I fall into will always be on
the side of praise. For, of course, praise is most likely to be given
when the thing praised is above one's knowledge ; and, therefore, as our
knowledge increases, such things may be found less praiseworthy than
we thought. But blame can only be justly given when the thing blamed
is below one's level of sight; and, practically, I never do blame anything
until I have got well past it, and am certain that there is demonstrable

more real material in them than Flaxman's, occasionally show
ing true fancy and power ; in artistic principle they are nearly
as bad, and in taste worse. All outlines from statuary, as
given in works on classical art, will be very hurtful to you if
you in the least like them ; and *nearly* all finished line engrav-
ings. Some particular prints I could name which possess in-
structive qualities, but it would take too long to distinguish
them, and the best way is to avoid line engravings of figures
altogether. If you happen to be a rich person, possessing
quantities of them, and if you are fond of the large finished
prints from Raphael, Correggio, &c., it is wholly impossible
that you can make any progress in knowledge of real art till
you have sold them all—or burnt them, which would be a
greater benefit to the world. I hope that some day, true and
noble engravings will be made from the few pictures of the
great schools, which the restorations undertaken by the modern
managers of foreign galleries may leave us ; but the existing
engravings have nothing whatever in common with the good in
the works they profess to represent, and if you like them, you
like in the originals of them hardly anything but their
errors.

falsehood in it. I believe, therefore, all my blame to be wholly trust-
worthy, having never yet had occasion to repent of one depreciatory
word that I have ever written, while I have often found that, with
respect to things I had not time to study closely, I was led too far by sud-
den admiration, helped, perhaps, by peculiar associations, or other de-
ceptive accidents ; and this the more, because I never care to check an
expression of delight, thinking the chances are, that, even if mistaken,
it will do more good than harm ; but I weigh every word of blame with
scrupulous caution. I have sometimes erased a strong passage of blame
from second editions of my books ; but this was only when I found it
offended the reader without convincing him, never because I repented
of it myself.

Finally, your judgment will be, of course, much affected by
your taste in literature. Indeed, I know many persons who
have the purest taste in literature, and yet false taste in art,
and it is a phenomenon which puzzles me not a little ; but I
have never known any one with false taste in books, and true
taste in pictures. It is also of the greatest importance to you,
not only for art's sake, but for all kinds of sake, in these days
of book deluge, to keep out of the salt swamps of literature,
and live on a little rocky island of your own, with a spring and
a lake in it, pure and good. I cannot, of course, suggest the
choice of your library to you, every several mind needs differ-
ent books ; but there are some books which we all need, and
assuredly, if you read Homer,[1] Plato, Æschylus, Herodotus,
Dante,[2] Shakspeare, and Spenser, as much as you ought, you
will not require wide enlargement of shelves to right and left
of them for purposes of perpetual study. Among modern
books, avoid generally magazine and review literature. Some-
times it may contain a useful abridgement or a wholesome piece
of criticism ; but the chances are ten to one it will either waste
your time or mislead you. If you want to understand any sub-
ject whatever, read the best book upon it you can hear of ;
not a review of the book. If you don't like the first book you
try, seek for another ; but do not hope ever to understand the
subject without pains, by a reviewer's help. Avoid especially
that class of literature which has a knowing tone ; it is the

[1] Chapman's, if not the original.

[2] Carey's or Cayley's, if not the original. I do not know which ar
the best translations of Plato. Herodotus and Æschylus can only be
read in the original. It may seem strange that I name books like these
for " beginners :" but all the greatest books contain food for all ages ;
and an intelligent and rightly bred youth or girl ought to enjoy much,
even in Plato, by the time they are fifteen or sixteen.

most poisonous of all. Every good book, or piece of book, is full of admiration and awe ; it may contain firm assertion or stern satire, but it never sneers coldly, nor asserts haughtily, and it always leads you to reverence or love something with your whole heart. It is not always easy to distinguish the satire of the venomous race of books from the satire of the noble and pure ones ; but in general you may notice that the cold-blooded Crustacean and Batrachian books will sneer at sentiment ; and the warm-blooded, human books, at sin. Then, in general, the more you can restrain your serious reading to reflective or lyric poetry, history, and natural history, avoiding fiction and the drama, the healthier your mind will become. Of modern poetry keep to Scott, Wordsworth, Keats, Crabbe, Tennyson, the two Brownings, Lowell, Longfellow, and Coventry Patmore, whose " Angel in the House " is a most finished piece of writing, and the sweetest analysis we possess of quiet modern domestic feeling ; while Mrs. Browning's " Aurora Leigh " is, as far as I know, the greatest poem which the century has produced in any language. Cast Coleridge at once aside, as sickly and useless ; and Shelley, as shallow and verbose ; Byron, until your taste is fully formed, and you are able to discern the magnificence in him from the wrong. Never read bad or common poetry, nor write any poetry yourself ; there is, perhaps, rather too much than too little in the world already.

Of reflective prose, read chiefly Bacon, Johnson, and Helps. Carlyle is hardly to be named as a writer for " beginners," because his teaching, though to some of us vitally necessary, may to others be hurtful. If you understand and like him, read him ; if he offends you, you are not yet ready for him, and perhaps may never be so ; at all events, give him up, as you would sea-bathing if you found it hurt you, till you are

stronger. Of fiction, read Sir Charles Grandison, Scott's novels, Miss Edgeworth's, and, if you are a young lady, Madame de Genlis', the French Miss Edgeworth ; making these, I mean, your constant companions. Of course you must, or will, read other books for amusement, once or twice ; but you will find that these have an element of perpetuity in them, existing in nothing else of their kind ; while their peculiar quietness and repose of manner will also be of the greatest value in teaching you to feel the same characters in art. Read little at a time, trying to feel interest in little things, and reading not so much for the sake of the story as to get acquainted with the pleasant people into whose company these writers bring you. A common book will often give you much amusement, but it is only a noble book which will give you dear friends. Remember also that it is of less importance to you in your earlier years, that the books you read should be clever, than that they should be right. I do not mean oppressively or repulsively instructive ; but that the thoughts they express should be just, and the feelings they excite generous. It is not necessary for you to read the wittiest or the most suggestive books : it is better, in general, to hear what is already known, and may be simply said. Much of the literature of the present day, though good to be read by persons of ripe age, has a tendency to agitate rather than confirm, and leaves its readers too frequently in a helpless or hopeless indignation, the worst possible state into which the mind of youth can be thrown. It may, indeed, become necessary for you, as you advance in life, to set your hand to things that need to be altered in the world, or apply your heart chiefly to what must be pitied in it, or condemned ; but, for a young person, the safest temper is one of reverence, and the safest place one of obscurity. Certainly at

present, and perhaps through all your life, your teachers are wisest when they make you content in quiet virtue, and that literature and art are best for you which point out, in common life and familiar things, the objects for hopeful labour, and for humble love.

Made in the USA
Lexington, KY
27 September 2014